#BIG BOOK ≒ BUSINESS CARDS

#BIG BOOK ≒ BUSINESS CARDS

DAVID E. CARTER

THE BIG BOOK OF BUSINESS CARDS Copyright © 2005 by COLLINS DESIGN and DAVID E. CARTER

All rights reserved. No part of this book may be used or reproduced in any manner whatsoever without written permission except in the case of brief quotations embodied in critical articles and reviews. For information, address Collins Design, 10 East 53rd Street, New York, NY 10022.

HarperCollins books may be purchased for educational, business, or sales promotional use. For information, please write: Special Markets Department, HarperCollins*Publishers*, 10 East 53rd Street, New York, NY 10022.

First Paperback Edition

www.harpercollins.com

First published in 2005 by: Collins Design An Imprint of HarperCollinsPublishers 10 East 53rd Street New York, NY 10022 Tel: (212) 207-7000 Fax: (212) 207-7654 collinsdesign@harpercollins.com

Distributed throughout the world by: HarperCollins*Publishers* 10 East 53rd Street New York, NY 10022 Fax: (212) 207-7654

Interior page design by Designs on You!

Paperback cover design by Anderson Design Group, Nashville, TN.

Library of Congress Control Number: 2005928941

ISBN: 978-0-06-114419-6

Produced by Crescent Hill Books, Louisville, KY. www.crescenthillbooks.com

Printed in China

First Paperback Printing, 2008

Business cards have changed.

Once they were designed almost as an afterthought, and made to match the letterhead and envelope.

Now that business mail has become almost extinct as e-mail takes over, business cards have a new level of importance.

Business transactions have become much more impersonal—automated voice customer service and orders completed totally online, for example. This lack of personal contact has made the rare one-to-one contact more important than ever. How to capitalize on that contact? Leave a business card.

But the business card that is given to someone must impact. It must connect the card with the person, and the old one-color, one-sided business card is no longer worth the paper it is printed on.

The new business card is a business tool, but only if it stands out. Increasingly, businesses are printing on both sides of the card. A few years ago, this technique was rare; now, it's common.

Yes, business cards have changed. And firms who create brand identities need to see just what's happening in the world of business cards. They need to see outstanding cards from large and small companies from around the world.

And that's the whole purpose of this book.

Danc

•			

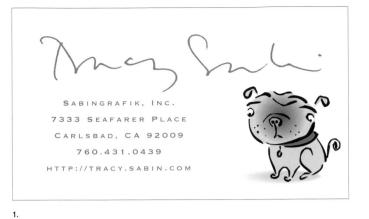

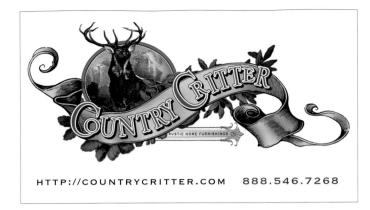

2

18755 Grahams Drive Abington, VA 24211

276.628.2818

P.O. Box 64
6461 El Apajo Road
Rancho Santa Fe, CA 92067

Fax: (858) 756-1466

3.

Greg Sabin

Zonk International 818 South Dakota Street Seattle, WA 98108

> 206.340.1296 f 206.545.7241

5.

(1-5)
Design Firm Sabingrafik, Inc.

Client Sabingrafik, Inc.
Designer Tracy Sabin

Client Country Critter
Designer Tracy Sabin

Designer Tracy Sabin

Client Big Weenie Records

Designer Tracy Sabin

Client Helen Woodward Animal Center Designers Tracy Sabin, Lesley Gunr

Client Zonk!
Designer Tracy Sabin

2

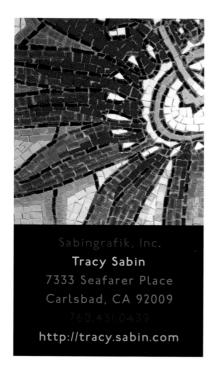

AN IMPRINT OF
HARCOURT CHILDREN'S BOOKS
525 B STREET, SUITE 1900
SAN DIEGO, CA 92101

619.231.6616

PARAGON
REALTY & FINANCIAL, INC
1202 Kettner Boulevard / Suite 6000, San Diego, CA / 619.234.2322

401 Mission Ave, Oceanside, California 760.439.1733

6.

8

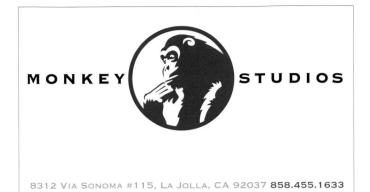

9665 CHESAPEAKE DRIVE, SUITE 300, SAN DIEGO, 92123

TURNER ENTERTAINMENT COMPANY 5890 WEST JEFFERSON BOULEVARD LOS ANGELES, CALIFORNIA 90016

300 East Ocean Blvd. Long Beach, CA 90802

7.

Tel: 562-436-3636

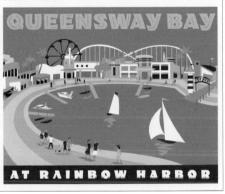

10.

11.

Design Firm Sabingrafik, Inc.

Tamarindo Pacifico Designer Tracy Sabin Consolite Boat Decals Designer Tracy Sabin Client Sabingrafik, Inc. Designer Tracy Sabin Client Odyssey Classics Designer Tracy Sabin Client Paragon Realty & Financial, Inc. Designer Tracy Sabin Client Oceanplace Designer Tracy Sabin Client Monkey Studios Tracy Sabin, Designers

Russell Sabin

San Pacifico Client Tracy Sabin Designer Client Queensway Bay Tracy Sabin Designer 10. Client Turner Entertainment Company Designer Tracy Sabin 11. Client Tracy Sabin Designer

HOTEL · BALBOA · PARK

25 Spruce Street, San Diego, CA 92103 800-874-2649 or 619-291-0999 MCRD, Building 9
P.O. Box 400144
San Diego, CA 92140

Hours:
8:30am-4:30pm
Monday-Friday

800.7 3 6.4 500
f 619.298.9405

2

CANYON LIVING IN BANKER'S HILL

9683 TIERRA GRANDE STREET
SUITE 201
SAN DIEGO, CA 92126
619.685.2148

3.

4.

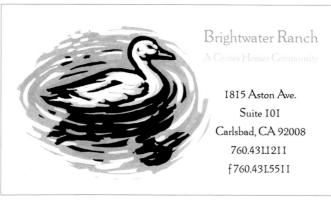

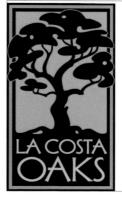

7411 CIRCULO SEQUOIA LA COSTA, CA 92009

PHONE: 760-633-0118 FAX: 760-633-1662

CENTEX HOMES CENTEX CORPORATION

6.

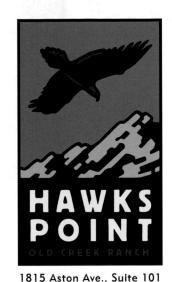

1815 Aston Ave., Suite 101 Carlsbad, CA 92008

760.431.1211 f760.431.5511

A CENTEX HOMES COMMUNITY

2734 Loker Avenue West, Suite K Carlsbad, CA 92008

A BREHM COMMUNITIES HOME

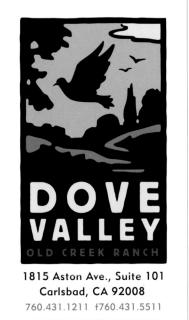

A CENTEX HOMES COMMUNITY

Flying Horse Ranch 1002 Meadowrun Road Encinitas, CA 92024

Client

Designers Client

Designers

Designers

Client

Brightwater Ranch Tracy Sabin, Danny Zaludek

Tracy Sabin, Steve Sharp

La Costa Oaks

Hawks Point Tracy Sabin, Steve Sharp

10.

Client

San Diego Gas & Electric Coyote Division 8326 Century Park Ct. San Diego, CA 92123-4150
--

Design Firm Sabingrafik, Inc. (2,3)
Design Firm McNulty Creative Design Firm Roni Hicks & Assoc. Design Firm Franklin Stoorza Client The Park Manor Designer Tracy Sabin Client Pacific Marine Credit Union Designers Tracy Sabin, Mary McNulty 7 On Third Client Designers

Danny Zaludek

Tracy Sabin, Steve Sharp Designers Client WaterRidge Tracy Sabin, Steve Sharp Designers 10. Client Flying Horse Ranch Tracy Sabin, Mary McNulty Designers Tracy Sabin, Danny Zaludek Settlers Ridge Tracy Sabin, Paige Cleveland, San Diego Gas & Electric Client Designers Tracy Sabin, Craig Fuller Designers

350 East First Street, Los Angeles, CA 90012

2

HORTON FARMER'S MARKET ONE HORTON PLAZA SAN DIEGO, CA 92101

619.696.7766

2560 Progress Street Vista, Ca 92083

760.598.7000

6

12522 Feather Drive, Riverside County, CA (951) 582-0816

7.

TOWNHOMES IN THE CULTURAL HEART OF ESCONDIDO Barratt Urban Development 760.431.0800

The Irvine Company, 550 Newport Center Drive, Newport Beach, CA 92660

A K L O

Parkloft Sales Office: 877 Island Avenue, San Diego CA 92101 1-877-PARKLOFT

10.

(7-11)

Client

Client

Designer

Designer

Designer

Designer

Client

Client

Designer

Brookfield Homes 12865 Pointe Del Mar Suite 200 Del Mar, CA 92014

Phone: 858.481.8500

Designers Tracy Sabin, Jim Naegli Client Riverbend Designers Tracy Sabin, Craig Fuller,

Design Firm Sabingrafik, Inc.

Design Firm Greenhaus

Design Firm Design Group West

Tracy Sabin

Tracy Sabin Horton Farmer's Market

Tracy Sabin Calif. Beach Co.

Tracy Sabin

Tracy Sabin

UCSD Tritons

Sandra Sharp

Kamikaze Skatewear

Heritage Apron Company

Japanese Village Plaza

8. Client The Paramount Designers

Tracy Sabin, Sandra Sharp, Craig Fuller

Client

10.

Woodbury Tracy Sabin, Craig Fuller Designers

Client

Designers Tracy Sabin, Craig Fuller,

Sandra Sharp

11. Client

Tracy Sabin, Craig Fuller, Sandra Sharp Designers

3.

The Ridge Golf Club 2020 Golf Course Road Auburn, CA 95602

(530) 888-7888

2.

OTAY RANCH

ST. 1988

1000 HERITAGE ROAD, CHULA VISTA, CA 91913
(800) 421-9088

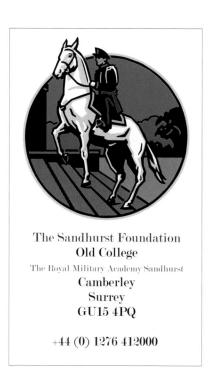

Building Industry Association 6336 Greenwich, Suite A San Diego, California 92122

858.450.1221

aquantive.com avenuea.com ifrontier.com atlasdmt.com

michael.vernon@aquantive.com

dir_ 206.816.8599 fax_ 206.816.8502

aQuantive

aQuantive, Inc. 506 Second Avenue Seattle, Washington 98104

Alan Perry

Unix Specialist alan@attenex.com

Attenex Corporation 701 Fifth Avenue, Suite 1450 Seattle, Washington 98104 m: 206.499.5501

f: 206.386.5841

Allan K. Ikawa President, CEO 585 Hinano Street Hilo, Hawaii 96720 t 808.961.2199 f 808.961.6941

Design Firm Greenhaus

Design Firm Tyler Blik Design

Design Firm The Flowers Group

Design Firm MDA Communications

Design Firm Conover

Design Firm Hornall Anderson Design Works

Client La Strada Designers

Tracy Sabin, Craig Fuller, Sandra Sharp

Client Designers

South Shore Marine Tracy Sabin, Craig Fuller

Client Tracy Sabin, Craig Fuller,

Designers

S. Michael Grace, Jerry Sisti

Client Otay Ranch

Tracy Sabin, Tyler Blik Designers

Designers

The Ridge Tracy Sabin, Corey Shehan

Designers

The Sandhurst Foundation Tracy Sabin, James Dewar Client Designers

Building Industry Association Tracy Sabin, David Conover

Client Designers aQuantive Corporation Jack Anderson, Kathy Saito, Henry Yiu, Sonja Max,

Gretchen Cook Client

Designers Katha Dalton, Jana Wilson Esser

Client Big Island Candies Designers

Jack Anderson, Kathy Saito, Mary Chin Hutchison,

clearw re

Travis Durden

Account Executive travis.durden@clearwire.com

9452 Phillips Highway #4 Jacksonville, FL 32256 T: 904 482 1414 F: 904 482 1888 M: 904 631 9643

1.

2.

FREEMOTION FITNESS INC"

principal engineer

etrieve

- 503.533.2300
- travis@etrieve.com
- www.etrieve.com

3000 nw stucki place suite 120

hillsboro, oregon 97124

Erin Kelly

Inside Sales Representative

Tel 719.955.1100, Ext 117
Fax 719.955.1104
Toll Free 877.363.8449

1096 Elkton Drive, Ste 600 Colorado Springs, Colorado 80907-3573

ekelly@freemotionfitness.com

FREEMOTION FITNESS INC

Mary Ann Petro Art Consultant

telephone: 415·749·1948 facsimile: 415·749·1952

2111 Hyde Street Suite 602 San Francisco CA 94109

www.heavenlystone.com ma_petro@heavenlystone.com

(1-6)Design Firm Hornall Anderson Design Works Client Clearwire Designers Jack Anderson, John Anicker, Leo Raymundo, Sonja Max, Andrew Wicklund Client etrieve John Hornall, Kathy Saito, Henry Yiu, Andrew Smith Designers FreeMotion Jack Anderson, Kathy Saito, Client Designers Sonja Max, Henry Yiu, Alan Copeland Client Heavenly Stone Designers Jack Anderson, Henry Yiu 5. Client impli Designers Jack Anderson, Sonja Max, Kathy Saito, Alan Copeland Client Designers John Anicker, Henry Yiu, Kathy Saito, Gretchen Cook, Sonja Max

Maveron LLC
800 Fifth Avenue
Suite 4100
Seattle, WA
98104
www.maveron.com

Judy Z. Neuman
jneuman@maveron.com

© 206.447.1300
206.470.1150

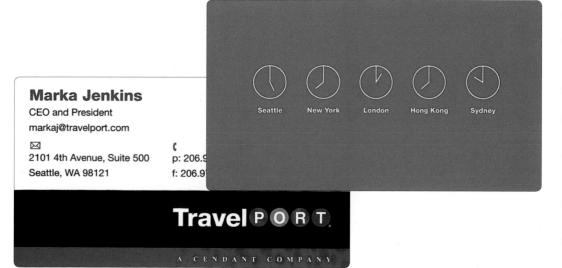

Design Firm Hornall Anderson Design Works Client Lease Crutcher Lewis Jack Anderson, Katha Dalton, Designers Belinda Bowling, Gretchen Cook, Andrew Smith Maveron Designers Jack Anderson, Margaret Long MetricsDirect Designers John Anicker, James Tee, Elmer dela Cruz, Kris Delaney Client Hornall Anderson Design Works Designers John Hornall, Jack Anderson, Henry Yiu, Andrew Wicklund. Mark Popich Client Urban Mobility Group Designers Jana Nishi, Belinda Bowling, Henry Yiu 6. Client Travelport Designers Lisa Cerveny, Andrew Wicklund,

Andrew Smith, Jana Nishi, Hillary Radbill

Virtutech AB Norrtullsgatan 15, 1tr SE-113 27 Stockholm Sweden

virtutech

Niklas Rudemo General Manager, EMEA mobile: +46 708 141 287 niklas@virtutech.com

phone: +46 8 690 07 27 **fax:** +46 8 690 07 29 www.virtutech.com

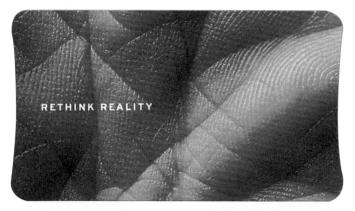

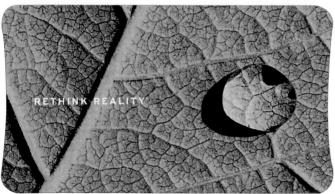

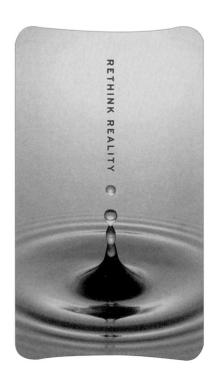

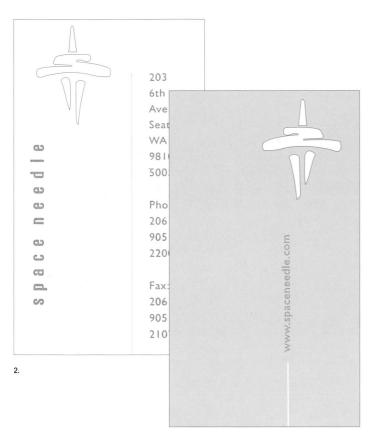

SOVARCHITECTURE ARCHITECTURE DESIGN ART

Design Firm Hornall Anderson Design Works

1. Client

Client Virtutech
Designers Daymon Bruck, Yuri Shvets

Client

Space Needle Jack Anderson, Mary Hermes, Designers

Gretchen Cook, Andrew Smith

Client

SOVArchitecture Jack Anderson, Larry Anderson, Designers

Henry Yiu

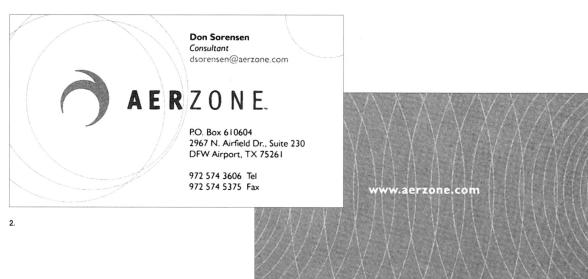

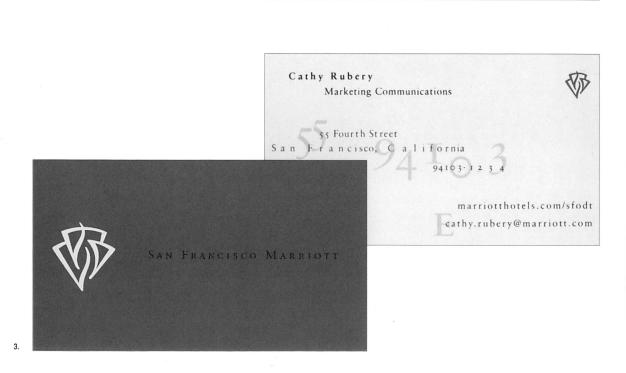

Pace International, LLC

Rick Lewis

Service Representative

1403 Hidden Creek Lane Winter Haven, FL 33880 cell 863 rickl@paceint.com fax 863

Corporate Office: 1011 Western Ave Suite 807 Seattle, WA 98104 cust ser www.po

Seattle's Convention and Visitors Bureau

Darouny Syphachane Housing Coordinator

dsyphachane@seeseattle.org

520 Pike Street, Suite 1300, Seattle, WA 98101 206 461 5870 206 461 5853

seeseattle.org

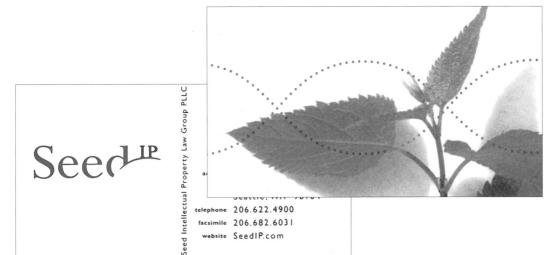

Design Firm Hornall Anderson Design Works

Client

Mulvanny/G2 Jack Anderson, Katha Dalton, Designers Michael Brugman, Jana Nishi, Hillary Radbill, Henry Yiu,

Linda Tharaldson, Ed Lee

Client Designers

Client

Mark Popich, Ed Lee, Gretchen Cook, Andrew Smith

San Francisco Marriott Jack Anderson, Kathy Saito, Sonja Max, Alan Copeland, Designers

Gretchen Cook

Client Pace International

Jack Anderson, Sonja Max,

Andrew Smith

Client Seattle Convention & Visitors Bureau Jack Anderson, Lisa Cerveny,

Bruce Branson-Meyer,

Mark Popich

Client Seed IP

Designers

Designers Jack Anderson, Katha Dalton,

Henry Yiu, Don Stayner

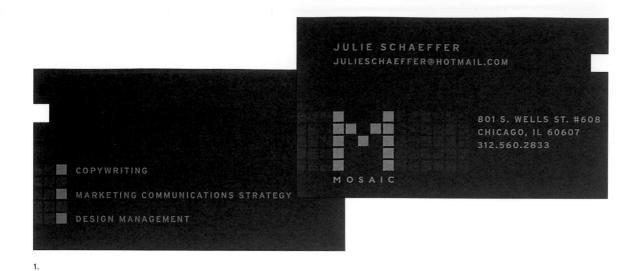

Rosy L. Santiago
Director of Education

Daniel Murphy
Scholarship Foundation

228 South Wabash, Suite 600
Chicago, Illinois 60604
direct: 312 455 7807
main: 312 455 7800
fax: 312 455 7801
email: rosy@dmsf.org
www.dmsf.org

ignite potential

ENRICH LIVES

Maria Mowbray SPECIAL PROJECTS COORDINATOR

SUITE 1601 CHICAGO, IL 60601 p 312 236 3681 x10 f 312 236 5429

188 WEST RANDOLPH STREET

mmowbray@chicagosinfonietta.org

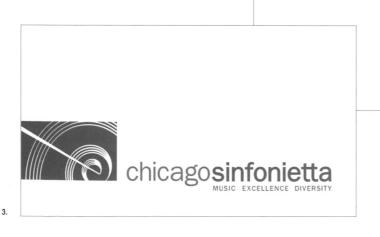

東洋課 イアナポリス美術館 学芸員 ジョン・忠雄・寺本

INDIANAPOLIS MUSEUM OF ART

John Tadao Teramoto, Ph.D. Associate Curator of Asian Art

> 4000 Michigan Road Indianapolis, Indiana U.S.A. 46208-3326 Tel 317-923-1331 Fax 317-926-8931 e-mail: jteramoto@ima-art.org www.ima-art.org

> > CONSUMER DRIVEN BRAND STRATEGY

ENVISION

SALLY DANCER PARTNER

E sally.dancer@brandenvision.com

V 847 412 5914

F 847 412 5901

630 DUNDEE ROAD SUITE 340 NORTHBROOK ILLINOIS 60062 www.brandenvision.com

5.

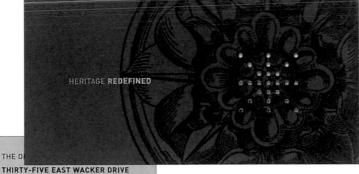

SUITE 600 CHICAGO ILLINOIS 60601 T 312.726.4260 F 312.977.0919

mshohet@creit.ca

Design Firm Pressley Jacobs: a design partnership

Client

2.

5.

6.

Sarah Lin Designer

Client Daniel Murphy Scholarship

Foundation Designers William Lee Johnson,

Mosaic

Jay Austin

3. Client

Chicago Sinfonietta Designer Kara Kotwas

4.

Client Indianapolis Museum of Art Designers Jay Austin, Kelly Bjork

Client Envision

Designer Amy McCarter

Client Thirty-Five East Wacker Drive

Amy McCarter Designer

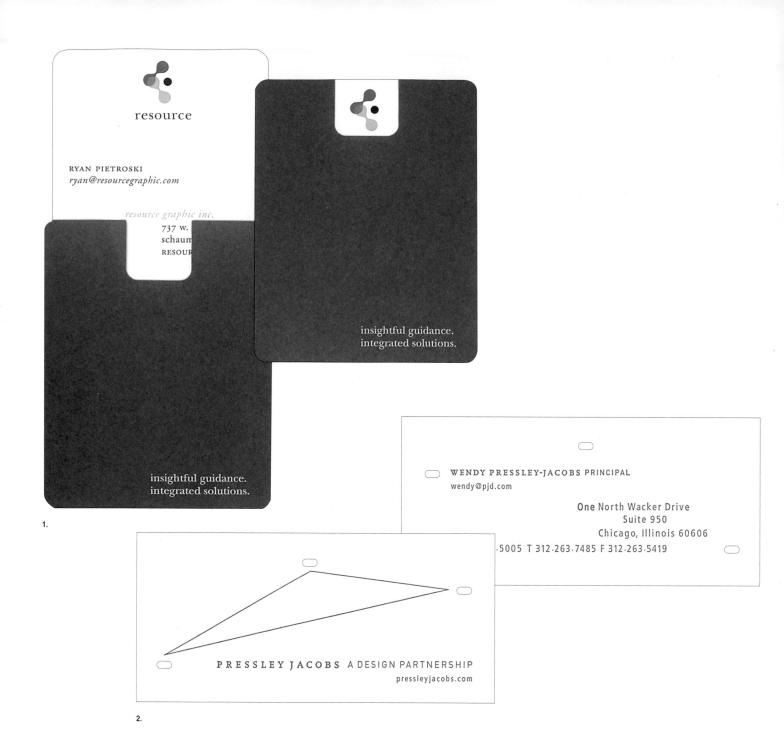

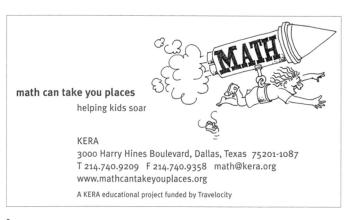

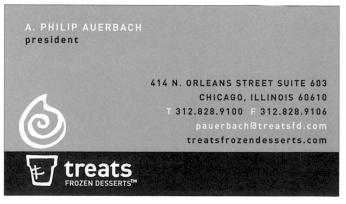

GENGHIS DESIGN

DALE MONAHAN Creative Director/Designer

> 303-445-0001 Fax: 303-235-0310

dale@genghis-design.com www.genghis-design.com

What Time Is It In Your World? Charles Vanstrom

1669 Clarkson Street, Denver, CO 80218 I**ne: 303.813.1159** Fax: 303.869.4989 Phone: 303.813.1159

DIGITAL VIDEOGRAPHY

Weddings, Special Events & Corporate Video Productions

Studio: 303-459-9000

Fax: 303-734-0764

Jeri-Lynn Kalish

Jerilynn@blkdiamondproductions.com

www.blkdiamondproductions.com 6382 S. Williams St., Littleton, CO 80121

Design Firm Pressley Jacobs: a design

partnership

Design Firm Genghis Design, LLC

Client Resource Graphic Amy McCarter, Sarah Lin Designers

Client

Pressley Jacobs: a design

partnership Jef Anderson

Designer

Client Math Can Take You Places

Amy McCarter Designer

Treats Frozen Desserts Client

Sarah Lin Designer

Genghis Design, LLC Dale Monahan Client

Designer

Client 11:59 Nightclub

Designer Dale Monahan

Black Diamond Productions, LLC

Designer Dale Monahan

ð

e-mail: sales@kingdom-clubhouse.com Fax: 970-453-9060 www.kingdom-clubhouse.com

All Phase

Troy Tinberg

303.914.8370 Fax 303.914.8399 1301 South Pierce Street, Lakewood, Colorado 80

2.

1.

All Phase Landscape strives to be the most respected landscape company in Colorado.

When you work with us, we want you to recognize that our integrity, flexibility and industry experience are the reasons we are able to provide superior services and opportunities to our clients, suppliers and employees.

DON MCINTYRE (303) 371-4444

4.

мсз A.R. MCINTYRE & COMPANY MARKET RESEARCH

GATEWAY OFFICE ONE AT DIA 3950 N. LEWISTON ST., STE. 310 AURORA, CO 80011

FAX (303) 371-4449

www.mc-3.com

MC3 IS LOCATED
MINUTES FROM DIA.
TAKE PENA BLVD. TO
E. 40TH AVE. &
GO 1 BLOCK WEST
TO GATEWAY PARK. • DIA PENA BLVD. E. 40TH

PARK CAPITAL MANAGEMENT GROUP

John S. Layman

PARK CAPITAL MANAGEMENT GROUP

toll free 877.728.8029 fax 615.370.9892

john@parkcapitalmanagement.com 216 Centerview Drive, Suite 303, Brentwood, TN 37027

Design Firm Genghis Design, LLC

Client

Kingdom Housing,LLC/ The Clubhouse, Inc.

Dale Monahan Designer

All Phase Landscape Client Dale Monahan

Designer Client

5280 Realty Dale Monahan

Designer 4. Client

David Deeble

Designers

Dale Monahan, Brian D'Agosta

5. Client

MC3, A.R. McIntyre & Company

Dale Monahan Designer

Client Park Capital Management Group Dale Monahan Designer

DENVER ORAL & MAXILLOFACIAL S U R G E R Y A S S O C I A T E S

Mark D. Berman, D.D.S., M.S., P.C.

303-694-1700 • Fax 303-773-6825 8200 E. Belleview Ave., Suite 515E Greenwood Village, CO 80111 303-948-9663 • Fax 303-773-6825 7325 South Pierce, Suite 204 Littleton, CO 80123

e-mail: denveroms@ibm.net

561.302.6525 | info@victoriacave.com

Victoria Cave interior refiner

Peace, like charity, begins at home.

- Franklin D. Roosevelt

Cave

Where thinking + feeling live.

matthew cave

PRINCIPA

CAVE DESIGN AGENCY

phone 561.417.0780 fax 561.417.0490 3500 nw boca raton blvd, 808, boca raton, fl 33431 email matt@cavedesign.com web cavedesign.com

> Joseph P. Walker M.D., F.A.C.S. Glenn L. Wing M.D., F.A.C.S. Paul A. Raskauskas M.D., F.A.C.S. Tom Ghuman M.D., F.A.C.S. Donald C. Fletcher M.D.

info@eye.md

2668 Winkler Ave Fort Myers, FL 33901 Tel (239) 939.4323 FL (800) 282.8281 Fax (239) 939.4712 www.eye.md

EXPERIENCE THE DIFFERENCE SM

Design Firm Genghis Design, LLC Design Firm Cave Design Agency Client Horizon Mechanical, Inc. Dale Monahan Designer Denver Oral & Maxillofacial Client Dale Monahan Designer Client Pound Interactive Matt Cave, David Edmundson Designers Client Victoria Cave Matt Cave, David Edmundson Designers Cave Design Agency Matt Cave, David Edmundson Client Designers Client Retina Consultants of Southwest Florida
Designers Matt Cave, David Edmundson

6.

ings

SCHOLARS

KURT WIEDENHOEFT

President / Co-Founder

KURT@SCHOLARSRESOURCE.COM

FIVE HORIZON LANE FREEPORT, MAINE 04032 TEL 800.688.3040

STEVE SIMS
SSIMS@THEBLUEFISH.COM

TEL 866.270.3879 | CELL 561.251.2096 | FAX 775.239.1057 777 E. ATLANTIC AVE SUITE Z251 | DELRAY BEACH FL 33483 WWW.THEBLUEFISH.COM

Marc Holbik marc@ecoripe.com

ECORIPE TROPICALS 750 Middle River Drive Fort Lauderdale, FL 33304 P 954 599 0480 F 866 842 8825 www.ecoripe.com The sweet taste of quality.

John Boden Managing Partner

3650 N Federal Hwy, Ste 215 Lighthouse Point, FL 33064 Phone: 954.727.2200 ext: 155 Fax: 954.727.2201 jboden@questinghound.com www.questinghound.com

technology's best friend

(1-5)
Design Firm Cave Design Agency

Client Scholars Resource Matt Cave, David Edmundson Designers 2. Cave Images Matt Cave, David Edmundson Client Designers 3. Bluefish Concierge Matt Cave, David Edmundson Client Designers 4. Ecoripe Tropicals Designers Matt Cave, David Edmundson 5. Client QuestingHound Designers Matt Cave, David Edmundson

5.

Apple Valley Villa 14610 Garrett Avenue Apple Valley, Minnesota 55124-7518

marketing@applevalleyvilla.com tel: 952.431.8016 fax: 952.431.9923

Apple Valley Villa

Scott Walter President and Mad Brittler

P.O. Box 47185 Plymouth MN 55447 612 804 6664 scott@beyondbrittle.com

smart copy that moves

brain traffic

KRISTINA HALVORSON copywriter

tel 651 646 7500

cel 612 644 3510

photo grAphy

Ann e. cutting

one eighty-eight south delAcy Ave pAsAdena cA 91105 p h $_{-}$ 6 2 6 $_{-}$ 4 4 0 $_{-}$ 1 9 7 4 fx 626 577 8036 ann $_{-}$ cutting.com

www.cutting.com

927 nicollet mall minneapolis minnesota, 55402 www.petals-floral-design.com

for you

telephone {612} 339 0065 info@petals-floral-design.com

Leading Strategically
Insights and Tools for CEOs.
Senior Managers, and HR Leaders

Candy Armstead registrations

2900 HIGHWOODS BOULEVARD RALEIGH, NC 27604-1060

919-878-9222 (Raleigh) or 336-668-7746 (Greensbord) www.capital.org

6.

fax {612} 339 1165

C2 Investment Group

CORPORATE OFFICE

19901 W. Catawba Ave. Suite 205

Cornelius, NC 28031

www.c2ig.com

888.327.1422 **TEL** 704.987.8730 **FAX**

David Silvas dsilvas@c2ig.com Client Apple Valley Villa
Designer Chad Olson
2.

(1-5)
Design Firm Graphiculture, Inc.
(6,7)
Design Firm CAI Communications

Client Beyond Brittle
Designer Lindsay Little

Client Brain Traffic Designer Lindsay Little

Client Ann E. Cutting Designer Chad Olson

Client Petals
Designer Chad Olson

Client Capital Associated Industries
Designer Beth Greene

Client C2 Investment Group
Designers Steve McCulloch, Debra Rezeli

henry vizcarra

creative director

2801 cahuenga blvd. west los angeles, california 90068 voice 323 850 5311 fax 323 850 6638 www.30sixtydesign.com henry@30sixtydesign.com

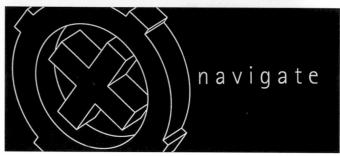

30sixtyadvertising+design

2801 cahuenga blvd west los angeles california 90068

ph + 323 850 5311 cl + 213 810 4222

fx + 323 850 6638

par@30sixtydesign.com www.30sixtydesign.com

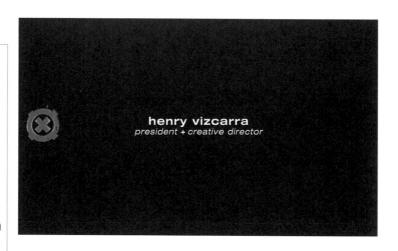

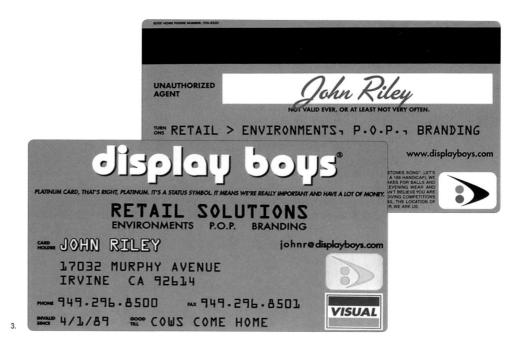

80 Tannock Street Balwyn North Victoria 3104 www.bmclandscape.com Bernard McInerney 0418 173 358 bernie®bmclandscape.com

QUALITY WORK BY PROFESSIONALS
OUTBOOR LIGHTING! DECKING
PERCOLAS! PAVING! LAWNS
RETAINING WALLS
WATER FEATURES
COITETY ARBIDS

ementwater conservation native gardensener gyefficiency healthy life an agement water conservation is a garden support of the property less than a garden support of the gardensener gyefficiency healthy lifesty lewaste man as mention to conservation native gardensener healthy lifesty lewaste man as mention to conservation native gardensener y healthy lifesty lewaste man agement water conservation of the gardensener gyefficiency healthy lifesty lewaste management water conservation native gardensener gyefficiency healthy lifesty lewaste management ervation native gardensener gyefficiency healthy lifesty lewaste management water conservation native gardensener gyefficiency healthy lifesty lewaste management water conservation native gardensener gyefficiency healthy lifesty lewaste management water conservation native gardensener gyefficiency healthy lifesty lewaste management water conservation native gardensener gyefficiency healthy lifesty lewaste management water gardensener

Design Firm 30sixty advertising+design Design Firm Display Boys (4-6)Design Firm At First Sight Client 30sixty advertising+design Henry Vizcarra, Pär Larsson, Designers Kae Singhaseni 3. Client Display Boys Designers Darin Rassmussen, John Riley Client BMC Landscape Construction Designers Olivia Brown, Barry Selleck Healthy Earth Homes Client Olivia Brown, Barry Selleck Designers Client Popboomerang Records Designers Olivia Brown, Barry Selleck

■ wpi finance

| homes | personal | business

wpi building

| domestic | commercial

wpi investment

| property | shares | opportunities

your next appointment

1.

manager construction

26a upton street altona victoria 3018 australia

t+61 1300 882 002 f+61 1300 882 001 m 0401 038 957

i www.werwpi.com e ouroffice@werwpi.com

ACN 097 694 525

mobile 0404 848 965 email lindsay@optimaudio.com.au

HIRE I SALES SERVICE I INSTALLATION LIVE DIGITAL (O/B) RECORDING SCHOOL AND THEATRE PRODUCTIONS CORPORATE AND AUDIO/VISUAL THEMING COMMUNITY EVENTS

Factory One, 34 Cumberland Drive (P.O.Box 2174) Seaford VIC 3198 phone +61 3 8796 3954 fax +61 3 8796 3957 www.optimaudio.com.au

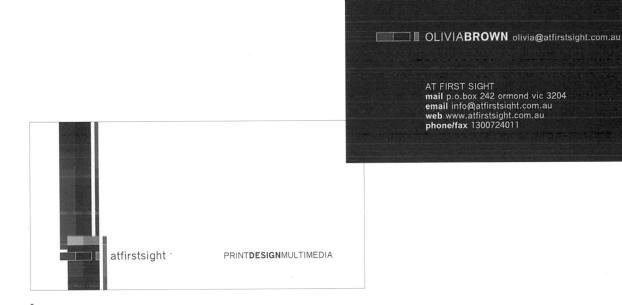

Client World Property Investments
Designers Olivia Brown, Barry Selleck Optim Audio Olivia Brown, Barry Selleck Designers Client Madame Monarch Olivia Brown, Barry Selleck Designers Client Aloi Na! Olivia Brown, Barry Selleck Designers Client At First Sight Olivia Brown, Barry Selleck Designers Client Bizzarri Ristorante Designers Olivia Brown, Barry Selleck

Design Firm At First Sight

3.

4.

5.

A.J. (Tony) McInerney

1685 Malvern Road, Glen Iris, Victoria, 3124

mobile) 0408 831 946

email) tony.mcinerney@telstra.com

1.

2

4.

Gabriel Sponsler
Technical Specialist

411 Pacific Street
Suite 307
Monterey, CA 93940
Tel 831-648-8111
Fax 831-648-8113
www.montereybay.com
Email gabe@montereybay.com

Living the Spa Lifestyle

MOSTAFA TAWFIK

119 Carmel Plaza / P.O. Box 4856 / Carmel, California 93921 Fax 831.622.0503 / Tel 831.622.7772 / www.retreatretreat.com

8.

10.

(1-5)

Client

6. Client

Designers

Designer

11.

(6-11) Design Firm The Wecker Group Client A.IM Designers Olivia Brown, Barry Selleck 2. K5 Trading Client Designers Olivia Brown, Barry Selleck 3. Client Green Options Marketing Olivia Brown, Barry Selleck Designers 4. Client Coach Club Olivia Brown, Barry Selleck Designers 5.

Wedding Creations

Montereybay.com

Robert Wecker

Design Firm At First Sight

Olivia Brown, Barry Selleck

Client Computer Repair Express Designer Robert Wecker Client Robert Wecker Designer 9. Client Northern California Golf Association Robert Wecker, Matt Gnibus Designer 10. Client Carmel Hills Care Center Designer Robert Wecker 11. Client Sage Metering, Inc. Robert Wecker, Matt Gnibus Designers

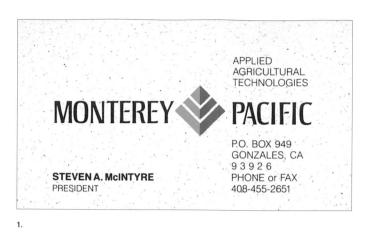

AQUAFUTURE

RICHARD P. DeMARCO
President / CEO

THE AQUAFUTURE CORPORATION
5-B HARRIS COURT
MONTEREY, CA 93940
TEL 408-648-1998
FAX 408-648-1968
rdemarco@aquafuturecorp.com

2

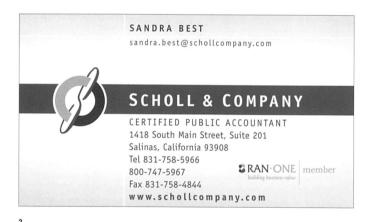

BOWLER
BILLIARDS

BRIAN STEEN
OWNER

SII TYLER STREET
MONTEREY
CALIFORNIA
93940
TEL 408-647-1809

TANNING 26352 CARMEL RANCHO LANE BEACH WEAR SUITE 102 SKIN+NAIL CARE CARMEL, CA 93923 HAIR PRODUCTS 831-624-TANZ (8269) ACCESSORIES AX 831-624-8276 MAIL reneken@msn.com COSMETICS BY THE SEA A BRONZING SPA MASSAGE SUZANNE ROYSTER

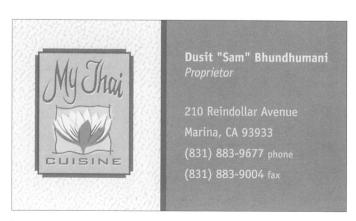

6.

5

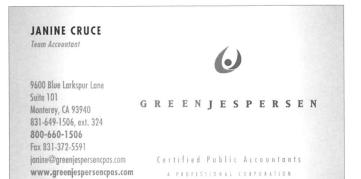

Ω

10.

(1-11)

Design Firm The Wecker Group Client Monterey Pacific Designe Robert Wecker Aquafuture Client Designe Robert Wecker 3. Client Scholl & Company Designer Robert Wecker 4. Client Bow Tie Billiards Matt Gnibus, Robert Wecker Designers 5. Client Tanning by the Sea Matt Gnibus, Robert Wecker Designers Client My Thai Cuisine Kevin Wecker, Robert Wecker Designers

Client Green Jespersen CPA Robert Wecker, Tremayne Cryer, Designers Sponsler Enterprises Culinary Center of Monterey Robert Wecker Client Designer Client MonterevBav.com Robert Wecker Designer 10. Client JZ Racing Matt Gnibus, Robert Wecker Designers 11. Client Community Foundation for Monterey County Robert Wecker Designer

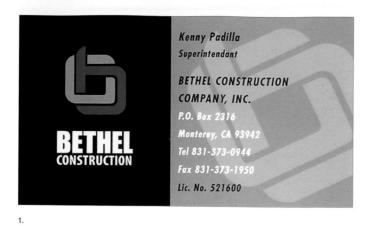

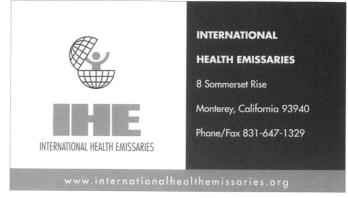

2.

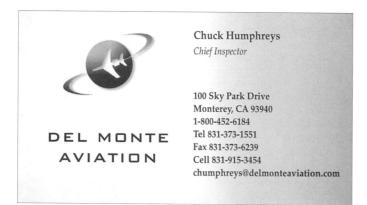

P.O. BOX

223201

CARMEL,

CALIFORNIA

93922

408-624-7338

FAX 408-624-7127

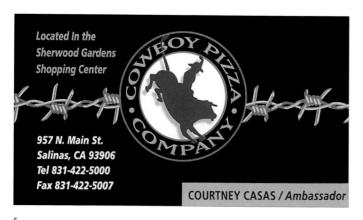

Design Firm The Wecker Group Bethel Construction Designer Robert Wecker Client International Health Emissaries Designer Robert Wecker Del Monte Aviation Client Designers Matt Gnibus, Robert Wecker John Bigham Racing Robert Wecker Client Designer Cowboy Pizza Company Robert Wecker, Courtney Casas, Client Designers Tremayne Cryer 6. Client Allison Carroll Motorsports Designer Client Hullaballoo Robert Wecker, Tremayne Cryer Designers Client The Centrella Inn Robert Wecker, Matt Gnibus Designers Client Monterev.com Robert Wecker Designer

•

Design Firm Octavo Designs Coast Gallery Maui Client Designer Terri Borucki Client Monterey Peninsula Country Club Robert Wecker Designer Client Cynthia Davis, CPA Matt Gnibus, Robert Wecker Designers Client Big Sur River Inn Kevin Wecker, Robert Wecker Designers Manzoni Family Estate Vineyard Client Designer Robert Wecker Winners Batting Cages Robert Wecker, Matt Gnibus Client Designers Platinum Travel Group Robert Wecker, Matt Gnibus Client Designers Client Blue Noise Sue Hough, Mark Burrier Designers Associated Credit Services Designer Sue Hough

Design Firm The Wecker Group

(8,9)

Mind Balancing Your Life Through Movement Lynn R. Dutrow, M.S. Licensed Brain Gym® Instructor/Consultant P (301) 473-4967 E lynn@mindandmotion.net P.O. Box 722 Frederick, MD 21705 www.mindandmotion.net

Giving Form to Electronic Information

Design Firm Octavo Designs Client Old Town Tea Co. Mark Burrier, Sue Hough Designers RAM Digital Client Sue Hough, Mark Burrier Designers Majestic Wood Floors Client Sue Hough Designer Mind & Motion Client Sue Hough Designer Fat City Graphics Client Mark Burrier, Sue Hough Designers Donna Parker Media Group Client Mark Burrier Designer Client Enforme Interactive Designer Sue Hough Client Heather K. Whittington, PRYT Designer Sue Hough

Designers

Moore Wealth Incorporated

Sue Hough

2.

4.

6.

8

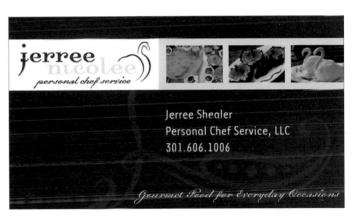

10.

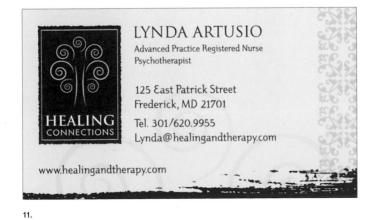

(1-11) Design Firm Octavo Designs 1-3. Client Octavo Designs Designer Sue Hough 4-7. . Client Stefany Lee Photography Designer Sue Hough CDE Management Designe Sue Hough Flightcraft Sue Hough 10. Client Jerree Nicolee Designer Sue Hough Healing Connections Sue Hough Client Designer

49 Locust Avenue New Canaan, CT 06840 203 966-7015

Argyle Associates, Inc.

Roger G. Langevin President

The Complete Research Resource

Clare Reilly Marketing Coordinator

BAIGlobal Inc. 580 White Plains Road Tarrytown, NY 10591

Tel: 914 332-5300 Fax: 914 631-8300 E-mail: creilly@baiglobal.com

2.

John F. Keane, Jr. President

Capitol Risk Concepts, Ltd. Insurance Brokers One Water Street Suite 230 White Plains, NY 10601-1009

Tel. 914 946-7161 NYC 212 868-8000 FAX 914 683-8048 For Games That Fill The House

Hal Rubin

Full House Gaming, Inc. 4 Dann Farm Road Pound Ridge, NY 10576 Telephone: 914 764 9494 E-mail: hrubin@optonline.com www.fullhousegaming.com

3.

The Explosive New Game!

Hal Rubin Full House Gaming 4 Dann Farm Road, Pound Ridge, NY 10576 Tel: 914 764 9494 E-mail: hrubin@optonline.com www.fullhousegaming.com

Bol Pre

Offices in New York City and Westchester

11 Conant Valley Road Pound Ridge, NY 10576 914 533 2325

Bob Lee President

6.

Ron McGhay President & CEO

COMPLETE CONTACT LENS CARE

Two Principal Road Scarborough, Ontario, Canada M1R 4Z3

Tel: 416 285-1024 Tel: 800 387-3301 Fax: 416 285-5140

Beaver Country Day School

791 Hammond Street Chestnut Hill, MA 02467.2300 www.bcdschool.org

Peter Hutton Head of School Tel: 617.738.2730 Fax: 617.738.2703 phutton@bcdschool.org

10.

William Wilson | Associated Architects Inc.

William F. Wilson, AIA Principal

374 Congress Street Suite 400 Boston, MA 02210

617.338.5990 Tel 617.338.5991 Fax

wilson@wilsonarch.com Email

Design Firm Lee Communications, Inc. Design Firm The Fluid Group

(10-11) Design Firm kor group

Client

Argyle Associates, Inc. Bob Lee

Designer

BAIGlobal, Inc. Client Bob Lee Designer

Capitol Risk Concepts, Ltd. Client Bob Lee Designer

Client Full House Gaming Designer Bob Lee

Hawaii Hi-Lo Client Bob Lee Designer

Client Lee Communications, Inc. Designer Bob Lee

Bob Lee

Lucence Photographic, Ltd. Client

Designer

Client

PuriLens, Inc. Designer Bob Lee

Kyle Phillips

Designer 10 Client

Beaver Country Day School MB Jarosik, Jim Gibson,

Designers Anne Callahan

William Wilson Associated Architects Designers Karen Dendy Smith

NICOLE F. CHABAT

The Jerry Brenner Group

consulting marketing promotion retail

Jonathan R. Lev T 617•713•0400 F 617•713•3818 JBGlev@aol.com

233 Harvard Street Suite 11 Brookline, MA 02446

visual communications kor group

One Design Center Place Boston MA 02210

5.

617 330 1007 tel 617 330 1004 fax alson@kor.com Marketing Manager Alison Noble

APPLIANCE + LIGHTING

Rogerio Pontes **Lighting Consultant**

296 Freeport Street Boston, MA 02122

T 617 • 825 • YALE F 617 · 825 · 6541

www.yaleappliance.com rogerio.pontes@yaleappliance.com TURN IT ON!

Design Firm kor group

Client Fidelity FCAT Kjerstin Westgaard Designers

Client Nicole Chabat Designers Karen Dendy Smith,

Brian Azer

Client Millennium Graphics Designer Kjerstin Westgaard

Client Jerry Brenner Promotions Designer MB Jarosik

Client kor group Designers Anne Callahan, Karen Dendy Smith, MB Jarosik

Client Yale Appliance + Lighting Designers Karen Dendy Smith, James Grady

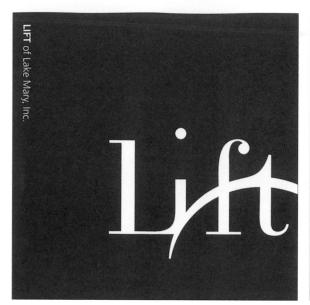

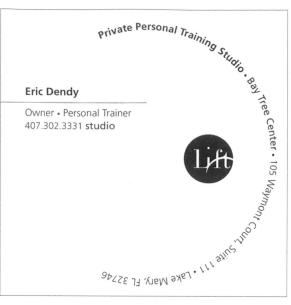

LULAS PANTRY

P

PRINCE LOBEL GLOVSKY & TYE & Attorneys at Law

NANCY A. DOLBERG

585 Commercial St. Boston, MA 02109 ndolberg@plgt-law.com

(617) 456.8000 x8502 Tel (617) 456.8100 Fax

Pure data Pure results

Carleton

Steven L. Thimjon Vice President & Chief Financial Officer

10729 Bren Road East Minnetonka, MN 55343

Main 612.238.4000 Tel 612.238.4068 Fax 612.238.4020 steve.thimjon@carleton.com

www.carleton.com

Scott Ormiston **Business Development Manager**

scottormiston@newmediary.com

313 Washington Street Main 617 • 395 • 7900

Suite 260

Newton • MA 02458 Fax 617 • 928 • 5080

Direct 617 • 395 • 7916

Cell 617 • 590 • 0655

5.

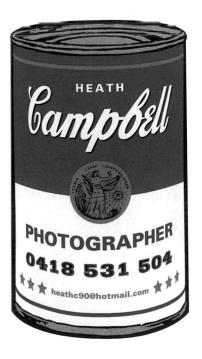

Design Firm kor group Design Firm Mono Design

Client

Designers Karen Dendy Smith, Kjerstin Westgaard

Client Lula's Pantry

Designers Jim Gibson, James Grady

Client Prince, Lobel, Glovsky & Tye Designers Karen Dendy Smith, Kjerstin Westgaard

Client Carleton Corporation MB Jarosik Designer

Client Newmediary
Designers Kjerstin Westgaard, Client James Grady

Client Heath Campbell Photographer Matt Clare Designer

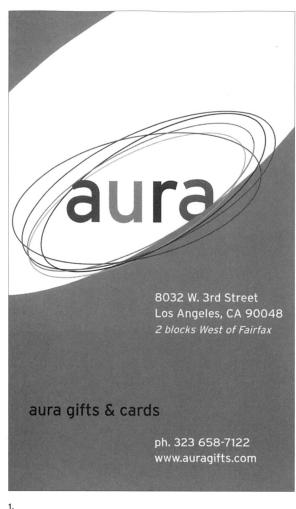

DESIRE: People with red auras tend to have the urge to win, a sense of adventure, and the survival instinct; the majority of them are young children and teenage boys

DEVOTION: People with purple auras appreciate tenderness and kindness in others, are not especially practical and tend to be entertainers, movie stars, free thinkers, visionaries and revolutionaries

CREATIVITY: Many sales people, entrepreneurs, and people who deal with the public have orange auras

HAPPINESS: People with yellow auras encourage and support others; they have a great ability to analyze complex concepts

TRUST: People with blue auras tend to be poets, writers, musicians, philosophers, serious students, spiritual seekers, and people looking for the truth, justice, and beauty in everything

PATIENCE: People with green auras are dedicated parents, social workers, counselors, psychologists, and focus on creating positive change in the world

OXYGEN SPACE
Alex Wigington

2.

PRINCIPAL

oxygen.ca

alex@oxygen.ca

CAPIC

3.

THE CANADIAN ASSOCIATION OF PHOTOGRAPHERS AND We represent the best in photography and illustration in code of ethics, education and marketing we help our met success in the global marketplace. CAPIC is committed the L'ASSOCIATION CANADIENNE DES PHOTOGRAPHES ET IN Nous représentons les meilleurs photographes et illustrat professionnelles de haut niveau et d'un Code de déontolog et en marketing, nous aidons nos membres à atteindre l'au sein du marché international. La CAPIC s'engage à pr

RANDY HARQUAIL
PRESIDENT

55 MILL STREET THE CASE GOODS BLDG SUITE 302 TORONTO ON M5A 3C4 TEL 613.237.4268 EMAIL RANDY@HARQUAILPHOTO.COM CAPIC.ORG ILLUSTRATORS IN COMMUNICATIONS
anada. Through best business practices, our
bers achieve excellence in their craft and
protecting the rights of visual creators in Canada.
LUSTRATEURS EN COMMUNICATIONS
urs au Canada. Par la promotion de pratiques
e ainsi que par nos initiatives en matière de formation
xcellence dans leur métier et à connaître le succès
téger les droits des créateurs visuels au Canada.

+ stacey

Susie Adelson

Director, Business Nevelopment

stacey brandford photography 9 davies ave, studio 103, toronto on m4m 2a6 let's talk 416.463.8877 my cell 416.712.7788 drop me a line sbrandford@bellnet.ca check out my site staceybrandford.com

+ everything you need in a photographer

(MINUTE)

4.

401 richmond st west, suite 430 toronto, on m5v 3a8 tel 416.599.TRIP [8747] EXT.*42 fax 416.599.8116 susie@weekendtrips.com

Weekendtrips.com

what are you doing this weekend?

(1)
Design Firm kor group
(2-5)
Design Firm oxygen design +
communications

1.
Client Aura
Designers MB Jarosik,

Jim Gibson

2.
Client Oxygen Space
Designer Alex Wigington

Client Capic
Designers Alex Wigington,
Blake Morrow

4.
Client Stacey
Designer Alex Wigington
5.
Client Weekendtrips.com

Client Weekendtrips.co Designer Alex Wigington

5

damir gusic

554 college st. toronto ontario canada M6G 1B1

GIVE US A RING 416 925 1818

TOLL FREE 888 238 8244

SEND A FAX 416 927 9893

DROP MAIL dgusic@motoretta.ca

SURF motoretta.ca

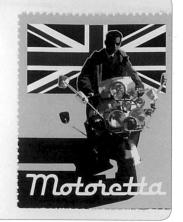

554 college st. toronto ontario canada M6G 1B1

GIVE US A RING 416 925 1818
TOLL FREE 888 238 8244
SEND A FAX 416 927 9893
DROP MAIL info@motoretta.ca
SURF motoretta.ca

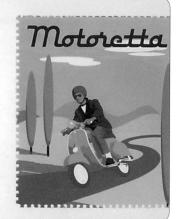

,

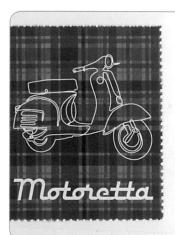

scooters authentic + true

parts service paraphernalia

554 college st. toronto ontario canada M6G 1B1

GIVE US A RING 416 925 1818

TOLL FREE 888 238 8244

SEND A FAX 416 927 9893

DROP MAIL Jgirard@motoretta.ca

SURF motoretta.ca

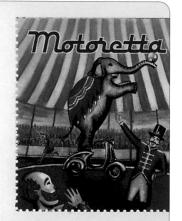

4.

steve petridis

554 college st. toronto ontario canada M6G 1B1

GIVE US A RING 416 925 1818

TOLL FREE 888 238 8244

SEND A FAX 416 927 9893

DROP MAIL Spetridis@motoretta.ca

SURF motoretta.ca

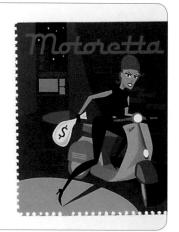

giancarlo serrafero

554 college st. toronto ontario canada M6G 1B1

GIVE US A RING 416 925 1818

TOLL FREE 888 238 8244

SEND A FAX 416 927 9893

DROP MAIL gserrafero@motoretta.ca

SURF motoretta.ca

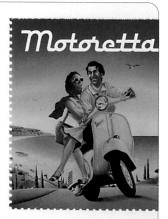

vicki boutin creative director/buyer 40 ridgevalley crescent, toronto canada M9A 3J6

> tel 905 681 9285 fax 416 236 0024 1 800 393 2151 • vicki@scraptivity.com

scraptivity.com

scraptiv!ty

A CLUB FOR SCRAPBOOKING MEMORIES"

6.

7.

oxygen design +

401 Richmond St W Suite 430, Toronto Ontario M5V 3A8

tel 416 506 0₂0₂ x46 fax 416 506 170₂ karolina@oxygen.ca oxygen.ca

Karolina Loboda

living and breathing design"

Design Firm oxygen design + communications Design Firm Morningstar Design, Inc. 1-6 Client Motoretta Alex Wigington, Daniel Chen, Doug Martin, Blake Morrow, Designers Rob Wigington Client Scraptivity Designers Alex Wigington, Karolina Loboda Client oxygen design + communications Designer Alex Wigington

> Morningstar Design, Inc. Misti Morningstar

Client

Designer

ASCENT LEARNING + DEVELOPMENT INC

132 Mona Drive, Toronto ON M5N 2R6 416 483 9928 Telephone 416 485 1633 Facsimile jane@ascent-inc.ca ascent-inc.ca

Jane Eastmure BUSINESS COACH

ASCENT

1.

Julie Shearburn

WilliamShearburnGallery

4735 McPherson Avenue
Saint Louis, Missouri 63108 USA
Telephone 314.367.8020
Facsimile 314.367.4010
julie@shearburngallery.com
shearburngallery.com

Rebecca Totty Corrington Commercial Property Specialist

Rothschild Realty Inc.

4746 McPherson Avenue • St. Louis, Missouri 63108 USA Telephone 314.367.7787 ext 121 • Facsimile 314.754.1106 Cel 314.640.3296 • Email rebcorrington@hotmail.com

NORTHWESTERN NASAL + SINUS

Daniel G. Carothers, M.D.

676 North Saint Clair, Suite 1575 Chicago, IL 60611 t 800.313.NOSE t 312.266.NOSE f 312.266.3680 dcarothers@nwnasalsinus.com

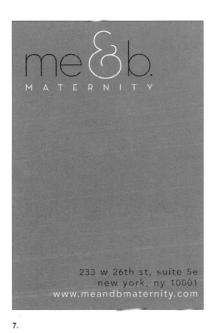

LISA DELEO PRODUCER MR BIG FILM LISA@MRBIGFILM.COM MR BIG FILM 1147 WEST OHIO CHICAGO ILLINOIS 60622 TEL 312 492 9900 | FAX 312 492 9902 | WWW.MRBIGFILM.COM

loft condominiums

Nina Esson Sales Manager

141 East Madison Saint Louis, Missouri 63122 Telephone 314.775.2921 Facsimile 314.775.2920 Cell 314.504.1171 Email stationplazaloft@mlpllc.com

www.station-plaza.com

Design Firm oxygen design + Client Northwestern Nasal + Sinus communications Designer Kristen Merry Design Firm Grizzell & Co. Kristi Kay Petitpren (5-8)Client Design Firm Liska + Associates Inc. Steve Liska Designer Client me&b Maternity Client Ascent Learning + Development Inc. Designer Danielle Akstein Designers Alex Wigington, Client Karolina Loboda Mr. Big Film Christina Nimry 2. Designer Client Station Plaza of Kirkwood Client Condominium Lofts at Station Plaza Designer John H. Grizzell John H. Grizzell 3. Designer Client William Shearburn Gallery Designer John H. Grizzell

4. Client

Designer

Rothschild Realty Inc.

John H. Grizzell

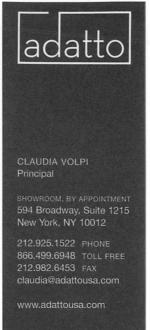

hazen

212.255.4198 ART@HAZENKEAY.COM

ART ADVISORY

LONDON TERRACE STATION PO BOX #20136 NEW YORK, NEW YORK

IOOII

ANDREA HAZEN

Ari Kaplan

Founder and CEO ari.kaplan@XB.com

Expand Beyond 640 N. LaSalle Street **F** 312.587.8510 Suite 330 Chicago, IL 60610

T 312.587.9990 www.XB.com

Hubbard Street Lou Conte Dance HSDC Education & Community Programs

Hubbard Street Dance Chicago

1147 West Jackson Boulevard Chicago, IL 60607-2905 USA t 312.850.9744 f 312.455.8240 hubbardstreetdance.com

PRODUCT
DESIGN
DEVELOPMENT
DELIVERY

LYNN ANDERSON

PD3, INC. - 4112 55TH AVE SW - SEATTLE, WA 98116

P: 206 938.1876 - F: 206 923.9939 - LYNN.PD3@COMCAST.NET

6.

7.

Design Firm Liska + Associates Inc. Design Firm Giorgio Davanza Design Client Adatto Designers Tanya Quick, Jonathan Seeds 2. Client Hazen Keay Jonathan Seeds Designer 3. Client Expand Beyond Designers Steve Liska, Paul Wong Client Hubbard Street Dance Chicago Steve Liska, Designers Sabine Krauss Client Nelson + Updike Designers Giorgio Davanza Client pd3 Giorgio Davanza Designer Client Giorgio Davanzo Design Designer Giorgio Davanza

SENOK"

TEA FOR THE SENSES

Landy Pen

126 S Spokane Street | Seattle, WA 98124

P 206.903.0858 | 1.877.736.6583 | F 206.624.3026

Ipen@senoktea.com | www.senoktea.com

CRANIUM®
play with your brain®

Jacobe Chrisman Doctor Tick Tock

1511 Third Avenue • Suite 433
Seattle, WA 98101 **T 206.652.9708 Ext.116**C 206.963.2229
F 206.652.1483
jacobe@playcranium.com
www.playcranium.com

2.

JEFF LANGSTON _ LOOPMASTER

25 E 94TH STREET #3 _ NEW YORK, NY 10128 _ WWW.LOOPWORX.COM P 212.348.1565 _ F 212.348.2886 _ E JLANGSTON@LOOPWORX.COM

JEB PROPERTIES

Barbara Epis
General Manager

P.O. Box 2624
Sunnyvale, CA 94087

Fax 941 - 6422
941 - 6453

Design Firm Giorgio Davanzo Design (5-7)
Design Firm Bondepus Graphic Design Client Senok Giorgio Davanza Designer 2. Client Cranium Giorgio Davanza Designer Client Loop Worx Glorgio Davanza Designer Client Pellini Giorgio Davanza Designer Client Bondepus Graphic Design Gary Epis, Amy Bond Designers Client Sports Chiropractic Gary Epis, Designers Amy Bond J&B Properties Client Designers Gary Epis, Amy Bond

ELDER+COMPANY Randy Elder relder@elder-company.com CPA, EA

> 408.825.130 408.782.948 18640 Sutter Blvd Ste 200 Morgan Hill, CA 95037

3.

www.elder-company.com

Barbagelata CONSTRUCTION Mark Barbagelata General Contractor 2618 McAlister St San Francisco California 94118 415.668.6115 415.668.6602 Bonded & Insured License no.745230

San Mateo Office 650.292.1383 P 650.292.1384 F Campbell Office 900 E. Hamilton Ave Ste 100 Campbell, CA 95008 408.825.1300 P 408.782.9482 F

Michael K. De Neve Principal

9 4 5 Airport Drive Reply: P.O. Box 14143 San Luis Obispo, CA 93406

T 805.543.7474 F 805.541.0806

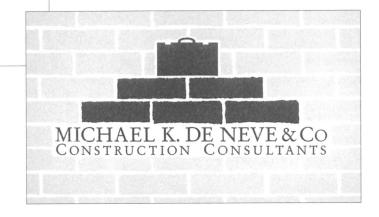

GARY KIRKE CHAIRMAN gary.kirke@ wildroseresorts.com

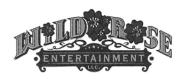

WILD ROSE ENTERTAINMENT L.L.C.
P.O. Box 93595 • DES MOINES, IA 50393-3595
(515) 248-1776 • FAX: (515) 243-5202
www.wildroseresorts.com

7.

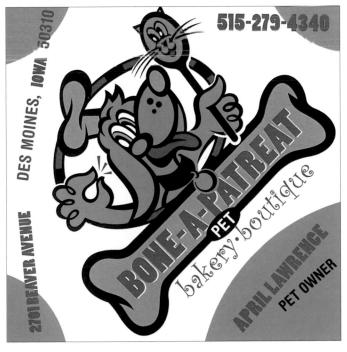

(1-6) Docign Firm **Dondebus ப**சுப்பி: பெலிரா (7,8) Design Firm **Sayles Graphic Design**

Client bestlodging.com
Designers Gary Epis,
Amy Bond

Client Skov Construction
Designers Gary Epis,
Amy Bond

Client Elder + Company
Designers Gary Epis,
Amy Bond

Client Barbagelata
Designers Gary Epis,
Amy Bond

Client Linden Arms Apartments
Designers Gary Epis,
Amy Bond

6.
Client Michael K. De Neve & Co.
Designers Gary Epis,

Designers Gary Epis, Amy Bond 7.

Client Wild Rose Entertainment, LLC
Designer John Sayles

Client Bone-A-Patreat Designer John Sayles

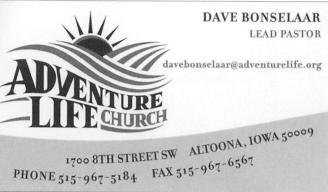

Mark Charnock

t: 44.(0)151.425.4881 f: 44.(0)151.425.3129 m: 44.(0)770.223.2441 e: mark@charnockdesign.co.uk

w: www.charnockdesign.co.uk

STEPHEN C. EISELE PRESIDENT

CLU

MDR

3319 109TH STREET DES MOINES, IOWA 50322-8105

2.

P: (515) 251-7900 F: (515) 251-7911 T: (866) 929-7900

WEB: WWW.EAGLEINVESTRESOURCE.COM EMAIL: STEVEEIS1@EAGLEINVESTRESOURCE.COM

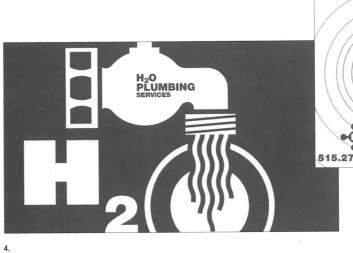

Jeff DuBois

H2O
PLUMBING
SERVICES
Specializing in small repairs

5415 Aurora Avenue
Des Moines, Iowa 50310

SHAWNA NEAL

921 40TH STREET
WEST DES MOINES, IA 50265

(515) 681-SHOP

DESMOINES.COM

sneal@ishopdesmoines.com

ISHOPDESMOINES.COM www.ishopdesmoines.com

Design Firm Sayles Graphic Design Client Adventure Life Church John Sayles Designer Charnock Design Client John Sayles Designer Eagle Investment Resources John Sayles Client Designer H2O Plumbing Services Client John Sayles Designer Client IshopDesMoines.com John Sayles Designer Client Wildwood Hills Ranch Designer John Sayles

COMMERCIAL • RESIDENTIAL • INTERIOR • EXTERIOR **NEW CONSTRUCTION • REMODELS**

SLOAN BROTHERS PAINTING, INC.

strokes of brilliance

www.you growgirl.org NW 21st Street Suite E 515 289 1452 Ankeny Iowa 50021 fax 515 289 2883 **Toll Free** 877-251-6247

JAMES W. GOSSETT | PRINCIPAL COLUMN WORKS WEST T 530.243.0796 • F 530.243.0736 4780 CATERPILLAR ROAD, BLG. C ● REDDING, CALIFORNIA 96003 U.S.A. JGOSSETT@COLUMNWORKS.COM | WWW.COLUMNWORKS.COM

vanitan creality ideas marketing & advertising • commercial production • industrial videos Juanita Ramos Proprietor

T. 530.242.6568 F. 530.241.8616 juanitamedia@aol.com

4.

CALIFORNIA HORSE PARK A STATE OF THE ART EQUINE SHOW FACILITY

Dave Dawson | Director of Development

PO BOX 992380 REDDING, C londavdaws@aol.com www.californiahorsepark.com

Rachel Andras

PROFESSIONAL FLYFISHING GUIDE AND INSTRUCTOR

2384 HAWN AVENUE REDDING, CALIFORNIA 96002 530.227.4837 RACHEL@RACHELFISHING.COM WWW.RACHELFISHING.COM

licenced • bon

Design Firm Sayles Graphic Design Design Firm Market Street Marketing

Sloan Brothers Painting, Inc. Designer John Sayles

Client You Grow, Girl John Sayles Designer

Client ColumnWorks West Designer Kathleen Downs

Client Juanita Media Kathleen Downs Designer

Client California Horse Park Kathleen Downs Designer

Client Rachel Andras Designer Kathleen Downs

Jim Gironda

1100 Center Street · Redding · California · 96001

t) 530.244.7663 · f) 530.244.7677 · jim@girondas.com · www.girondas.com

Jami Kay Foltz, Resthetician

2626 Edith Ave. Suite D Redding, CA 96001 voice 530.241.7772 fax 530.241.7786 jami@renewlaserskincare.com www.renewlaserskincare.com

You have an appointment with:

If you're unable to make your appointment, kindly give us 24 hours notice. Thanks!

FOR (

Pat Brown Administrative Assistant

sacramento river conservation area forum

a voice for all interests

T. 530.528.7435 F. 530.528.7422 pbrown@water.ca.gov • www.sacramentoriver.ca.gov 2440 Main Street • Red Bluff • California • 96080

ギャラリーホテル シンガポール

GALLERYHOTEL

MICHELLE NATSUMI TAN Guest Relations Manager

76 Robertson Quay Singapore 238254 Tel (65) 6849 8686 DID (65) 6849 5167 Fax (65) 6235 3590 Hp (65) 9819 8778 www.galleryhotel.com.sg michelle.natsumi@galleryhotel.com.sg

ミッシェル 夏海 お客様担当マネージャー

ABI BAGHERI • Managing Director Email abi@theorientalist.com

(1-4)
Design Firm Market Street Marketing Design Firm Ukulele Brand Consultants Pte Ltd Gironda's Restaurant Client Kathleen Downs Designer Client Renew for 2 Kathleen Downs Designer Client total vein care Kathleen Downs Designer Client Sacramento River Kathleen Downs Designer 5. Client Gallery Hotel Designer Lynn Lim 6. Client The Orientalist Singapore Designer Lynn Lim

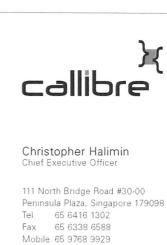

218 Main Street, Suite 102 Kirkland, WA 98033, USA Tel 1 877 844 1166 Fax 1 425 650 6744

Email chrish@telequam.com

www.callibre.com

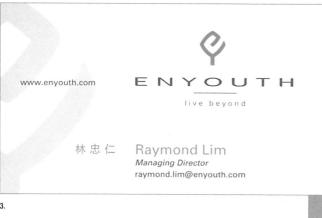

Enyouth Singapore Pte Ltd 36 Carpenter Street #05/06-01 Singapore 059915 T 65 6536 5771 F 65 6536 5773 M 65 9684 8498

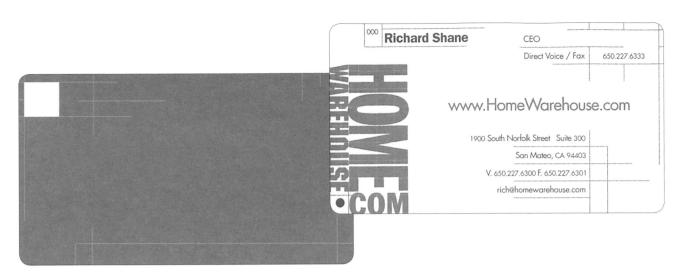

5.

Design Firm Ukulele Brand Consultants Pte Ltd Design Firm Hausman Design 1. Client Super Bean International Pte Ltd Lynn Lim, Yohji Neoh Designers 2. Client Callibre Yohji Neoh, Aliah Hanim Designers 3. Client Enyouth Singapore Pte Ltd Designers Liu Kar Ming 4. Client HomeWarehouse.com Joan Hausman, Tammy Tribble Designers 5. Client Roxy Rapp & Company Designer Joan Hausman 6.

Words by Design

Joan Hausman

Client

Designer

1.

Dave Matovich

Burlingame Stone & Tile, Inc. 1322 Marsten Road Burlingame, CA 94010 p 650 340 9474 f 650 340 9776 e bstinc@aol.com Contractor's lic. #C54769913

2.

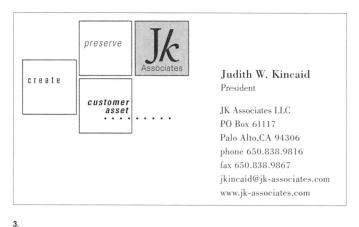

3351 N. Racine #D
Chicago, IL 60657
www.jillphoto.com

PHOTOGRAPHY

tel 773.871.5719
mobile 773.469.5079
jill@jillphoto.com

4.

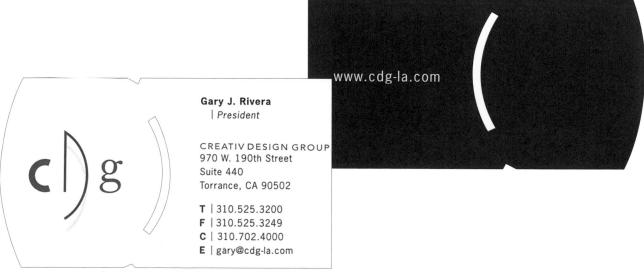

Pearl O

1311 B Montana Ave.

Santa Monica, GA 90403

tel 310 576 7136

fax 310 576 7126

Jennifer Nicholson

cations
way
254

(B)

IE | Design + Communications

422 Pacific Coast Highway Hermosa Beach, CA 90254 Tel 310 376 9600 Fax 310 376 9604

7.

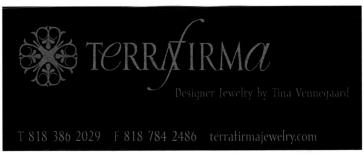

(1-3)
Design Firm Hausman Design
(4)
Design Firm Franny Cheung Design

Design Firm IE Design + Communications

Client Healthy Transitions

Designer Joan Hausman
2.
Client BST
Designer Joan Hausman
3.

Client JK Associates LLC Designer Joan Hausman

Client Jill Wijangco Photography Designer Franny Cheung 5.

Client Creative Design Group
Designer Richard Haynie

6.

Client Jennifer Nicholson Designer Cya Nalson

Client IE Design + Communications
Designer Marcie Carson

Client Terra Firma Designer Marcie Carson

1-866-366-8483

DESIGN

VINCENT WILCOXEN

5914 BLACKWELDER ST. CULVER CITY, CA 90232

FAX: 310-559-7922

WWW.WILCOXENDESIGN.COM

1.

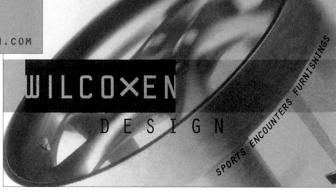

medical spa

KATHLEEN HAYES

Registered Nurse Practice Manager 715 KENSINGTON AVE. SUITE 24A MISSOULA, MT 59801 T/ 406.549.5777 F/ 406.549.5777

kathy@montanamedicalspa.com

montanamedicalspa.com

2.

facial plastic surgery

DAVID M. HAYES, M.D.

n Academy of Facial onstructive Surgery Otolaryngology — Surgery 715 KENSINGTON AVE.
SUITE 24A
MISSOULA, MT 59801
T/ 406.541.7546 (SKIN)
F/ 406.541.3955
info@montanamedicalspa.com

montanamedicalspa.com

A Division of Rocky Mountain Ear, Nose and Throat Center P.C.

Joy Kovaleski President

10960 Wilshire Blvd. Suite 1240 Los Angeles, CA 90024

t 310·478·9700

f 310·478·2823

e ikovaleski@funzoneinc.com

Studio za arhitekturo in grafično oblikovanje, d.o.o. KROG Studio za arijitektulo ili graficilo Samana Krakovski nasip 22, 1000 Ljubljana tel.+ faks 01/4265 761, GSM 041/780 880

Edi Berk, dipl. ing. arh. e-mail: edi.berk@krog.si

MLINARIČ

Mesarija Mlinarič, d.o.o., Lesce

Železniška ul. 1, 4248 Lesce, Slovenija

T: +386 (0)4 531 83 32

F: +386 (o)4 531 88 72

M: +386 (0)41 721 556

E: joze.mlinaric@mlinaric.si

I: www.mlinaric.si

Jože Mlinarič

univ. dipl. inž. živil. tehnol. direktor

Design Firm IE Design + Communications (4-6)
Design Firm KROG, Ljubljana Client Wilcoxen Design Cya Nelson Designer 2. Client Rocky Mountain Cya Nelson Designer Client Fun Zone Marcie Carson Designer Client Krog Edi Berk Designer Mlinario Client Edi Berk Designer Client Institut za primerjalno pravo

Edi Berk

Designer

Univerzitetna knjižnica Maribor

UNIVERZA V MARIBORU Univerzitetna knjižnica Maribor Gospejna ulica 10, 2000 Maribor tel.: 02/250 74 34, 040/261 333 faks: 02/252 75 58 e-pošta: vlasta.stavbar@uni-mb.si

mag. Vlasta Stavbar prof. zgod. in geog. bibliotekarka v enoti za domoznanstvo

hotel **M** mons

hotel in Kongresni Center Ljubljana

Monsadria, d.o.o., Pot za Brdom 55 SI-1000 Ljubljana, Slovenija

T: +386 (0)1 47 02 730

F: +386 (0)1 47 02 708

Andrea Peters M: +386 (0)41 605 990

Vodja namestitev E: andrea.peters@hotel.mons.si

Rooms Division Manager I: www.hotel.mons.si

Perger •1•7•5•7•

Medičarstvo, svečarstvo Perger Hrabro s.p. Glavni trg 34, 2380 Slovenj Gradec tel. + faks: 02/884 14 96 Galerija: tel.: 02/883 82 91, faks: 883 82 92 GSM: 041/66 88 98 e-pošta: h.perger@sgn.net

Hrabroslav Perger

DR. JULIJ NEMANIČ, ENOLOG

Mednarodni pokuševalec vin Predavatelj

JEREBOVA 14, 8330 METLIKA
TEL.: 01/280 52 43, 07/363 54 31
MOBITEL: 040/242 620

FAKS: 01/280 52 55 E-POŠTA:

JULIJ.NEMANIC@SIOL.NET
JULIJ.NEMANIC@KIS.SI

C/o Deborah Collinson &

Associates

Deborah Collinson

The Garden Flat, 40 Lexham Gardens London W8 5JE, United Kingdom

> Phone: 020 7373 0774 Telefax: 020 7373 0818 E-mail: WinePR@aol.com

5.

Odvetnik Peter Toš

Beethovnova 12, 1000 Ljubljana, Slovenija T: +386 (0)1 / 200 17 40, **M**: +386 (0)41 / 733 000 F: +386 (0)1 / 200 17 41, **E**: peter.tos@siol.net

Peter Toš, odvetnik, Attorney at Law

Biro (za) komunalo

Biro za komunalo, d.o.o.

Projektiranje, inženiring in svetovanje

Dunajska 106, 1000 Ljubljana, Slovenija tel.: +386 (0)1 5300 682

faks: +386 (o)1 5300 681 e-pošta: kranjc@b-k.si

Anton Kranjc, unlv. dipl. ing. grad. direktor

7.

Grafika¶**aradoks**

Grafika Paradoks Čopi Marko s.p.

Šmartinska 10, 1000 Ljubljana Telefon: 01/430 11 20, 430 11 25 Telefaks: 01/430 11 25 Mobitel: 031/344 661 e-mail: grafika.paradoks@siol.net

Marko Čopi direktor

R

(1-8) Design Firm **KROG**, **Ljubljana**

Client Univerzitetna knjiznica Maribor
 Designer Edi Berk

Client Hotel Mons
Designer Edi Berk

Client Perger 1757
Designer Marcic Carson

Client Vinski konvent sv. Urbana Designer Edi Berk

Client Wines from Slovenia

Designer Edi Berk

Client Odvetnik Peter Tos Designer Edi Berk

Client Biro za komunalo
Designer Edi Berk

Client Grafika Paradoks
Designer Edi Berk

restavracija **glažuta**

stekleni dvor, dunajska 119, 1000 ljubljana

robert renninger, vodja restavracije

T: 01 565 43 26 F: 01 565 43 27 M: 031 357 751

E: glazuta@hotel.mons.si

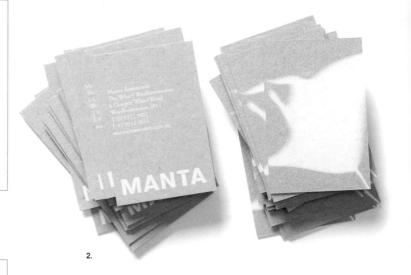

Diana Liacos, MSN, CPNP

www.Perkins.org 617-972-7470

Preschool Services Infant/Toddler Program and Preschool Outreach

PreschoolServices@Perkins.org 617-972-7393 phone

175 North Beacon Street Watertown, MA 02472

MUSEUM OF CONTEMPORARY ART CLEVELAND

Heather Young Visitor Services Manager

8501 Carnegie Avenue Cleveland, Ohio 44106

www.MOCAcleveland.org

hyoung@MOCAcleveland.org D 216.421.8671 ext. 42

1 216.421.0737

I. James Cavoli Chief Executive Officer

30775 Bainbridge Road, Suite 270 Cleveland, Ohio 44139

P 440.519.1450 T 877.574.4321 F 440.519.1449

E Jim.Cavoli@LSInsights.com

LifeSettlementInsights.com

-

Frederick C. Crawford Museum of Transportation and Industry

Lisa DeVito Pastor Campaign Associate

10825 East Boulevard Cleveland Ohio 44106 www.wrhs.org email lisa@wrhs.org fax 216.721.8934 voice 216.721.5722 x289

6.

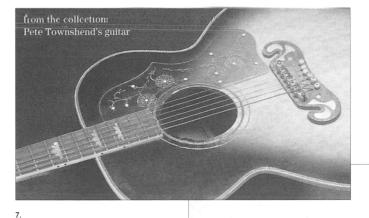

One Key Plaza Cleveland, Ohio 44114 fax 216 781.1326 216 515.1226

April TracyEvent Coordinator

Design Firm KROG, Ljubljana Design Firm emeryfrost (3-7). Design Firm **Nesnadny + Schwartz** 1. Client Restavracija Glazuta Designer Edi Berk 2. Client emeryfrost Designer Vince Frost, Anthony Donovan 3. Client Perkins School for the Blind Gregory Oznowich, Keith Pishnery Designers Client MOCA Museum of Contemporary Art Cleveland Michele Moehler, Teresa Snow Designers Client Life Settlement Insights Gregory Oznowich, Michelle Moehler Designers Client Crawford Museum of Transportation and Industry Designers Gregory Oznowich, Mark Schwartz

Rock and Roll Hall of Fame and Museum

Mark Schwartz, Joyce Nesnadny

Client

Designers

- a 3109 Mayfield Road, Suite 201 Cleveland, Ohio 44118
- e irwin@LowensteinDurante.com w www.LowensteinDurante.com
- f 216.932.1891 p 216.932.1890

Imagination

Hair-body-soul Patrick funke

CO-OWNER

216.464.4311

www.FunkeHairBodySoul.com

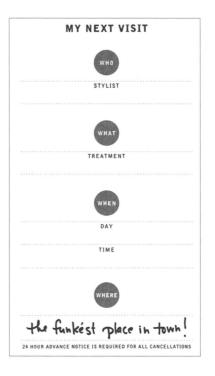

jumpstart

Benjamin (Ben) R. Keller IT Director

18

JumpStart Inc.
737 Bolivar Road, Suite 3000
Cleveland, Ohio 44115
Ben.Keller@JumpStartInc.org
www.JumpStartInc.org
C 216.299.2989
T 216.363.3434

William J. Adams

Group Tour Manager

- P] 202.EYE.SPY.U [202.393.7798]
- D] 202.207.0220
- C] 202.262.7251

International Spy Museum 901 E Street NW Suite 103 Washington, DC 20004 www.spymuseum.org badams@spymuseum.org F] 202.393.7797

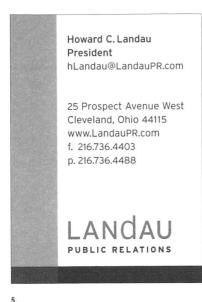

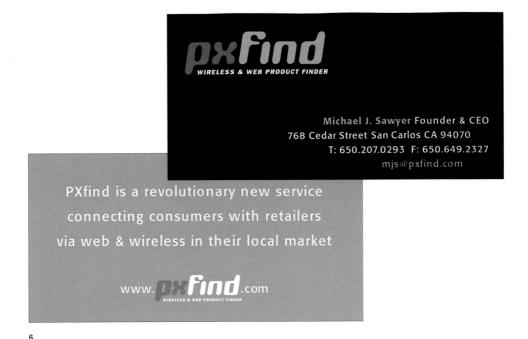

Eastside Location

Store: (520) 615-9050

homecooking made simple Fax: (520) 232-5483

7865 E. Broadway, Suite 155 • Tucson, Arizona 85710-3975

www.simply_dinners.com • customerservice@simply_dinners.com

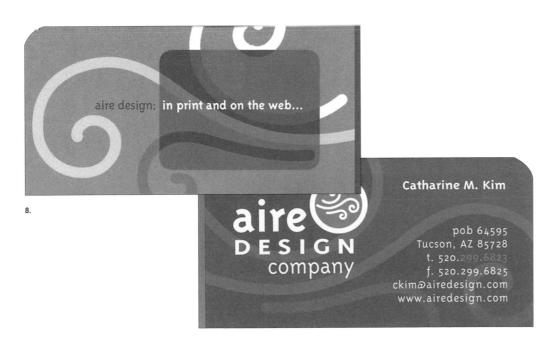

Design Firm Sandy Gin Design Design Firm Aire Design Company Client Lowenstein Durante Architects Keith Pishnery Designer Client Funké Hair Body Soul Designers Stacie Ross, Teresa Snow JumpStart Inc. Jamie Finkelhor, Client Designers Gregory Oznowich Client International Spy Museum Designers Mark Schwartz, Gregory Oznowich Client Landau Public Relations Joyce Nesnadny, Designers Michele Moehler PX Find Designer Sandy Gin Client Simply Dinners Designer Catherine Kim Woodin Aire Design Company Catherine Kim Woodin Client Designer

Design Firm Nesnadny + Schwartz

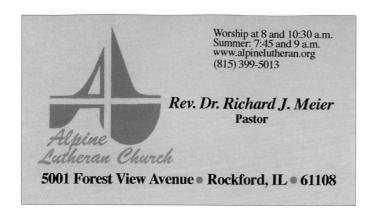

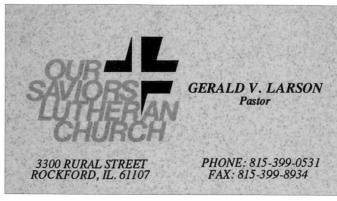

Robert E. Hughes

6903 St. Ives Blvd. Hudson, Ohio 44236 WORSHIP OPPORTUNITIES AT WASHINGTON PARK 9:30 A.M. SUNDAY 7:00 P.M. WEDNESDAY

SUNDAY SCHOOL

11:00 A.M. SUNDAY **WORSHIP SERVICE**

BIBLE STUDY

7:00 P.M. FRIDAY **WORSHIP SERVICE**

Phone: 1 (815) 965-8979

Fax: 1 (815) 965-8625

WASHINGTON PARK CHRISTIAN CHURCH

801 Concord Avenue Rockford, IL 61102

Jesse Allen, Pastor

'an anchor of hope in a drowning world"

The Advanced difference: "We charge by the job, not by the hour"

Residential & Commercial

Mike Vaughn President

Heating & Air-Conditioning (815) 874-5400 (815) 398-8100 Eastrock Industrial Park, 5055 28thAve.. Rockford, IL 61109

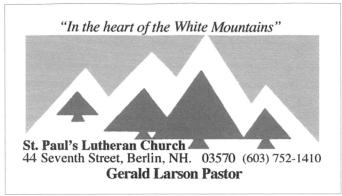

7.

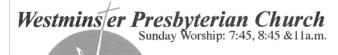

Rev. David Smazik

Web: www.connectingforlife.org E-Mail: WestPresChurch@aol.com

3000 Rural St. Rockford. IL @ 61107-3499 @ (815)399-2431

8.

(1-8)
Design Firm Larson Logos
(9)
Design Firm The Eden

Communications Group (10)

Design Firm Ó!

Client Alpine Lutheran Church
Designer Gerald V. Larson

Client Our Saviors Lutheran Church Designer Gerald V. Larson

Client Robert E. Hughes
Designer Gerald V. Larson

Client Washington Park Christian Church
Designer Gerald V. Larson

Client Advanced Heating & Air-Conditioning

Designer Gerald V. Larson

Client Immanuel Lutheran Church
Designer Gerald V. Larson

Client St. Paul's Lutheran Church Gerald V. Larson Designer Client Westminster Presbyterian Church Gerald V. Larson Designer Client The Eden Communications Group Donna Malik Designer 10. Client Designer Einar Gylfason

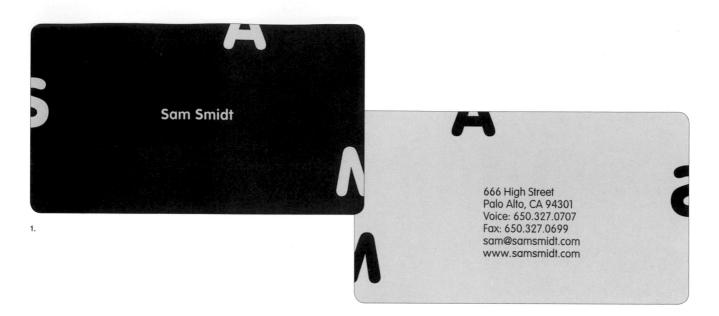

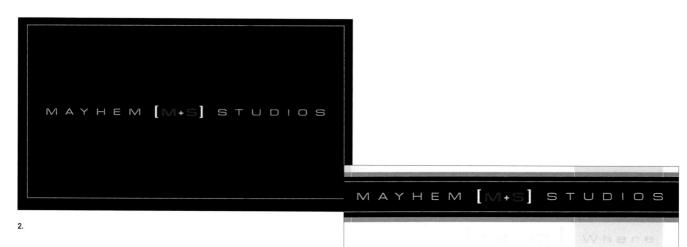

Calvin Lee
Senior Designer

www.mayhemstudios.com
cal@mayhemstudios.com
T: 323.276.9503
C: 323.533.8423

FAGERHOLM & Third Floor
Burbank, CA 91505

JEFFERSON
Law Corporation

Note: 818.973.2731
Fax: 818.973.2781
Third Floor
Surbank, CA 91505

Tel: 818.973.2731
Fax: 818.973.2781
Third Floor
Surbank, CA 91505

Tel: 818.973.2731
Third Floor
Surbank, CA 91505

Tel: 818.973.2731
Third Floor
Surbank, CA 91505

President & Executive Creative Director

- v 310.393.3993 x308
- F 310.394.4705
- E g.baker@bakerbuilds.com

Baker | Brand Communications[™]

725 Arizona Ave. Suite 400 | Santa Monica, CA 90401 www.bakerbuilds.com

Design Firm Sam Smidt

Design Firm Mayhem Studios

(5) Design Firm EPOS, Inc.

Design Firm Baker I Brand Communications

Design Firm Clark Creative Print & Graphic Design

Design Firm the Mixx no kidding!

2.

Client Sam Smidt Sam Smidt Designer

Client

Mayhem Studios Calvin Lee Designer

Client

Client

Emtek Products, Inc. Calvin Lee Designer

Fagerholm & Jefferson Law Corporation

Calvin Lee Designer

Designers

Gabrielle Raumberger, Christina Landers

Client

Baker | Brand Communications

Clark Creative Client Cari Clark Designer

Client Apartment in Paris Lisa Delanev Designer

Donna T. Pepe PRESIDENT/CEO

donna.pepe@cstratinc.com Communications Strategies Inc BECAUSE EXPERIENCE MATTERS

MARNIE J. OMANOFF 219 East 69 St Ste 34 MC 1852 272 3 1924

LUCKY CHARM DESIGNS

www.cstratinc.com

Real Estate, Real Vision.

Five Marine View Plaza Suite 401 Hoboken, New Jersey 07030 tel 201 420 7142 fax 201 420 7696 www.remicampanies.com

VARSITY ENTERTAINMENT

5.

David Swartz Senior Producer swartz@varsityent.com

A

Stephanie Astic

Stephanie Astic George steph@asticproductions.com 850 Seventh Ave Suite 1102 NYC 10019 T 212.581.1400 F 212.581.1442

VARSITY ENTERTAINMENT

PETER CHERNIN
PRESIDENT
peter @easy-as-toast.com

310 W 47 Suite 3D NYC 10036
t 888 TOAST 4U / 888 862 7848
c 914 584 4475
easy-as-toast.com

(1-8)
Design Firm themixx

Client Les Femmes Chic Designer Lisa Delaney 2.

Client JOFA
Designer Lisa Delaney
3.

Client Communications Strategies
Designer Reed Seifer

4. Client Lucky Charm Designs
Designer Lisa Delaney

5.
Client REMI Companies
Designer Lisa Delaney
6.

Client Varsity Entertainment
Designer Lisa Delaney

7.
Client Stephanie Astic Productions
Designer Lisa Delaney

8.
Client TOAST
Designer Lisa Delaney

antique and contemporary design

info@abhayatribeca.com

145 hudson street nyc 10013 212.431.6931 f 212.431.6932

FIRST QUALITY MAINTENANCE

CLASSIC SECURITY

BRIGHT STAR COURIERS

ONYX RESTORATION WORKS

ALLIANCE BUILDING SERVICES

Michael Rodriguez

President

70 West 36th Street New York, NY 10018 T: 212-244-6045 F: 212-947-7833

E: mrodriguez@alliancebuilding.us

CONSIDER IT DONE.

2.

ART JOHNSON, VICE PRESIDENT art@metrohomesIIc.com

PO Box 271 Hoboken, NJ (T 201 420 0980 Ext.104 F 201 420

www.metrohomesII

Carol Martin Director, Sales and Operations CarolM@footagebank.com

1733 Abbot Kinney Boulevard Suite C Venice California 90291 tel 310 822 1400 fax 310 822 4100 www.footagebank.com

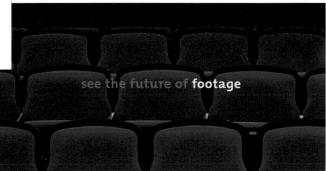

Lisa A. Foti lisafoti@citura.com

350 Seventh Avenue | Suite 1503 | NYC 10001 P 212 760 0545 | C 201 401 6839 | F 212 695 6664

5.

LINDA J. LUPPINO
PROJECT MANAGER
Iluppino@valfloors.com

CERAMIC
MARBLE
WOOD
CARPET
RESILIENT

4200 westside avenue
north bergen nj 07047
tel [NJ] 201 617 7900
tel [NYC] 212 690 7688
fax 201 617 0508
www.valfloors.com

Design Firm themixx Client Abhaya Designer Lisa Delaney Client Alliance Building Services Designer Lisa Delaney Waterfront Mgmt. Systems Client Designer Lisa Delaney Footage Bank Lisa Delaney Client Designer Client Citura Liz Bernabe Designer Client VAL Floors Reed Seifer Designer

95

A REAL ESTATE COMPANY

1.

PO Box 271 Hoboken, NJ 07030 T 201 420 0980 Ext.105 F 201 420 5134 P 800 568 8437

www.metrohomesllc.com

different. together.

marc leonard.
vice-president, programming.
marc.leonard@logostaff.com

1775 Broadway, New York, NY 10019 t 212.767.8544 f 212.767.3943

PAUL FRIED, PARTNER paul@metrohomeslic.com

2.

PO Box 271 Hoboken, NJ 0 T 201 459 0990 F 201 459 0910 P 800 374

www.metrohomesII

JAMES C. MCKENNA

PRESIDENT CHIEF EXECUTIVE OFFICER jmckenna@hunterrobertscg.com

- 212 786 4440
- 212 786 4441
- 917 453 2688

2 World Financial Center, 6th Floor ■ New York, New York 10281

www.hunterrobertscg.com

6.

karen@kfrcommunications.com

Design Firm themixx Design Firm KFR Communications, LLC Client Metro Homes Designer Lisa Delaney LOGO Designer Lisa Delaney Waterfront Design Group Designer Lisa Delaney Client Hunter Roberts Construction Group Designer Lisa Delanev 5. Client Brew Worx Designer Lisa Delaney 6. Client Superstar Exp Designer Lisa Delaney 7. Client KFR Communications, LLC Designer Karen Riley

SHARP DESIGNS

Graphics on the Cutting Edge

STEPHANIE SHARP

50 Florence Street Hamilton, NJ 08610 (609) 392-8724 FAX (609) 392-8725 www.sharpdes.com stefs@sharpdes.com alkemi creative

melinda stephenson
design guru

1995 2622
250 818 7391

info@alkemicreative.com

2.

4.

6.

9.

746 Toro Canyon Road, Santa Barbara, CA 93108 Toll Free: 888-394 1333 | Tel: 805-695-0427 E-mail: ritarivest@mindspring.com | www.ritarivest.com

10.

Design Firm Sharp Designs Design Firm alkemi creative (3-11)
Design Firm Tajima Creative Client Sharp Designs Stephanie Sharp Designer 2. Client alkemi creative Melinda Stephenson Designer 3-9. Client BUILD Youth Business Incubator Designers Komal Dedhia, Ximena Quijano, David Russell, Rich Nelson 10. Client Rita Rivest

Komal Dedhia 11. Client Washington Mutual Designers Komal Dedhia, Ellen Roebuck

Designers

949 645-KIDS

949 645-5003

theFirstPage.net

Fax:

1.

3.

Chris Pearce
President

Ph: (808) 733-3330
Fax: (808) 733-3340

WORLD SAKE
IMPORTS

3465 WAIALAE AVENUE · SUITE 340 · HONOLULU · HAWAII 96816 USA
cpearce@worldsake.com · Honolulu · San Francisco · New York

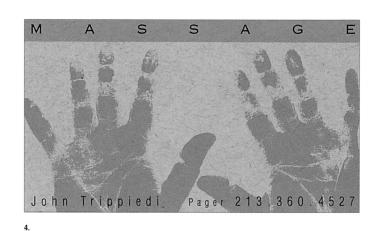

ROBERT FRAIDENBURGH
PRESIDENT

4970 WINDPLAY DRIVE, SUITE C-6
EL DORADO HILLS, CA 95762
ph: 916-941-7366 fax: 916-941-7369

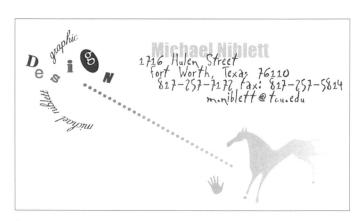

6.

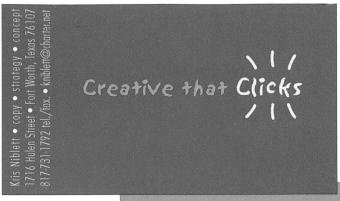

7.

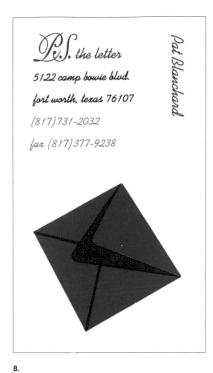

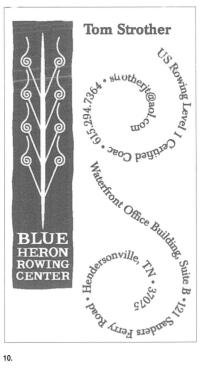

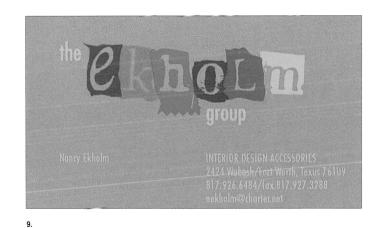

(1,2)
Design Firm Tajima Creative Client Optimet Designers Robert Fraidenbergh, Design Firm UCI Inc/Urano Communication Bob Faulkner International Client Michael Niblett Design (4,5)
Design Firm J. Robert Faulkner Advertising Designer Michael Niblett (6-10) 7. Design Firm Michael Niblett Design Creative that Clicks Client Michael Niblett Designer The First Page Client Client PS the Letter Designer Janice Wong Designer Michael Niblett Client Yorozu Law Group Client The Eckholm Group Komal Dedhia, Rich Nelson Designers Designer 10. Blue Heron Rowing Center Client World Sake Imports Client Ryo T. Urano, Dwight Irick Michael Niblett Designer Designers Client John Trippiedi Designers John Trippiedi, Bob Faulkner

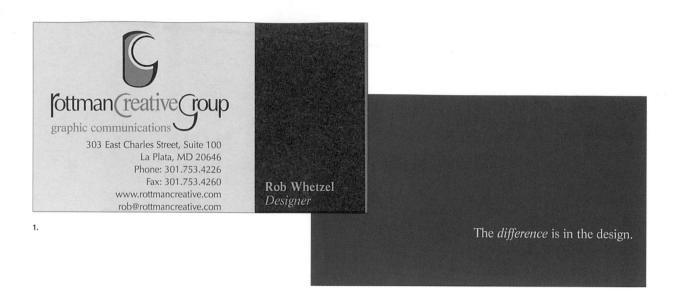

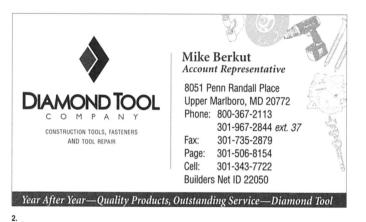

502 Tobacco Quay Alexandria, VA 22314 Phone: 703-299-0188

Fax: 703-299-1094 Patricia L. Doyle Email: pdoyle@pldoyle.com

www.pldoyle.com

PRESIDENT

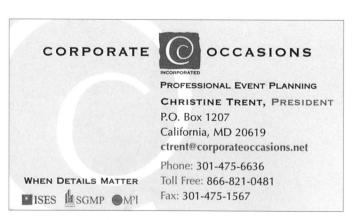

Tim Lancaster Vice President

805 | Penn Randall Place Upper Marlboro, MD 20772

Phone: 301-568-7288

Fax: 301-967-0218 Cell: 240-882-7179

Specializing in Firestop Installation Services

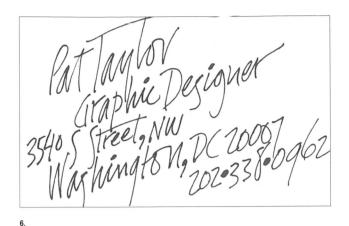

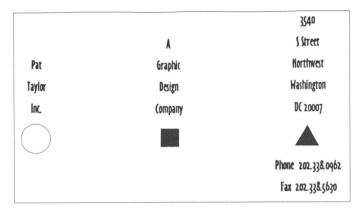

7.

PAT TAYLOR INC 3540 S STREET NW WASHINGTON DC 20007 (202) 338-0962

R

PAT		
TAYLOR		
Graphic	3540	Phone
Designer	S Street	202
	NorthWest	338
	Washington	0962
	DC	Fax
	20007	202
117		944
		5471

9

My company name is: Pat Taylor Inc
I'm a graphic design company
My address is: 3540 S Street NW
Washington DC 20007
My phone number is: 202.338.0962
My facsimile number is: 202.944.5471
I do not have e-mail or a website.
Sorry.

10.

Design Firm Rottman Creative Group, LLC (6-10)Design Firm Pat Taylor Graphic Designer Rottman Creative Group, LLC Client Gary Rottman Designer 2. Diamond Tool Company Client Gary Rottman Designer P.L. Doyle Client Gary Rottman Designer Client Corporate Occasions Gary Rottman Designer Atlantic Fire Stopping Client Designer Gary Rottman Client Pat Taylor Graphic Designer Designer Pat Taylor

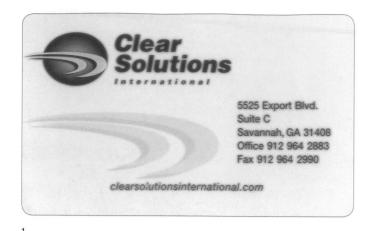

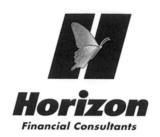

Carol Whorley

Senior Loan Officer
6205 Abercorn Street
Suite 103
Savannah, GA 31405
912 303 9335 Office
912 303 9747 Processor
912 547 3132 Cell
912 303 9741 Fax

carol@horizonfinancialconsultants.com

2.

Longwater & Company

Elaine Longwater President

Marketing Advertising PR and Multimedia

619 Tattnall St. Savannah, GA 31401

Phone 912 233 9200 Fax no. 912 233 1663 e-mail elaine@ longwater.com

HAIR COLOR AND DESIGNS, INC.

Teresa Atwell

7373 Hodgson Memorial Drive * Building#2 Savannah, Georgia 31406 * 912-352-0700

4.

Kim Askey Financial Manager/ Competition Coordinator

26 East Bay Street Savannah, GA 31401 Post Office Box 8105 Savannah, GA 31412 Phone (912) 236-5745 Fax (912) 236-1989

kim@savannahonstage.org www.savannahonstage.org

Ralph F. Wackenhut Secretary & Treasurer

One Bolt, Inc. 333A Choccolocco St. Oxford, AL 36203 U.S.A.

Phone: 256-835-1393 Fax: 256-831-6349

5.

6

Linda McCorkle Admissions & Marketing Director

6711 LaRoche Avenue, Savannah, GA 31406 (912) 354 8225 • Fax (912) 790 3238 www.riverviewhealth.net • riverviewhealth@aol.com

Mission Statement

Riverview Health and Rehabilitation Center has been founded to provide competent and compassionate care to meet the ever-changing health care needs of the community and to provide a physically and emotionally safe environment that will enrich the quality of life for the residents.

ADAM VELA OWNER

1531 stoul st. #150 denver, co 80202 | 303 629 mici (6424) | cell 720 427 4568 fax 3O3 629 8552 | adamvela@msn.com www.miciitalian.com

gelato

panini vino

Design Firm Longwater & Company Client Design Firm Ellen Bruss Design Designer Client Clear Solutions International Client Kathryn Strozier Designer Designer Horizon Financial Consultants Client Designer Kathryn Strozier Designer Longwater & Co., Inc. Client Designer Kathryn Strozier Designers Greener Grass Client Designer Kathryn Strozier Designers Ellen Bruss Design Team

Savannah Onstage Music &

Arts Festival Kathryn Strozier

One Bolt, Inc.

Kathryn Strozier

Kathryn Strozier

Sapphire Grill

MICI

Riverview Health & Rehabilitation Center

Amy Mason, Patrick Grone

pizza

THELAB ART+IDEAS

THE LAB AT BELMAR 1430 WYNKOOP NO 100 DENVER, CO 80202 P 303 573 0050 F 303 573 0011 ADAM@BELMARLAB.ORG

Giovanni Stone IDSA Curator · BLOCK SEVEN 303-742-1525 303-742-1526 445 South Saulsbury Street Lakewood Colorado 80226

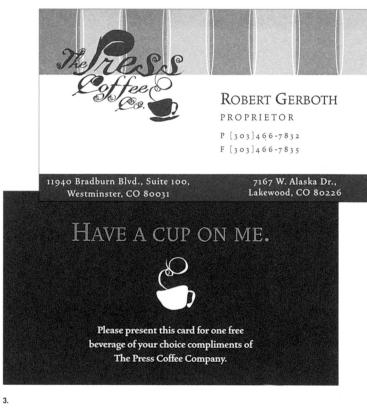

DEE CHIRAFISI KENTWOOD CITY PROPERTIES

1660 SEVENTEENTH STREET SUITE 100 DENVER CO 80202

WWW.REALTOR.COM/DENVER/DEECHIRAFISI

P303 881 6312 F303 302 5011

4.

FOUNDATION FOR WOMEN'S WELLNESS

SHARON CRAVITZ EXECUTIVE DIRECTOR

foundation for women's wellness 1000 south race street denver, co 80209 303.548.0595 phone 303.744.7759 fax sharongravitz@thfww.org www.thefww.org

5.

K. C. LIM Chief Executive Officer H/P: +6 012-202 8889

BAE INTERNATIONAL INC. SDN BHD Level 25, Plaza Pengkalan, 3rd Mile Jalan Ipoh, 51100 Kuala Lumpur, Malaysia. Tala (603) 4043 8880 Fare (603) 4043 8880

Tel: +(603) 4043 8889 Fax: +(603) 4043 8899 E-mail: kc13@tm.net.my Website: www.myBAE.com

6.

Design Firm Ellen Bruss Design Design Firm Truefaces Creation SDN BHD Client The Lab Designers Ellen Bruss Design Team Client Block 7 Designers Ellen Bruss Design Team Client Press Coffee Company Designers Ellen Bruss Design Team Client Arthouse Designers Ellen Bruss Design Team 5. Client Foundation for Women's

Designers Ellen Bruss Design Team

6.

Client BAE International Inc. Sdn Bhd

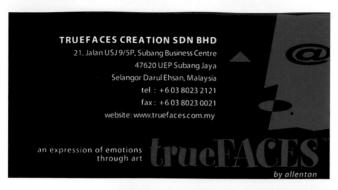

@llentan mobile +6 012 208 2608 allentan@truefaces.com

@llentan mobile +6 012 208 2608 allentan@truefaces.com.my

TrueFACES paintings are also displayed & KARIA COM SDN BHO Sight A-OG-U3, Ribotk A-Flaza Mont Kiara 1 Julio Figur, Mart Kiara GSRN Busini Language

Canon

TrueFACES paintings are also displayed & KIARR-COM SON BHD Suite A-OS-O3, Block A, Plaza Mont Kiara 2, Jalan Kiara, Mont Kiara, SO480 Kuala Lump

@llentan mobile +6 012 208 2608 allentan@truefaces.com.mo

TrueFACES paintings are also displayed & KIARA COM SDN 8HD Suite A-05-03, Block A, Plaza Mont Kiara

Canon

@llentan mobile +6 012 208 2608 allentan@truefaces.com.my

TrueFACIS paintings are also displayed th KIARA COM SUN 6HD Sette A-OG-OI. Block A, Plaza Mont Klara Julian Kate Mont Krasa (1987) Kiala La

Cane

@llentan mobile +6 012 208 2608 allentan@truefaces.com.my

TrueTACES paintings are also displayed © KIARA-COM SDN BHD Suite A-0G-03, Black A, Plaza Mont Klara 2. Jalan Kiara, Mant Klara, SDA60 Kwala Lumbur

Canon

@llentan mobile +6 012 208 2608 allentan@truefaces.com.my

Truef ACTS paintings are also displayed as KDARA-COM SON BHO Suite A-0G-03, Block A, Plaza Mont Kigra 2, Jolan Kiara, Mant Kiera, SO480 Kuala Lumpur

Canon

@llentan mobile +6 012 208 2608 allentan@truefaces.com.my

TrueFACES paintings are also displayed © KIARA-COM SEN BHD Suite A-05-03, Risck A-Plazo Mont Kiaro 2. Jolan Kiara, Mont Kiara, 50480 Kuala Lumpur

Canon

@llentan +6 012-208 2608

2.

TRUEFACES CREATION SDN BHD

11, Jalan USJ5/3F, UEP Subang Jaya 47610 Subang Jaya, Selangor, Malaysia Fax : +6 03-5631 0051

Email: allentan@truefaces.com.my

Original paintings also displayed @ KIARA-COM SDN BHD Suite A-0G-03, Block A, Plaza Mont Kiara, 2, Jalan Kiara, Mont Kiara, 50480 Kuala Lumpur.

21, Jalan USJ 9/5P, Subang Business Centre 47620 UEP Subang Jaya Selangor Darul Ehsan, Malaysia tel: +6 03 8023 2121 fax: +6 03 8023 0021 email: admin@truefaces.com.my website: www.truefaces.com.my

(1-3)
Design Firm Truefaces Creation Sdn Bhd

1-3. Client

Truefaces Creation Sdn Bhd

王 荣 禄 **Dato' Albert E.L. Ong** Chief Executive Officer

ABRIC BERHAD

Level 3, Lot 8, Jalan Astaka U8/84 Bukit Jelutong, 40100 Shah Alam Selangor Darul Ehsan, Malaysia Tel: +603 7847 5555

Fax: +603 7846 5555 E-mail: albertong@abric.net

RESTORAN ALI BERKAT JAYA
1-1, Jln. USJ 9/5Q, Subang Business Centre, UEP Subang Jaya,
47620 Subang Jaya, Selangor Darul Ehsan. Tel: 03-8024 7867

RESTORAN ALI BERKAT JAYA CAHAYA
E-1-13 & E-1-14, Sri Tanjung, Jln. USJ 16/7, UEP Subang Jaya,
47620 Subang Jaya, Selangor Darul Ehsan. Tel: 8024 6569

(Catering Services Available)

2.

3.

5

kamaltan 019-3710386

10, JALAN USJ 11/3K, UEP SUBANG JAYA SELANGOR DARUL EHSAN, TEL: 03-5637 2764

CHUNG HON CHEONG Managing Director

Reward-Link-com Sdn Bhd

19th Floor, Menara Kurnia, No. 9, Jalan PJS 8/9, 46150 Petaling Jaya, Selangor Darul Ehsan. Tel: +6 03-7875 7266 Fax: +6 03-7875 7070 H/P: +6 012-329 1830 email: hcchung@rexit.com

TING PAI SHIN 012-337 0077

TTL DISTRIBUTORS SDN BHD

19, Jalan Penyelengara U1/77, Taman Perindustrian Batu Tiga, 40150 Shah Alam, Selangor. Tel: 03-5510 9781, 5510 3495 Fax: 03-5510 3512 E-mail: ttldist@tm.net.my

Website: www.ttldistributors.com.my

10.

Design Firm Truefaces Creation Sdn Bhd

Client Abric Berhad

Client Restoran Ali Berkat Jaya

Client Bigreen Leaf Restaurant Sdn Bhd

Client Canai & Such International Holding Sdn Bhd

5. Client Stargate Resources

Datin Jacqueline Ong Client

Client KIP 8.

Client Landscape

Client Reward-Link.com Sdn Bhd 10. Client TTL Distributors Sdn Bhd

PUA YU LEN 潘宥年 DIRECTOR

012-2116129

Taman Perindustrian Belmas Johan, 48000 Rawang, Selangor Darul Ehsan, Malaysia. Tel: 03-6093 3928, 6093 6468 Fax: 03-6093 1928 E-mail: fbkmal@tm.net.my

1.

Muraleedarren

Principal Facilitator 019 215 6278

Suite 33-01, 33rd Floor, Menara Keck Seng, 203 Jalan Bukit Bintang, 55100 Kuala Lumpur Tel: +603 2116 5606 Fax: +603 2116 5888 Email: griptnw@tm.net.my

2.

DON YONG

B.Sc., M.Sc. (UK). CHIEF EXECUTIVE OFFICER H/P: 019-351 3518

11, Jalan 52/8, New Town, 46200 Petaling Jaya, Selangor Darul Ehsan Tel: 603-7956 9011 / 7956 9043 Fax: 603-7954 1557 / 7955 2457 E-mail: don_yong@tm.net.my / ehbsb@tm.net.my

Muhammad Adam Bin Abdullah

Director of Sales 012-366 0786

MAJU CURRY HOUSE SDN. BHD. (617550-X)

11-1, Jln 45A/26, Taman Sri Rampai, Setapak, 53300 Kuala Lumpur, Malaysia. Tel: 603-4149 2611 Fax: 603-4142 6211

MARKETING OFFICE:

42-2, Jalan Dagang, SB4/2 Taman Sungai Besi Indah, 43300 Balakong, Selangor Darul Ehsan. Tel: 603-8941 1786, 8941 2786 Fax: 603-8941 3786

Hala Lim Chin Leong

+6012-538 1557

MAX POWER ADVANTAGE SDN BHD (658767-D)

J-1-17, Jalan PJU 1/43, Aman Suria Damansara, 47301 Petaling Jaya, Malaysia. e-mail: halatrans2003@yahoo.com

ECO CHARGE

MANTOWER

www.eco-charge.jp

I'm Eco-Friendly×Eco-Power

42-2, Jalan Dagang, SB4/2 Taman Sungai Besi Indah, 43300 Balakong, Selangor Darul Ehsan. Tel: 03-8941 1786, 8941 2786 Fax: 03-8941 3786

Interior Design • Renovation • Wall Paper • Customized Cabinets
 • Vertical Blind • Wiring • Carpeting • Commission Agent
 • Souvenir And Florist Center • Marketing Agent

1-6)
Design Firm Truefaces Creation Sdn Bhd

1. Client FBK Systems Sdn Bhd
2. Client Grip Training Workshop
3. Client Malaysian Institute of Baking
4. Client Maju Curry House Sdn Bhd

Client Maju Curry House Sdn Bhd

5.
Client Max Power Advantage Sdn Bhd

5.
Client Subaahana Malaysia Sdn Bhd

Gun CUSTOMER SERVICE ■ 012-334 6666

USAHA SELATAN LOGISTICS SDN BHD

IMPORT, EXPORT & CUSTOMS CLEARANCE
LOT 0026, GROUND FLOOR, BLOCK C,
RESOURCE COMPLEX, 33 JALAN SEGAMBUT ATAS,
51200 KUALA LUMPUR.

203-6257 2211/6257 2233 **3**03-6250 8899

Tara Hallacher LEASING MANAGER

301 Friendship Avenue Hellam, PA 17406

PHONE 717-840-4700 FAX 717-840-4708

leasing@buttonwoodgardens.com

www.buttonwoodgardens.com

2.

Colonial GARDENS

Randy Farrales
PROPERTY MANAGER

3002-1 Mackenzi Lane York, PA 17404

PHONE 717-792-4595

pmgr@colonialgardensyork.com

www.colonialgardensyork.com

3.

Ronald B. Low M.D., F.A.C.S. EAR, NOSE & THROAT HEAD AND NECK SURGERY

20 PROSPECT AVENUE, SUITE 909 HACKENSACK, NJ 07601 Tel: 201-489-6520

Fax: 201-489-6530

DAVID SABLE, M.D. 154 West 71st Street New York, NY 10023 Tel: 212.496.1177 Fax: 212.712.2389 E-Mail: DSable@armtnyc.com

ASSISTED REPRODUCTIVE MEDICAL TECHNOLOGIES

Albert Melera Service Manager

12 East 22nd Street New York, NY 10010

Reservations 212.505.1222 Business 212.253.5647 Fax 212.253.5649

Communications Solutions That Mean Business Claire M. Stoddard, President

180 Cabrini Boulevard, Suite 126, New York, NY 10033 T 212.795.6606 F 212.795.6586 claire@worldofworksolutions.com

	Design Fill Truelaces Creation Sun Blid							
(2-	4)							
	Design Firm Holberg Design							
(5-9)								
Design Firm John Kneapler Design								
1.								
	Client	Usaha Selatan Logistics Sdn Bhd						
2.3								
-,-	Client	Statewide Management, Inc.						
	Designer	AliceAnn Strausbaugh						
4.								
	Client	Cad-Ware, Inc.						
	Designer	Joseph Szala						
5.	Designer	oosepii ozala						
J.	Client	Zoë Restaurant						
		John Kneapler, Matt Waldman,						
	Designers	Daymond Bruck						

Client Ronald B. Low John Kneapler, Michael Frizzell Designers Client ARMT John Kneapler, Designers Holly Buckley Client World of Work John Kneapler, Designers Niccole White

> Client Cena Restaurant Designers John Kneapler, Chris Dietrich

JASON FRIEDMAN

Studio Manager/Senior Photographer

adam raphael photography, LLC

347 Fifth Avenue, #303 New York, NY 10016 Tel: (212) 685-6661 Cell: (917) 861-6030 Fax: (212) 685-6662 user171251@aol.com www.adamraphael.com

the one on the left. Graphic Design

John Kneapler

President

John Kneapler Design

151 West 19th Street Suite 11c New York, NY 10011

Tel 212.463.9774 Fax 212.463.0478

JKneapler@aol.com www.JohnKneaplerDesign.com

2.

Mann Realty Associates OWNERS - INVESTORS - MANAGERS

Maurice A. Mann CHIEF EXECUTIVE OFFICER

1776 Broadway, 23rd Fl. New York, NY 10019 Tel: 212.977.0000 Ext. 222 Fax: 212.977.0086 Email: maurice@mannrealty.com

Licensed Real Estate Broker

Leigh W Maida Graphic Design

2215 Christian Street Philadelphia, PA 19146 t/215.605.5667 f/419.710.9357 e/info@leighmaidadesign.com

www.leighmaidadesign.com

6

ABBE LUNGER PRINTMEDIA, LLC.

Media, Pennsylvania tel. 610.892.2722 fax. 610.892.2744

alunger3@comcast.net

GREGORY HARTRANFT
COLORIST designer stylist

4114 East Calle Redonda Drive | Suite 55
Phoenix, Arizona 85018
215.284.2111 | hairtranft1@comcast.net

8

MISS SADIE MAE'S
GOURNET
BOOGGIF
BISCUITS

CYNDI NEEDLEMAN / Chef & Owner

PO Box 63725 Philadelphia, PA 19147 · tel.215.726.1931 · fax.952.487.0978
cyndi@sadiesbiscuits.com · www.sadiesbiscuits.com

1-4)
Design Firm John Kneapler Design
5-9)

Design Firm Leigh Maida Graphic Design

. Client Designers

Adam Raphael Photography Colleen Shea, John Kneapler

Client Designers

John Kneapler Design John Kneapler, Charles Kneapler

Client

Mann Realty Associates
John Kneapler, Scot Sterling,
Subita Shirodkar

Suhita Shiroo

Client Designers

Beyond Spa Colleen Shea, John Kneapler Client Designer Mopping Mama's Leigh Maida

Client

nt Leigh Maida Graphic Design

Designer Leigh Maida

Client PrintMedia Designer Leigh Maida

Client Gregory Hartranft
Designer Leigh Maida

Client Sadiesbiscuits.com
Designer Leigh Maida

Thomas C. Young
Associate Underwriter

Archway Insurance Group, LLC

1301 Wright's Lane East West Chester, PA 19380

tel.610.719.0838 x291 fax.610.692.8913

tyoung@archwayins.com www.archwayins.com

Silk Abstract Company

224 South 20th Street Philadelphia, PA 19103

tel.215.751.0111 fax.215.751.0112

sparisi@silktitle.com www.silktitle.com

Susan Parisi

1.

A PROFESSIONAL CORPORATION

Peter O'Hara, Esquire

224 South 20th Street Philadelphia, PA 19103
tel.215.985.1500 | fax.215.751.0112 | pohara@wilkbrand.com
www.wilkbrand.com

3.

5.

1

Leigh Maida Creative Director

InMarket Partners, LLC

2215 Christian Street, Suite A, Philadelphia, PA 19146-1718 tel.610.408.8022 > cell.215.605.5667 > fax.419.710.9357 leigh@inmarketpartners.com > www.inmarketpartners.com

[strategic insurance communications]

Sauren Suszkowski
Massage Therapist

Swedish Massage
Shiatsu
Deep Jissue
Reflexology

Available for Parties & Small Groups
610.389.4134

AMTA Member

6

James Fernandes **Tom Peters** Fergus Carey

full menu 11:30am - 2am daily

> 23rd & South Streets 2229 Grays Ferry Ave Philadelphia, PA 19146

> > 215.893.9580

a lovingly restored neighborhood tavern

John Silva, President

3448 Progress Drive, Suite G Bensalem, PA 19020

tel.215.633.9901 fax.215.638.8696 cell.215.760.7463

silvaprintingassociates@aol.com

Design Firm Leigh Maida Graphic Design

Client Archway Leigh Maida Designer

Client Silk Abstract Company Leigh Maida

Wilk Brand & Silver Client Leigh Maida Designe

Designer

Sheila's Husband Client Leigh Maida Designer

Client InMarket Partners, LLC Leigh Maida Designer

Client Designer

Lauren Suszkowski Leigh Maida

Client

Nodding Head Brewery & Restaurant

Leigh Maida Designer

Client Grace Tavern

Leigh Maida Designer

Client Silva Printing Associates Leigh Maida Designer

Troy W. Santora

5540 Trabuco Road, 2nd Floor - Irvine, CA 92620 Tel.949.679.7135 - Cell.949.887.4499 - Fax.949.679.7235 tsantora@coastlinecaptives.com - www.coastlinecaptives.com

Restaurant • Pub • Accommodations local (ask Ales • 100+ whiskies • Extensive Beer List Great Food • (omfortable Rooms w/Private Baths

Your Home in the Highlands

Union Street Fortrose Scotland IV10 8TD 011.44.1381.620.236 www.theanderson.co.uk

3.

5.

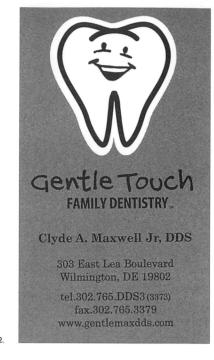

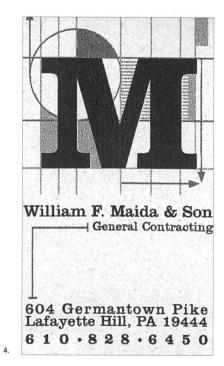

331 Fifth Avenue • Pelham, NY 10803 tel 914.738.6066 · fax 914.738.6073 www.pelhamprint.com

igital 🍨 BW & Color Copies onary - Brochures - Signs letters • CAD Output ...and more

porate Identity - Logo's - uckaging • Promotional Products

Multimedia • Website Design & Hosting

Robin L. Iten Porter executive director

p.o. box 1051 Harrisonburg, VA, 22803 p540-801-8779 \$ 540-438-9589 email@valleyarts.org www.valleyarts.org

p.o. box 1051 Hurrsonburg, U.L. 22803 p540-801-8779 \$540-438-9589 email@valleyarts.org www.valleyarts.org

10136 Maple Street - Omaha, Nehraska 68134 gentrysmiles.com

Design Firm Leigh Maida Graphic Design

Design Firm Gregory Richard Media Group

Design Firm TLC Design

Design Firm emspace design group

Client Coastline Captive Solutions Leigh Maida Designer

Client Gentle Touch Family Dentistry Designer Leigh Maida

Leigh Maida

Client The Anderson

Designer

Client Designer

William F. Maida & Son Leigh Maida

Client

Chris Jobin Voice Over Designer Richard Sohanchyk

Client Designer

PELHAMPRINT.com Richard Sohanchyk

Client Art Council of the Valley Trudy L. Cole Designer

Client Gentry Smiles Designer Juliane Bautista

Painting
Wallcovering
Wood Finishing
Shop Finishes
Duroplex
Concrete Staining
Elastomerics
Multi-color Finishes
Special Coatings
Floor Coatings
Waterproofing

HARWOOD SERVICES COMMERCIAL, INC

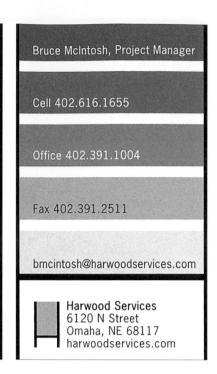

Rob Israel

President

Phone: 212 655 5112 Email: rob@docpopcorn.com Fax: 212 655 5286

60 Madison Ave. 3rd Floor New York, NY 10010 www.docpopcorn.com

2.

JOE MASIELLO, CPT

25 1/2 E 61 ST, STUDIO 5E NY, NY 10021 T: 212.319.3816 F: 212.319.3817 C: 917.797.2827 JOE@FOCUSNYC.COM

Harvey Appelbaum

Creative Director

happel@inc-3.com

www.inc-3.com

220 East 23rd Street . New York, NY 10010 . P212.213.1130 . F212.532.8022

4

Beth Singer Design, LLC

P 703.469.1900 info@bethsingerdesign.com

P703.469.1900 F703.525.7399 1408 North Fillmore Street, Suite 6, Arlington, VA 22201 www.bethsingerdesign.com

E & G GROUP

SARA B. BARNES, HCCP Senior Property Manager

1350 BEVERLY ROAD, SUITE 200 MCLEAN, VA 22101 P703.893.0303 F703.893.3273

sbarnes@eandggroup.com

www.eandggroup.com

Design Firm emspace design group

Design Firm inc3

Design Firm Beth Singer Design, LLC

Client Designer

Harwood Services Juliane Bautista

Client Designers

Doc Popcorn Harvey Appelbaum, Christofer Nystrom

Client Designers

Focus Harvey Appelbaum,

Christofer Nystrom

Designers Harvey Appelbaum, John Sexton

Client

Beth Singer Design, LLC Suheun Yu Designer

Client

E&G Group Designer Chris Hoch

Client

B'nai B'rith Youth Organization Suheun Yu Designer

LEDDEN DESIGN

Cathy Ledden R.G.D. Principal Designer

tel. 416.252.0294 cl@leddendesign.com fax. 416.252.8185

Creating Communications — Simply

50 Holbrooke Avenue Toronto Ontario

Canada M8Y 3B4

KATE HART Principal Designer 110 Park Street, Toronto, Ontario M1N 2P3 t: 416-267-2642 e: kate@watersheddesigns.ca c: 416-676-2388 w: watersheddesigns.ca

McLean SOFTWARE .com Bill McLean Software Designer

McLean **SOFTWARE** .com

416.252.0294

bill@mcleansoftware.com

50 Holbrooke Avenue Toronto Ontario Canada M8Y 3B4

CITY OF CHAMBLEE

3518 BROAD STREET CHAMBLEE, GA 30341

R. Marc Johnson
Chief of Police

P 770.986.5026 F 770.986.5017 E chiefmi@chambleepol.com

a city on the right track.

Design Firm Ledden Design (4-6) Design Firm sky design Client Ledden Design Designer Cathy Ledden 2. Client Watershed Designs Designer Cathy Ledden 3. Client McLean Software Designer Cathy Ledden 4. Client Sweet Pea Gourmet Designer W. Todd Vaught

Baldwin GRAPHICS

Eric J. Baldwin

President

1301 Pennsylvania Ave. NW Mezzanine Level Washington DC 20004-1701

202 347.0123 f 202 347.0596 eric@baldwingraphics.com www.baldwingraphics.com

PRINTING · PHOTOCOPYING · DESIGN

KABEL

Robert J. Kabel

805 15th Street NW Suite 700 Washington DC 20005-2282

+1 **202 312 7408** voice

+1 202 257 0708 cell

+1 202 312 7460 fax

rk@robertkabel.com www.robertkabel.com

Jeff Shewey

Coldwell Banker Residential Brokerage
Owned and Operated by NRT Incorporated

202 332-3228

move@jeffshewey.com

Four Seasons Plaza
2828 Pennsylvania Avenue NW
Washington DC · 20007-3719
202 333-6100 o · 202 342-9118 F
www.jeffshewey.com

CHR Communications

Kathy Hourigan

800 N. Milford Rd.
Suite 700
Milford, MI 48381

248.685.9933
248.685.9944 fx

khourigan@chrcommunications.com

www.chrcommunications.com

Karen Mattson General Manager

57075 Pontiac Trail New Hudson, MI 48165

(248) 437-4141 (248) 437-3970 Fax (248) 921-0525 Cell

kmattson@glcylinders.com www.glcylinders.com

children's Trust FOUNDATION

tel 206 343 5911 fax 206 583 0161 318 First Ave S, Suite 305 Seattle, Washington 98104 www childrenstrust.org

(1-4) Design Firm Eyebeam Creative LLC (5,6) Design Firm CHR Communications (7)

(7)Design Firm Belyea

Client Designers

Azar s Gregory Gersch, Joseph Azar

Client Designer Baldwin Graphics Gregory Gersch

Client Designer

Kabel Gregory Gersch Clier

Client Jeff Shewey
Designers Gregory Gersch,
Joseph Azar, Richard Lippman

5. Client Designers

CHR Communications

6. Client

Kathy Hourigan, Gene Renaker Great Lakes Cylinders

Kathy Hourigan

Designer
Client
Designer

Children's Trust Foundation Nick Johnson Christian Hazelmann: President and CEO chazelmann@proluminatech.com

80 South Washington Suite 200 Seattle Washington 98104

P 206 622 6700

F 206 467 1777

W proluminatech.com

Natalie Price SENIOR VICE PRESIDENT

nprice@feareygroup.com cell 206.790.5282

1809 Seventh Avenue, Suite 1111 Seattle, Washington 98101

T 206.343.1543 F 206.622.5694 www.feareygroup.com

BARRY ACKERLEY Founder and Co-chair

1301 Fifth Avenue, Suite 3525 Seattle, Washington 98101 206.624.2888 206.623.7853 fax

www.ackerleyfoundation.org

Ensuring That Every Child Receives A Great Education.

Jerry Judge

jerry@bayside-insurance.com

1610 Postal Road PO Box 545 Chester, Maryland 21619 410.643.6641 800.773.0046 Fax 410.604.3571

408 N. Washington Street PO Box 3087 Easton, Maryland 21601 410.822.2800 866.ERIE.INS Fax 410.820.0210

Rachel Elgin Education & Program Specialist

1736 Highway T17 Tracy, Iowa 50256 Tel: 641-828-8545 Fax: 641-842-3722 E-mail: relgin@sciswa.org

Serving Lucas, Marion, Monroe and Poweshiek Counties

Julia M. Kennedy, LPO
Escrow Manager

2037 East Sims Way • P.O. Box 598 • Port Townsend, WA 98368 360/385-1322 • 800/401-1001 • Fax 360/385-1877 jkennedy@fatcojc.com

6.

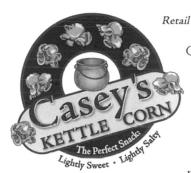

Retail + Wholesale + Fundraisers

Casey & Carolyn Dennis
Owners

P.O. Box 280 Sequim, WA 98382 Phone: (360) 582-1138 Fax: (360) 582-9454

www.caseyskettlecorn.com

7.

A MAGICAL PLACE...

On the beach on the Strait of Juan de Fuca

Events • Weddings • Special Occasions

Lyndee Lapin, Proprietor

2026 Place Road

Port Angeles, Washington 98363

(360) 565-8030

lyndee@laplacesur-la-mer.com www.laplacesur-la-mer.com

Design Firm Foth & Van Dyke (6-8)
Design Firm Laurel Black Design, Inc. Client Prolumina Ben Reynolds Designer Client The Fearey Group Designers Naomy Murphy, Ben Reynolds Client Ginger & Barry Ackerley Foundation
Anne Dougherty,
Nancy Stentz Designers Client Bayside Insurance Associates, Inc. Designer Charlene Whitney Edwards

Design Firm Whitney Edwards Design

Design Firm Belyea

Client South Central Iowa
Solid Waste Agency
Designer Daniel Green

Client First American Title Company
of Jefferson County
Designer Laurel Black

Client Casey's Kettle Corn
Designer Laurel Black

La Place sur la Mer

Laurel Black

Client

Designer

246 Patterson Road

Port Angeles, WA 98362

Office: 360.457.0217

Fax: 360.457.8122

Cell: 360.460.1834

info@laurelblack.com

www.laurelblack.com

PERCEPTION IS EVERYTHING.

GRAPHIC DESIGN • ELECTRONIC DESIGN

IDENTITY CREATION • CREATIVE SERVICES • PROMOTIONAL STRATEGIES

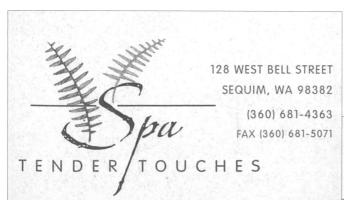

YOUR NEXT APPOINTMENT IS

DATE

TIME

SERVICE

MON

WED THUR FRI

24 HOUR CANCELLATION NOTICE IS REQUIRED (360) 681-4363

Call Me! Nathan Van Hoeck (Licensee) 0408 496 036 nvh@ryanshotels.com.au

590 Kingsway Miranda NSW 2228 T. 02 9524 0398 F. 02 9526 2460

www.carmens.com.au

5.

(megaluck)	post locked bag 2000 rozelle nsw 2039 telephone 9555 5000 mobile 0500 51 2000 facsimile 9555 4000	MES PEGUM
	0	JAME

(1,2	Design Firm	Laurel Black Design, Inc.	5.	Client Designers	Ireland Global Lewis Jenkins, Trent Agnew
	Design Firm	Percept Creative Group	6.		
				Client	Ad-Lib Theatrical
1.			_	Designers	Lewis Jenkins, Trent Agnew
	Client	Laurel Black Design, Inc.	7.	01:	1115
	Designer	Laurel Black		Client	MJB
2.	01:	Total of Taxabas Can	8.	Designer	Lewis Jenkins
	Client	Tender Touches Spa Laurel Black	0.	Client	Megaluck Consulting
3.	Designer	Laurei Biack		Designer	Lewis Jenkins
٥.	Client	Carmens Nightclub		Designer	Lewis delikiris
	Designer	Lewis Jenkins			
4.	Designer	LOWIS SOTIMITS			
	Client	Stunt Clothing			
	Designer	Lewis Jenkins			

Show them what you're made of.

6.

Nitish Jain
Managing Director

Crescent Finstock Limited
DoubleDot Centre
533, Kalbadevi Road, Mumbai 400 002
Phone: 201 9200 / 234 7777
Fax: 201 7880 Email: nitishjain@doubledot.co.in

Sunita Zaveri

Tribhovandas Bhimji Zaveri

Westend

442, Chitrakar Dhurandhar Marg, Khar West

Mumbai 400 052

Phone: +91 (22) 649 0606 Fax: +91 (22) 648 7408

Design Firm Percept Creative Group Design Firm Daniel Green Eye-D Design Design Firm Graphic Communication Concepts Client Designer Lewis Jenkins Client Daniel Green Eye-D Design Designer Daniel Green Client Mobile World Telecom Designer Sudarshan Dheer Client Design Scope

Sudarshan Dheer

Sudarshan Dheer

Unidesign Jewellery

Client Strand Book Stall Designer Sudarshan Dheer Client Designer Sudarshan Dheer 8. Client Croscent Finstock Designer Sudarshan Dheer 9. Client Tribhovandas Bhimji Zaveri Designer Sudarshan Dheer

9.

Designer

Client

Designer

Ramesh Kejriwal Managing Director

PARKSONS PRESS LTD.

15 Shah Industrial Estate, Off Veera Desai Road, Andheri West Mumbai 400 053. India

Phone: +91 (22) 636 2344, 633 8624 Fax: +91 (22) 636 0690, 632 9508 Email: parksons@bom2.vsnl.net.in

Vikas Choudhury Director

18° 55' 35" N, 72° 49' 22" E

Aurovision Pvt. Ltd.

41/42 Atlanta, Nariman Point, Bombay-400 021. India Phone: +91-22-285 6527/8/9 Fax: +91-22-287 3100 E-mail: vc@aurovision.com Web: www.aurovision.com

Raghu Mailapur Managing Director

Super Market

Gulbarga-585 101, Karnataka

Phone: 34399, 22799 Fax: 08472 - 23670

E-mail: mjpl@123india.com

Gopal Narang

Emgeen Holdings Pvt. Ltd.

Dwarka, 57 Tagore Road, Santacruz West Mumbai-400 054, India

Phone:+91 (22) 649 8262 Fax:+91 (22) 604 4644 E-mail: gopal@emgeen.com

Atul Kothari

Jewelex New York Ltd 22 West 48th Street, Suite 1500 New York, NY 10036

Phone: (212) 840 6970, (800) 208 9999

Fax: (212) 840 6971 E-mail: akothari@jewelexltd.com

Xerxes Desai Managing Director

TITAN INDUSTRIES LIMITED

Golden Enclave, Tower-A, Airport Road, Bangalore-560 017, India Telex: 0845-8683 TITN IN. Phone: 559 3551 Fax: 080-558 9923

S.S.Godbole

Chief Executive Officer

IDBI INTECH LIMITED

IDBI Building, Plot: 39-41, Sector-11 CBD Belapur, Navi Mumbai-400 614, India

Phone: +91 (22) 756 2077 Fax: +91 (22) 756 2086

Fax: +91 (22) 756 2

7.

JIGEESHA THAKORE

Managing Trustee

E/14 Venus Apartments,
R.G. Thandani Marg, Worli,
Bombay-400 018. Phone: 4930776, 4921037

8.

10.

(1-11) Client IDBI Intech Design Firm Graphic Communication Sudarshan Dheer Designer Concepts 8. Client Vatsalya Parksons Press Sudarshan Dheer Client Designer Sudarshan Dheer Designer Jasras Digital Client 2. Designer Sudarshan Dheer Client Aurovision Sudarshan Dheer 10. Designer Client Guru Dutt 3. Mahalaxmi Jewellers Designer Sudarshan Dheer Client Sudarshan Dheer 11. Designer Client Rose M DeNeve Sudarshan Dheer Emgeen Holdings Designer Client Sudarshan Dheer Designer 5. Client Jewelex New York Sudarshan Dheer Designer Client Titan Industries Sudarshan Dheer Designer

Suresh Bansal

Melstar Information Technologies Ltd. Melstar House, G-4, M.I.D.C. Cross Road, 'A' Andheri East Mumbai 400 093. India Phone: +91 (22) 831 0505 Fax: +91 (22) 831 0520

Email: sbansal@melstar.com URL: www.melstar.com

Arun Sekhsaria **Executive Director** clickforcotton.com NetBusiness Solutions (India) Limited 604, Dalamal House, Nariman Point, Mumbai- 400021, India Phone: +91-22-230 6825 Fax: +91-22-204 5910 E-mail: arun@netbsolutions.com Web: www.clickforcotton.com

IN THE HUNT
CANINE @ EQUESTRIAN FARM

EQUESTRIAN BOARDING
615.368.2443 PH
615.368.2444 FX
WWW.INTHEHUNTFARM COM

8462 COVINGTON ROAD EAGLEVILLE, TENNESSEE 37060

HUNT SEAT LESSONS

Design Firm Graphic Communication Concepts (3-7) Design Firm Hubbell Design Works Client Melstar Information Designer Sudarshan Dheer Client NetBusiness Solutions Designer Sudarshan Dheer Client Hubbell Design Works Leighton Hubbell Designer Montgomery Productions, LLC Leighton Hubbell Client Designer Andy Kitchen Photography Client Designer Leighton Hubbell Client In the Hunt Canine & Equestrian Farm Designer Leighton Hubbell Client Ann Reese Photographer Leighton Hubbell Designer

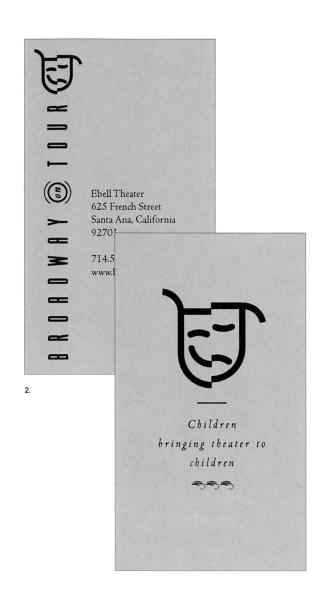

ELLEN SHAKESPEARE

158 N. GLASSELL STREET

SUITE 203

ORANGE, CALIFORNIA

92866

TEL 714.538.4464

FAX 714.538.4473

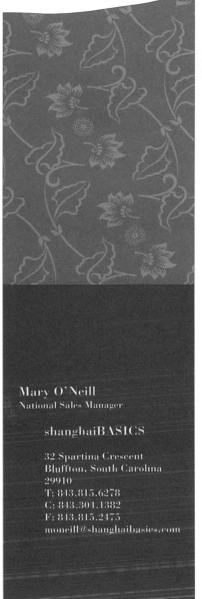

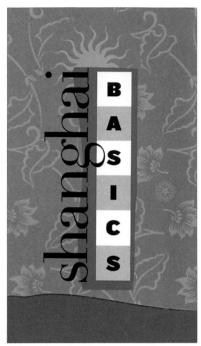

Design Firm Hubbell Design Works Client Zetta Lou's Heavenly Catering Leighton Hubbell Designer Client Broadway on Tour Leighton Hubbell Designer Client Hubbub Advertising Designer Leighton Hubbell Client shanghaiBASICS Leighton Hubbell Designer Client International Color Posters Leighton Hubbell Designer Client Pawsitive Dog Training Designer Leighton Hubbell

Bellingham Bell Foundry

Work of Art

Grant LaMothe - Principal
360,398,1245
grant@bellinghambell.com
www.bellinghambell.com

2

4.

0

Norm Hammers
Production Foreman

559-485-2760 Fax: 559-674-6676 31754 Avenue 9 Madera, CA 93638

George Kosmas

209-522-1220 Fax: 209-522-5133

1-800-262-7755

400 I. Street, Suite 4

Modesto, CA 95351

10.

Design Firm Gabriela Gasparini Design Design Firm Brand Equity Project (3) Design Firm Todd Nickel (4-11) Design Firm Marcia Herrmann Design Client Gato Mia Designer Gabriela Gasparini 2. Bellingham Bell Foundry Client Designer Tim Davenport Client Nickel Properties, Inc. Designer Todd Nickel Client Old World Plastering Designer Marcia Herrmann

Client Progressive Viticulture Designer Marcia Herrmann Client Esteban Ismael Durãn Designer Marcia Herrmann Client Michael Hat Farming Designer Marcia Herrmann Client St. Luke's Family Practice Designer Marcia Herrmann Client Grapeco Designer Marcia Herrmann 10. Client Edith's Gourmet Baking Co. Designer Marcia Herrmann 11. Client Archworks Designer Marcia Herrmann

AGILE OAK ORTHOPEDICS

Karen Horrocks, M.A.

1191 E. Yosemite Ave., Suite C Manteca CA 95336 209-239-5077 Fax: 209-239-5085 e-mail: karen@agileoak.com

PETER SEAGLE

CONSTRUCTION

Peter Seagle
General Contractor
Cell: 209-499-7191

General Contractor
Cell: 209-499-7191

General Contractor
Cell: 219-499-7191

Bog Sylvan Ave. Suite 104
Modesto, CA 95350
Office: 209-525-8493
Fax: 209-521-4748

4

WINERY Chris Wiskerchen
Office Administration/Lab

31795 Whisler Road
McFarland, CA 93250
805-792-2100
Fax: 805-792-5604
email:
cwiskerchen@grapeco.com

6.

5

LJM DESIGN GROUP

Landscape Architecture & Planning

BRÉTHERS

INTERNATIONAL FOOD CORPORATION

Travis D. Betters

224 Ellicott Street Batavia, NY 14020 Tele: 585-343-3007 Fax: 585-343-4218

e-mail:cpbetters@2ki.net www.brothersinternational.com www.grapeco.com

8.

Gloria Cordle

10

Four Seasons Farms

Ann Blair Endsley 209-599-2234 Fax: 209-599-7548 23073 S. Frederick Rd. Ripon, CA 95366

11.

Design Firm Marcia Herrmann Design

Client Designer Marcia Herrmann

Client Agile Oak Orthopedics Designer Marcia Herrmann

Client Peter Seagle Construction Marcia Herrmann Designer

Client Mambo Designer Marcia Herrmann

Client Capello Winery Designer Marcia Herrmann

Client MDS Architect Designer Marcia Herrmann

Client LJM Design Group Designer Marcia Herrmann

Client Brothers International

Food Corporation Marcia Herrmann Designer

Client Genesis Family Enterprises Inc. Designer Marcia Herrmann

10. Client NRC Inc. Designer Marcia Herrmann

Client Four Seasons Farm Designer Marcia Herrmann

209.522.7811
1016 H STREET
MODESTO, CA 95354
WWW.CLAYTONCOFFEE.COM

REAL PEOPLE REAL COFFEE REAL SIMPLE

2.

P.O. Box 1530 / 820 Arch Way Carnelian Bay, CA 96140 Phone / Fax: 530-581-2046 Cell: 530-330-3082 email: bpodesta@eartlink.net

Marcia Herrmann Design
d
209-521-0388

M

Marcia Herrmann

Marcia Herrmann Design

809 Sylvan Ave., Suite 104

Modesto, Ca 95350

209-521-0388

Fax: 209-521-4748

email: mh@her2man2.com

www.her2man2.com

SAVED BY

The world's natural food preservative

Hirotaka Furukawa, Ph.D.

Meitetsu U.S.A. Inc.

3450 Arden Road Hayward, CA 94545-3906

Toll free: 888-211-7233 (SAFE) Fax #: 510-259-0119 hfurukawa@save-ory.com

NATURAL FOOD

PRESERVATIVE

www.save-ory.com

The Save-ory ... Spectrum:

Natural Thermal stability Prevents food poisoning

Safe Easy to use

Odorless

Water soluble

Effective over a wide pH range

Meitetsu U.S.A. Inc.

Fax #: 510-254-9797 info@save-ory.com

BARBARA GRANT

P.O. Box 3791 TURLOCK, CA 95381

Office/Fax: 209-669-7656 CELL: 209-605-4177 WWW.BUNGALOWBAKING.COM

Helen M. Russell

1-800-552-4424 Ext. 518 415-342-1111 Fax 415-697-6464 882 Mahler Road Burlingame, CA 94010

Crossroads Espresso

We Know Espresso!

The Company With A National Service Network

1-800-552-4424

Design Firm Marcia Herrmann Design

Client Lance Ellis Real Estate & Development

Marcia Herrmann 2. Clayton's Client

Marcia Herrmann Designer 3.

G. Ellis & Co. Marcia Herrmann Designer SF Productions

Client

Client

Marcia Herrmann Designer 5.

Client Marcia Herrmann Design Marcia Herrmann Designer

Save-ory Marcia Herrmann Client Designer

Client Bungalow Baking Co. Designer Marcia Herrmann

Client Crossroads Espresso Designer Marcia Herrmann

The Experienced Source For California Almonds

C.F.O.

13890 Looney Road & Ballico, CA 95303
Tel: 209-874-1875 & Fax: 209-874-1877 & www.hilltopranch.com
Pager: 209-569-1633 & gerrit @ hilltopranch.com

Gerrit N. Dorrepaal

Isabella Piestrzynska 5 Midland Gardens

#2G

Bronxville, NY 10708 (914) 787-8785

fax (914) 793-4422

cell (914) 325-5223

umbrellart@optonline.net

McFarland * State Bank

Banking You Can Believe In

E. David Locke

President

Office: 608.838.3141 Direct: 608.838.7400

Fax: 608.838.8916 5990 Hwy. 51, Box 7

dlocke@msbonline.com

McFarland, WI 53558

SINCE 1904

NTERPRISE ASSOCIATES

Tom Fauré

405 Prides Run, Lake in the Hills, IL 60156 tel 847.658.2485 cell 847.331.5970 fax 847.458.9815

faure@vibrantenterprise.com

Imagination Made

Greg Meir Account Manager

Direct: 608.268.3727 Mobile: 608.444.1362 Email: gmeir@mcd.net

MCD Incorporated, 2547 Progress Road, Madison, WI 53716 800.395.9405 Fax: 608.223.6850 www.mcd.net

Design Firm Marcla Herrmann Design

Design Firm Jeff Silva : make sense(s)

Design Firm Umbrella Graphics

(5-7)
Design Firm Welch Design Group, Inc.

Client

Hilltop Ranch Inc.

Designer

Marcia Herrmann

Client Designer

St. Stanislaus Marcia Herrmann

Jeff Silva

Client Designer

Jeff Silva

Client

Umbrella Graphics Isabella Piestrzynska Designer

Client

McFarland State Bank

Mary Sarnowski, Designers

Nancy Welch

Client

Vibrant Enterprise Associates Designers

Mary Sarnowski, Nancy Welch

Client MCD

Designers Lisa Heitke, Nancy Welch

CRUZAS CUIDADOSAMENTE PLANEADAS PARA PRODUCIR CACHORROS DE SUPERIOR CALIDAD, EXCELENTE TEMPERAMENTO Y CONFORMACION.

VON VELOHAUS
CRIADERO
BOXERO ROTTWEILERO MALINOIS

MANUEL TORAN TORRES
MANEJADOR

ROMA No. 100 COL. LOS ANGELES C.P. 60160 TEL-FAX: (452) 3 57 07 URUAPAN, MICHOACAN, MEXICO E MAIL: cornamen@mail.compusep.com

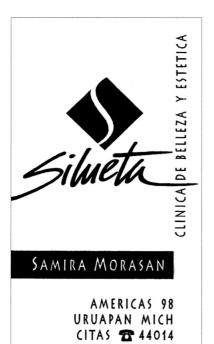

2.

SUSANA ILLSLEY G.

MIGUEL TREVIÑO S/N
TEL: (91 452) 4 14 63
ANTIGUA FABRICA SAN PEDRO
C.P. 60030 URUAPAN, MICH.

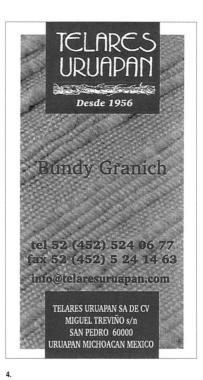

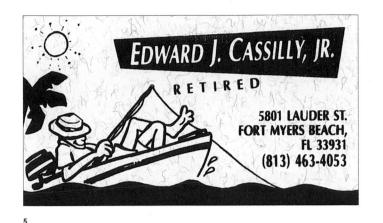

LDG kenneth treviño c.

entronque carr. pátzcuaro 1100 tel: (452) 5 24 25 26, 5 24 17 46 fax: (452) 5 24 69 60 uruapan michoacán méxico udv@ulter.net www.udv.edu.mx

PATRICK STRÜBI MANAGING DIRECTOR

FAIRTRASA MEXICO S.A. DE C.V. FAIR TRADE SOUTH AMERICA

MIGUEL TREVIÑO S/N INT. 7 COL. CENTRÓ C.P. 60070 URUAPAN, MICHOACÁN, MÉXICO
TEL +52 452 523 1017 CEL. +52 452 100 0183 FAX+52 452 524 0677
patrick.struebl@fairtrasa.com www.fairtrasa.com

7.

VICTOR JESÚS OLVERA BRAVO

DISTRIBUIDORA DE PRODUCTOS ALIMENTICIOS

LACTEOS - CARNES SELECTAS

Tel. 01 352 5 26 50 20 Blvd. Lázaro Cárdenas No. 556-3 C.P. 59300 La Piedad Michoacán

8.

TEQUILERA D LOS ALTOS

INDUSTRIAL MULSA SA DE CV

ATENAS # 3-A JARDINES DEL CUPATITZIO CP 60080 URUAPAN, MICH. MEXICO TELS: 01(4)527 12 18, 527 01 40

10070 AGAV

1-9)
Design Firm Kenneth Diseño

1.
Client Von Velohaus
Designer Kenneth Treviño

Client Silueta Designer Kenneth Treviño

Client San Pedro
Designers Kenneth Treviño,
Dolores Arroyo

Client Telares Uruapan Designers Kenneth Treviño, Minerva Galván Client Designer Ed Cassilly Kenneth Treviño

Client Designer Escuela De Diseño Kenneth Treviño

Client Designer Fairtrasa Kenneth Treviño

Client Designer Delicat Kenneth Treviño

Client Designer Tequila Del Los Altos Kenneth Treviño

OTTPOS · FOLLETOS · EMPAQUES · CARICATURAS · BENDS · CARTELES · ANUNCIOS · IDENTIDAD CORPORATIVA · ETI

| (ATURAS · MENUS · CARTELES · ANUNCIOS · IDENTIDAD CORPORATIVA · ETI
| (ATURAS · MENUS · CARTELES · ANUNCIOS · IDENTIDAD CORPORATIVA · ETI
| (ATURAS · MENUS · CARTELES · ANUNCIOS · IDENTIDAD CORPORATIVA · ETIQUETAS · IL USTRACION · MA

| CALIGRAPIA · LOGOTIPOS · FOLLETOS · EMPAQUES · CARICATURAS · MENUS · (AR)
| CALIGRAPIA · LOGOTIPOS · FOLLETOS · EMPAQUES · CARICATURAS · MENUS · CARTELETOS · EMPAQUES · CARTELETOS · CARTELETOS · EMPAQUES · CARTELETOS · EMPACEDOS · CARTELETOS · EMPACEDOS · CARTELETOS · EMPACEDOS · CARTEL

7.

5.

Ing. Gerardo Alfonso Mancera Huante

JALISCO No. 81 COL RAMON FARIAS C.P. 60050 TEL 447-85 FAX 447-90 URUAPAN, MICHOACAN.

Fresh & Spice

tel. **+52 (452) 524 0771**, tel./fax **+52 (452) 523 4588**MANUEL PEREZ CORONADO #5 int. c C.P. 60080 URUAPAN, MICHOACAN, MÉXICO e-mail: fresh&spice@hotmail.com

6.

ARTICULOS Y ACCESORIOS PARA BEBE

Karla Beltrán de Demerutis

BLVD. GARCIA DE LEON 1785 B
CHAPULTEPEC ORIENTE
CP 58280 MORELIA MICHOACAN

FABRICA DE SAN PEDRO
MIGUEL TREVIÑO S/N
CP 60000 URUAPAN MICH.

EMAIL
kenneth@mail.compusep.com
TEL Y FAX (452) 3 1738

(1-8)
Design Firm Kenneth Diseño

1.
Client Kenneth Diseño
Designers Kenneth Treviño,
Minerva Galván

Client Orapondiro
 Designer Kenneth Treviño
 3.

Client La Bodega Designers Minerva Galván, Kenneth Treviño

Client Global Frut
Designer Kenneth Treviño
5.

Client Hernandez Designer Kenneth Treviño Client Designer Fresh & Spice Kenneth Treviño

Client Designer

Kenneth Diseño Kenneth Treviño

Client Designer La Casa Del Bebe Kenneth Treviño

2.

Director, Mary Kuntz, Ph.D.
tel: 334.844.6363
email: kuntzme@auburn.edu

the
Quilts of Gee's Bend
in context

GG

6030 Haley Center Auburn University, AL 36849

4

RANDI WOLF GRAPHIC DESIGNER WWW.RANDIWOLFDESIGN.COM RANDESIGN@ERW-GROUP.COM 18 CYPRESS COURT . GLASSBORO, NJ 08028 PHONE 856 582 8181 . FAX 856 582 8187

7.

Art Levy words sideas 405 Lakeside Road Wynnewood, PA 19096 TEL: 215-658-0250 FAX: 215-658-0251

Design Firm Kenneth Diseño Client Quilts of Gee's Bend in context Kelly Bryant Designer Design Firm Kelly Bryant Design Allan J. Rickmeier Client Design Firm incitrio design {brand} media Natasha Krochina Designer (6,7)
Design Firm **Triple** 'B' Ranch Design Triple 'B' Ranch Design Client (8-10)

Design Firm Randi Wolf Design Dosigner Barry Power Client Jeff Lee Designers Jeff Lee. Client Kenneth Diseño Barry Power Designer Kenneth Treviño Client Old Market Street Client 4 x 4 Randi Wolf Designer Designers Kenneth Treviño, Client Randi Wolf Design Minerva Galván Designer Randi Wolf Client Dennis Treviño Designer Kenneth Treviño Client Words & Ideas Designer Randi Wolf

2.

3.

0 2200 Norcross Pkwy Suite 200 Norcross, GA 30071 0 Bus: (770) 446-2822 ext. 222 Fax: (678) 868-1043 Mitchell Furbush Cell: (770) 329-4083 Managing Principle mfurbush@depsol.com

JENNIFER RISPO-MAGUIRE Business Manager, Site Supervisor

Philadelphia, PA 19114 215-673-1500 215-673-6660 (fax)

6409 Rising Sun Ave. Philadelphia, PA 19111 215-725-9700 215-725-4973 (fax)

6.

EYE-

MARK FIELDS DIRECTOR (856) 256-4548 fields@rowan.edu

ROWAN UNIVERSITY GLASSBORO, NJ 08028 Fax: (856) 256-4919 www.rowan.edu/centerarts Liz Shapiro 🚛 Legal Search

226 W. Rittenhouse Square · Suite 613 · Philadelphia, Pennsylvania 19103 Telephone 215-546-3646 • Facsimile 215-546-3645 LShapiro@LizShapiroLegalSearch.com • www.LizShapiroLegalSearch.com

Nationwide Permanent Attorney Placements

9 North Preston St. • Philadanco Way • Philadelphia, PA 19104-2210 Phone 215-387-8200 • Fax 215-387-8203

Joan Myers Brown, D.F.A. **Executive/Artistic Director**

135 SOUTH 18TH STREET PHILADELPHIA PENNSYLVANIA 19103 TELEPHONE 215 569-8587 FAX 215 569-9497

ANTHONY P. CHECCHIA. Music Director

PHILADBLPHIA CHAMBER MUSIC SOCIETY

10.

Cheryl Ping Typist

1687 Briarcliff Rd. NE Apartment 5 Atlanta, GA. 30306 (404) 876-1910

Client Garden Court Physical Therapy Designer Randi Wolf 2. Client Aquatic Therapy International Designer Randi Wolf 3. Client Babbling Brook Designer Randi Wolf 4. Client Children's Miracle Network of Greater Philadelphia Randi Wolf Designer

Design Firm Randi Wolf Design

Client Deployment Solutions, Inc. Randi Wolf Designer

Client Keystone Eye Associates Designer Randi Wolf Client Glassboro Center for the Arts Designer Randi Wolf Client Liz Shapiro Legal Search Designer Randi Wolf 9. Client Philadanco (The Philadelphia Dance Company) Designer Randi Wolf 10. Philadelphia Chamber Client Music Society Designer Randi Wolf 11.

..Ping!

Randi Wolf

Client

Designer

2.

Marc S. Cohen, MD Nancy G. Swartz, MS, MD

Philadelphia • Bala Cynwyd • Voorhees • Northfield ph: (888) 478-3535 fax: (856) 772-1946 www.cosmetic-eyes.com

3.

Wills Eye Hospital 840 Walnut St. Philadelphia, PA 19107 215.772.0900

40 Monument Road, Fifth Floor Bala Cynwyd, PA 19004 610.660.0662

The Pavilions of Voorhees 2301 Evesham Road, Suite 101 Voorhees, NJ 08043 856.772.2552

> 1500 Tilton Road Northfield, NJ 08225 609.646.5200

- Residential, Commercial & Industrial
- Free Estimates
- Licensed & Insured
- All Work Guaranteed
- Interior Decorating Service Available
- Major Credit Cards Accepted
- Wholesale Discounts on Wallcoverings
- Specializing in all types of wallpaper installation and wall preparation techniques
- Ceiling options Paper, Paint, or Sprayed-Textured

(215) 467-8249

7.

b@dinger group

internet and e-business solutions

president: **Mikel Bedinger** address: 1071 Sixth Ave., Suite 261, San Diego, CA 92101 phone: 619-233-7550 fax: 619-233-7531

e-mail: mikel@bedinger.com internet: www.bedinger.com

4.

Design Firm Randi Wolf Design (6-8)

Design Firm Jensen Design Associates, Inc.

Client

SilverSun, Incorporated Randi Wolf

Designer

Terri Masters, Massage Therapy Client

Designer Randi Wolf

Ophthalmic Plastic and Client Cosmetic Surgery

Designer Randi Wolf

Client Dermedics Designer Randi Wolf Client

8.

Designer

Tri-State Wallcoverings Randi Wolf

Client Designer

Stranded in Paradise David Jensen

Client

Kusar Court Reporters David Jensen

Designer

Client Bedinger Group

Designer

David Jensen

p_jensen@jensendesign.com www.jensendesign.com

Aline Hilford a line@alexander is ley.comt:(203) 544-9692 ext. 15

Alexander Isley Inc. DESIGNERS

9 Brookside Place $Redding,\,CT\,06896$

www.alexander is ley.com

BlueBolt Networks Inc. 3710 University Drive Suite 160 Durham, NC 27707 p (919) 865-2600

f (919) 865-2601

www.bluebolt.com info@bluebolt.com

3.

DAN BARBER
Creative Director
TEL: 914 366 6200
FAX: 914 366 7905
danb@stonebarnscenter.org
www.stonebarnscenter.org

STONE BARNS CENTER FOR FOOD & AGRICULTURE

630 Bedford Road Pocantico Hills, New York 10591

DAN BARBER

TEL: 914 366 6200 FAX: 914 366 7905 danb@stonebarnscenter.org www.stonebarnscenter.org

STONE BARNS CENTER FOR FOOD & AGRICULTURE

630 BEDFORD ROAD POCANTICO HILLS, NEW YORK 10591

DAN BARBER

TFL: 914 366 6200 FAX: 914 366 7905 danb@stonebarnscenter.org www.stonebarnscenter.org

STONE BARNS CENTER
FOR FOOD & AGRICULTURE

630 Bedford Road Pocantico Hills, New York 10591

DAN BARBER Creative Director

TEL: 914 366 6200 FAX: 914 366 7905 Uaiib@stonebarnscenter.org www.stonebarnscenter.org

STONE BARNS CENTER FOR FOOD & AGRICULTURE

630 BEDFORD ROAD
POCANTICO HILLS, NEW YORK 10591

DAVID BARBER

TEL: 914 366 6200 FAX: 914 366 7905 davidb@stonebarnscenter.org www.stonebarnscenter.org

STONE BARNS CENTER FOR FOOD & AGRICULTURE

630 Bedford Road Pocantico Hills, New York 10591 (1)
Design Firm Jensen Design Associates, Inc.
(2-4)
Design Firm Alexander Isley Inc.

Client Designers

Jensen Design Associates, Inc. David Jensen, Alyssa Igawa

2. Client

Client Alexander Isley Inc.
Designers Alexander Isley,
Cherith Victorino

3. Client Designers BlueBolt Networks Alexander Isley, Liesl Kaplan

4.

Client Stone Barns Center for Food & Agriculture

Designers Randi Wolf, Alexander Isley, Tara Benyei

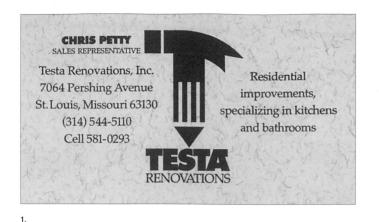

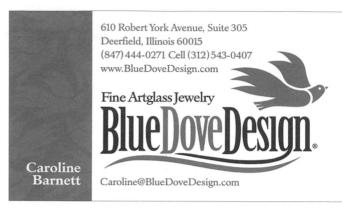

2.

Devilish Good Advertising & Design

Mike Whitney

7912 Bonhomme Avenue

Suite 207

St. Louis, Missouri 63105

(314) 862-5226

Fax (314) 862-5227

E-mail mike@whitneystinger.com

www.whitneystinger.com

96 Executive Avenue Edison, NJ 08817 (732) 650-9905 Ext 115 Fax (732) 650-9909

BRIAN DENMAN

Controller

bdenman@hersheyimport.com

3.

Whitney Design Works, LLC 7066 Pershing Avenue Suite 300
St. Louis, Missouri 63130
Phone (314) 862-5994
Fax (314) 862-5318
www.whitneydesignworks.com

Design Morks

Advertising & Graphic Design

Shropshire Educational Consulting, LLC

30791/2 Royster Road Lexington, Kentucky 40516 (859) 396-9508

Jane Schoenfeld Shropshire
JShrop@att.net

OsmoTech

17295 Chesterfield Airport Road Suite 200

Chesterfield, Missouri 63005

Toll Free 1 (866) GO-4-OSMO Phone (636) 733-7570 Fax (636) 733-7571

www.GoOsmo.com

Paul Femmer

Vice President, Sales pfemmer@GoOsmo.com

FROM DRYTRONIC, INC.

Mike Whitney

7833 Kenridge Lane

St. Louis, Mo. 63119

314,968,1255

Advertising

Design

Sales Promotion

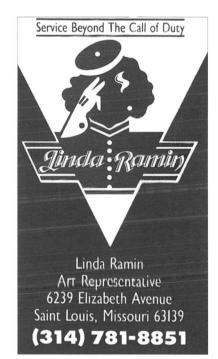

9.

Quantum Léaps, No Bounds. 917 Locust Street, 9th Floor St. Louis, Missouri 63101 (314) 436 9050 • Fax (314) 436-9053 Cell (314) 503-9050

E-mail doug@littlefieldunlimited.com

www.littlefieldunlimited.com

Douglas A. Littlefield

Design Firm Whitney Design Works, LLC (3,4,10) Design Firm Whitney Stinger

Design Firm Whitney Design Works & Explore Marketing

Client Designer

Testa Renovations, Inc. Mike Whitney

Client Designer

Blue Dove Design Mike Whitney

Client Designers

Whitney Stinger, Inc. Mike Whitney, Karl Stinger

Client Hershey Imports Mike Whitney, Designers Karl Stinger Client

Whitney Design Works, LLC Mike Whitney Designer

Client Shropshire Educational Consulting Mike Whitney Designer

Client Osmotech Mike Whitney Designer

Mike Whitney Client Mike Whitney Designer

Linda Ramin, Client Art Representative Designer Mike Whitney 10.

Client Littlefield Unlimited Mike Whitney, Designers Karl Stinger

1056 WEST STREET, LAUREL, MD 20707 TEL 301-776-2812 • FAX 301-953-1196

dever designs

JEFFREY L. DEVER
PRESIDENT-CREATIVE DIRECTOR

1056 WEST STREET, LAUREL, MD 20707 TEL 301-776-2812 • FAX 301-953-1196

the point
where art
and
communication
meet

dever designs

JEFFREY L. DEVER
PRESIDENT-CREATIVE DIRECTOR

david brillhart producer/director

9 2 0 0 R T. 1 0 8, S U I T E 2 0 9 | T 410-730-5994 C O L U M B I A, M D 2 1 0 4 5 | F 410-730-7496

2.

DENNIS
CREWS
PHOTOGRAPHY

809-C
E. South
Street,
Frederick,
Maryland
21701

We see more...

CROSSROADS RECORDS INC.
6 9 0 3 B R O O K S R O A D
H I G H L A N D, M D 2 0 7 7 7
P H O N E 3 0 1 - 8 5 4 - 0 8 2 9

Jerry RaderDirector of Marketing
Phone 301-964-5755

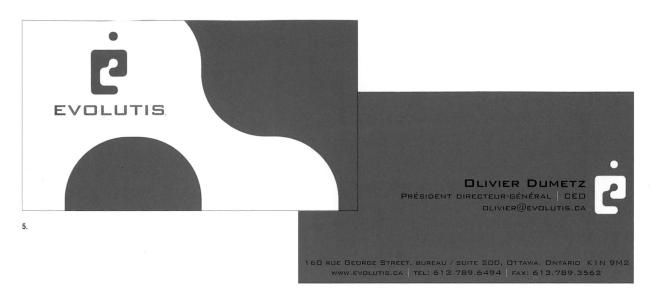

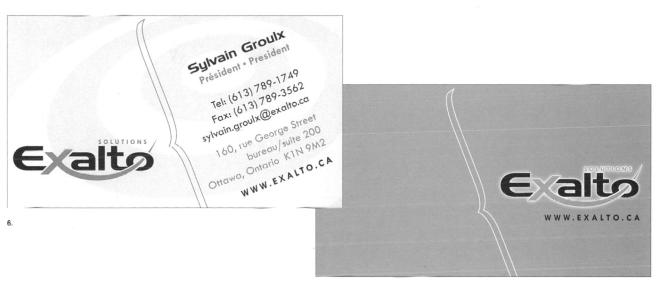

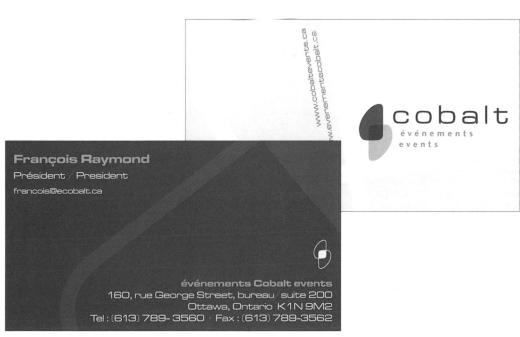

Design Firm Dever Designs Design Firm NBA Communications Client Dever Designs Designer Jeffrey Dever Client Brillhart Media Designer Jeffrey Dever 3. Client Dennis Crews Photography Designer Jeffrey Dever 4. Client Crossroads Records, Inc. Designer Jeffrey Dever 5. Client Evolutis Designer NBA Communications 6. Client Exalto Solutions Designer NBA Communications 7. Client Événements Cobalt Events Designer NBA Communications

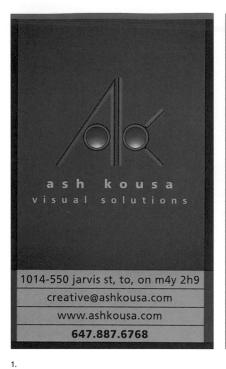

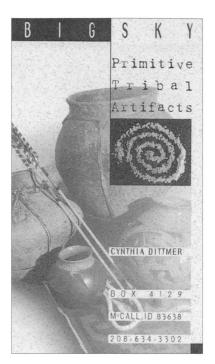

2.

MICHAEL W. CROW CHAIRMAN

MARQUEE MUSIC, INC.

A SUBSIDIARY OF SPENCER ENTERTAINMENT, INC.

9701 WILSHIRE BOULEVARD, SUITE 1200, BEVERLY HILLS, CA 90212 TEL (310) 786-8877 FAX (310) 786-1701

DIRECTIONS

From New York State and Northern or Southern New Jersey via Garden State Parkway North or South

- Garden State Parkway North or South to Exit 145
- Follow signs for I-280 West
- Take Exit 10 off 280 West
- At the end of exit ramp, turn Left at the light onto Northfield Ave.
- After the 6th light, make a Right onto Rock Spring Ave.
- Follow to entrance 50 yards on Right

From Western New Jersey via I-280 East

- 280 East to Exit 7 (Pleasant Valley Way)
- At end of exit ramp, turn Left at the traffic light onto Pleasant Valley Way
- Follow Pleasant Valley Way to 2nd traffic light and make Left onto Northfield Ave./County 508 West
- After the 3rd traffic light, make a Left onto Rock Spring Ave. (just before Ekko)
- Follow to entrance 50 yards on Right

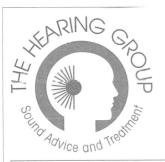

Robbi Hershon, Au.D., CCC-A

Doctor of Audiology

Tel 973.243.8860 • Fax 973.243.8863

412 Pleasant Valley Way, West Orange, NJ 07052

www.thehearinggroupusa.com

Stephen Longo

Package Design, Graphic Design, Marketing & Corporate Identity

8 Colony Drive East, West Orange, NJ 07052 973.868.0343

8.

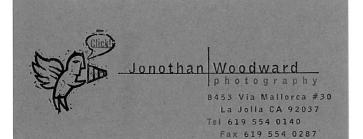

Design Firm Ash Kousa Visual Solutions
(2.3)
Design Firm Redpoint design
(4-8)
Design Firm Stephen Longo
Design Associates
(9)
Design Firm Visual Asylum

1.
Client Ash Kousa Visual Solutions

Designer Ash Kousa
2.

Client Big Sky Artifacts
Designer Clark Most
3.

Client Redpoint design
Designer Clark Most

Client The Township of West Orange Designer Stephen Longo Ekko Restaurant Client Designer Stephen Longo Client The Hearing Group Designer Stephen Longo Client Stephen Longo Designer Stephen Longo 9. Client Jonothan Woodward Designer Joel Sotelo

Marquee Music, Inc.

Stephen Longo

Client

Designer

stephen Longt

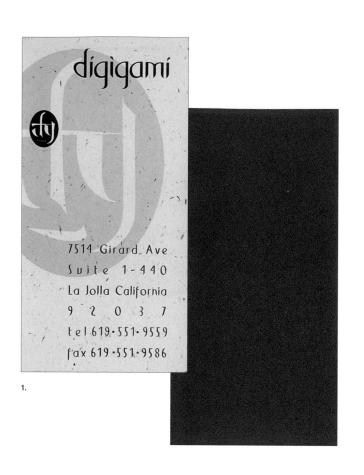

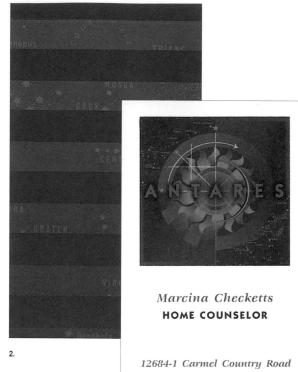

SAN DIEGO CALIFORNIA 92130 tel 619.350.9951 FAX 619.350.9197

GWYN DAVIESSenior Quality Assurance Engineer

gdavies@kinzan.com

2111 Palomar Airport Road Suite 250 Carlsbad CA 92009 † 760.602.1168 # 760.602.2910 www.kinzan.com

KINZAN

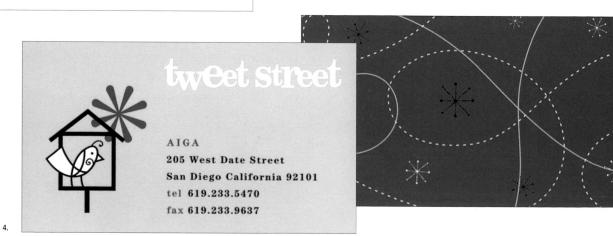

MAELIN LEVINE

partner/designer maelinl@visualasylum.com

205 WEST DATE SAN DIEGO CA 92101 T 619.233.9633 F 619.233.9637 VISUALASYLUM.COM

SAN DIEGO CITY COLLEGE GRAPHIC DESIGN 1313 PARK BOULEVARD SAN DIEGO CA 9 2 1 0 1 TEL (619) 3 8 8 - 3 9 3 3 FAX (619) 3 8 8 - 3 5 2 2

ADJUNCT FACULTY

www.sdccgraphicdesign.com

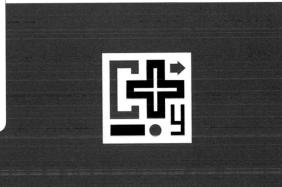

THERESA R. KOSEN

executive director

p.o. box 3836 san diego california 92163 T/F 619.276.0101 sandiegomuseumcouncil.org tkosen@san.rr.com

SAN DIEGO MUSEUM COUNCIL

(1-7)
Design Firm Visual Asylum

Client digigami
Designer Joel Sotelo
2.

Client Antares
Designer Joel Sotelo
3.

Client Kinzan
Designer Joel Sotelo

Client AIGA Tweet Street
Designer Joel Sotelo

Client Visual Asylum
Designer Joel Sotelo

6.

Client San Diego City College Graphic Design

Designer Joel Sotelo
7.
Client San Diego Museum Council

Designer Min Choi

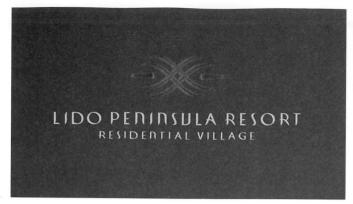

Sherry Coshow

LIDO RESORT HOMES

One Anchorage Way, Newport Beach, CA 92663

TEL 714.673.6623 FAX 714.673.7846

ALIFORNIA 92688 AX 714 459-0440

714 459-0707

3

GALEN R. JOHNSON, PE

VICE PRESIDENT

PO BOX 70507

FAIRBANKS ALASKA 99707

T 907.452.5191 F 907.451.7797

E GALEN@GHEMM.COM

CHITA TUERES

Chief Chemist Film Laboratory Services

835 N SEWARD STREET HOLLYWOOD CA 90038 PHONE 213.462.6266 x4320 FACSIMILE 213.466.5047

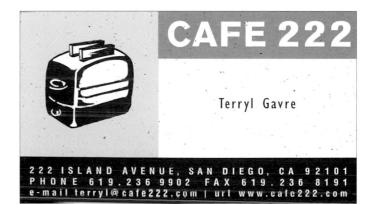

6.

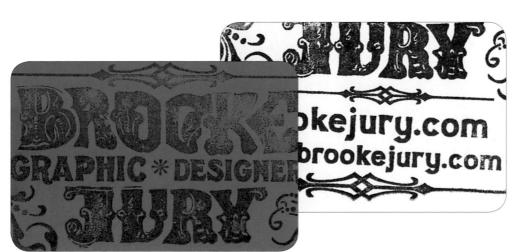

1-6)
Design Firm Visual Asylum

Design Firm www.brookejury.com

Client Lido Peninsula Resort Designer Amy Levine
2.

Client Los Abanicos CourtHome Collection Designer Amy Levine

Client You Lucky Dog Designer Joel Sotelo

Client Ghemm
Designer Joel Sotelo

Client LaserPacific
Media Corporation
Designer Amy Gingery

6.
Client Cafe 222
Designer MaeLin Levine

Client Brooke Jury Graphic Design Designer Brooke Jury

7.

p 310.823.8742 f 310.823.8743

Opening Doors to Big Ideas!"

Lisa Strick Chief Idea Officer

Lisa@IdeaBungalow.com 4712 Admiralty Way #609 • Marina Del Rey, CA 90292

1.

2.

Branding

Brainstorming Market Research Product Innovation Marketing Strategy

FunVentions™

Leslie Lanahan

Board of Directors

Post Office Box 191889 Dallas Texas 75219 TEL 214 821 3112 FAX 214 821 2997 Ilanahan@gordie.org www.gordie.org

Promoting Alcohol Awareness and Educ

GORDIECHECK

Alcohol Poisoning can have any of these six symptoms.

Not sure? Get help.

Alcohol can kill.

Confusion

Passing Out

Vomiting

Vomiting

Seizures

Jennifer Sailer

Creative Director

jsailer@evokeideagroup.com

902 South Randall Road Suite 336C St. Charles, IL 60174

P 630.879.3846 P 866.842.7424 F 630.761.9407

www.evokeideagroup.com

advertising and marketing with the power to persuade

JOE CAMPAGNA

1820 TOWER DRIVE | GLENVIEW, IL 60025

MAIN 847-729-WINE FAX 847-729-9465

4.

JOE@FLIGHTWINEBAR.COM FLIGHTWINEBAR.COM

FOOD WINE HEIGHTS

YUNG LUU (443) 465-2495 yungbeauty04@yahoo.com

www.geocities.com/yungbeauty04 MARYLAND * DC * NORTHERN VA

MAKE-UP ARTIST

LOOK...

FEEL...

BE...

YUNG

- Design Firm Otis Design Group
- Design Firm DesignKarma Inc.
- (3) Design Firm Jowaisas Design
- Design Firm Evoke Idea Group, Inc.
- Design Firm ZGraphics, Ltd. (6)
- Design Firm Trang Dam
- Client Designer

The Idea Bungalow Jessica Raddatz

2 Client Designers

Design Karma Inc. Vitaliy Yasch, Timofei Youriev

- Client Designer

The Gordie Foundation Elizabeth Jowaisas

Client Designers

Fvoke Idea Group, Inc. Jennifer Sailer, Jill Roberts

Client Flight Wine Bar Designers

Joe Zeller, Kris Martinez Farrell

Client Designer Yung Luu Trang Dam

mobile spray tan located centrally within the Limestone Coast and servicing the entire region

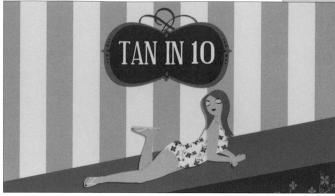

Lucille André 0408 816 312

tanin10.com.au | www.tanin10.com.au

Holly M.O'Neill President

620 Newport Center Drive Suite 1100 Newport Beach, CA 92660 (949) 721-4160 tel (949) 209-4946 fax Holly@TalkingBusiness.net

www.TalkingBusiness.net

DAVID M. HAHN

GRAPHIC DESIGNER CORPORATE SERVICES

4111 East 37th Street North Wichita, Kansas 67220 TEL 316+828.7677 FAX 316+828.5778 DELL 316+214.8954

DAVID.HAHN@KBSLP.COM

4.

GABRIEL R. PALAZZI

MANAGING DIRECTOR/TECHNICAL SERVICES

2000 TOWN CENTER - SUITE 2110 SOUTHFIELD MI 48075 PHONE 248 352 5600 FAX 248 352 5671 CELL 248 302 7026 GPALAZZI@VERITAS-GLOBAL.COM

DETROIT | LONDON | NEW YORK | WASHINGTON

Danya Gerstein

Associate Manager of Sales

The Shops at Columbus Circle Ten Columbus Circle · New York · NY · 10019 tel 212 823 9511 · fax 212 823 9512 · cel 917 297 2482 dgerstein@lockesdiamonds.com www.lockesdiamonds.com

Design Firm E-lift Media TM

Design Firm CDI Studios

Design Firm Talking Business

Design Firm KOCH BUSINESS SOLUTIONS (5,6)

Design Firm sterling group

Client Tan In 10 Designer Simone Burdon Client

Designers Michelle Georgilas, Victoria Hart

Client Talking Business Designers Holly M. O'Neill (Talking Business),

Suzanne Issa (Issa Marketing & Designs)

KOCH BUSINESS SOLUTIONS Client

Designer David M. Hahn Client Veritas

Marcus Hewitt Designers

Client Lockes Diamantaires Kim Berlin Designer

1.

Samantha Guerry

President & CEO

3050 K Street, NW, Suite 400 Washington, DC 20007

PHONE 202.342.8415
FAX 202.342.8546
samantha@sightlinemarketing.com

www.SightlineMarketing.com

integrated marketing $\,\cdot\,\,$ brand development $\,\cdot\,\,$ advertising $\,\cdot\,\,$ communications

Renny Ponvert

President

7272 Wisconsin Avenue, Suite 3 Bethesda, MD 20816 PHONE 301.455.5886 FAX 301.656.0183

rponvert@coredatagroup.com

2.

David Brotherton President

Brotherton Strategies, Inc. 933 11th Avenue East – Suite E Seattle, WA 98102

206.324.0403 office 206.954.8672 mobile

www.brothertonstrategies.com

david@brothertonstrategies.com

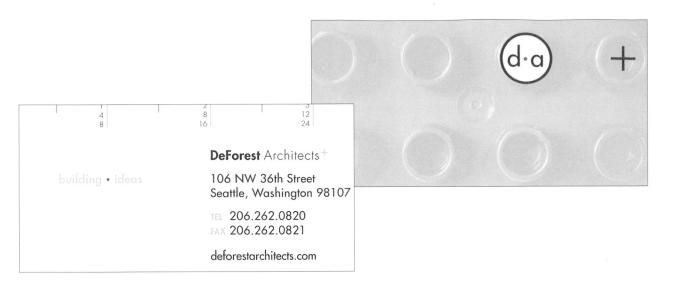

tim@bearcreekweb.com

206.779.2021 telephone 425.226.5434 facsimile

PO Box 1428

Woodinville, WA 98072

bearcreekweb.com

Design Firm Sightline Marketing

Design Firm Pernsteiner Creative Group, Inc.

Design Firm CDI Studios

(3-5)
Design Firm Monster Design

Andrew Perns Owner

Just off I-94 and Hwy 10 next to the Red Carpet Inn 12830 Cox Lane P.O. Box 38 Osseo, WI 54758

Phone (715) 441-9298

Sightline Marketing Client Designer Clay Marshall Client CoreData Clay Marshall Designer

Client Designer Brotherton Strategies Theresa Monica

Client

DeForest Architects Hannah Wygal Designer

Client Designer

Bear Creek Web Theresa Monica

Crossroads Bar & Grill Todd Pernsteiner Client Designer

Marathon Office-Corporate, Weston & Merrill Offices www.countymaterials.com

205 North St., P.O. Box 100 Marathon, WI 54448-0100 tel (715) 848-1365 toll free (800) 289-2569 fax (715) 443-3691 Rdy Mix Disp. (715) 848-1365

9303 Schofield Ave. Weston, WI 54476 tel (715) 359-7731 fax (715) 355-5752

496 Brandenburg Ave. Merrill, WI 54452

Todd Pernsteiner CREATIVE DIRECTOR

7831 East Bush Lake Rd., Suite 100 > Bloomington, MN 55439 email: info@pernsteiner.com > www.pernsteiner.com tel [952] 841-1111 > fax [952] 841-3460

2.

INNOVATIVE MARKETING COMMUNICATIONS THAT DEMAND ATTENTION.

Identity systems > Brand management > Direct mail Campaign development > Graphic design > Copywriting Publications > Exhibit design > Advertising

Stacey Nunn

Customer Account Manager

3400 188th St. SW, Ste 185, Lynnwood WA 98037 800 729.4767 • 425 672.1304 • 425 672.0192 FAX staceyn@aproposretail.com

Kathleen Dudley

3203 13¹¹ Avenue West Seattle, Washington 98119 206 285 7918

Bill Zuydhoek
INTERNATIONAL SALES MANAGER

425 201 6012 D 425 644 6000 T 425 644 8222 F

15015 Main Street Suite 200 Bellevue, WA 98007

BILL@ULIKABAC.COM

5.

Kim Falcon kim@graphicasolutions.com	Principal
	611 Eastlake Ave E Seattle, WA 98109 206 652 9646 206 652 9654 F
graphica	graphicasolutions.com

Design Firm Pernsteiner Creative Group, Inc. (3-6)
Design Firm Graphica County Materials Corporation Andy Hauck, Todd Pernsteiner Client Designers Client Pernsteiner Creative Group, Inc. Todd Pernsteiner, Designers Kären Larson Apropos Retail Christa Fleming Client Designer Fine Feline Photography Craig Terrones Client Designer Client Ultrabac Robin Walker Designer Graphica Client

Craig Terrones

Designer

Building a world-class foster care system while serving our neighborhood youth

Jim Theofelis
Executive Director jim@mockingbirdsociety.org
mockingbirdsociety.org
2100 24th Avenue S, Suite 350
Seattle, Washington 98144
206 323-KIDS (5437)
206 323-1003 fax

The Mockingbird Society

Margaret Morris
Office Manager
margaretm@sizeti.com
Size Technologies, Inc.
465 10th Street

Size rechnologies, Inc.
465 10th Street
Suite 101
San Francisco, CA 94103
t: 415.701.0000 x 115
f: 415.701.0293
www.sizeti.com

3.

Captive Wild Animal Protection Coalition P.O. Box 6944 San Carlos, CA 94070 p:650.595.4692 f:650.595.4690 www.cwapc.org

Phone 650-821-6000 • Fax 650-821-6005

San Francisco International Airport, Boarding Area G · San Francisco, CA 94128
Mailing Address · P.O. Box 280417 · San Francisco, CA 94128-0417

5.

4

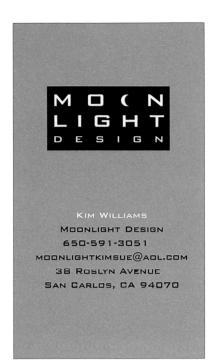

Leena Partner

Hair Loft 1870 South Norfolk Street San Mateo, CA 94403 650.574.0801

7

CIAO BAMBINO!

AMIE D'SHAUGHNESSY
FOUNDER
927 SUNNYHILIS RÖAU
OAKLAND, CA 94610
510.763.8484 / 866.802.0300
AMIE@CIAOBAMBINO.COM
WWW.GIAOBAMBINO.COM

We are focused We are bright We are interactive

Appareo

Louis Stone-Collonge louis@appareointeractive.com 1484 Pollard Rd., Suite 356 Los Gatos, CA 95032 t: 408.348.4026 f: 408.374.9712 www.appareointeractive.com

Design Firm Graphica (3-9) Design Firm Look Client Patrick Barta Photography Designer Christa Fleming Client Mockingbird Society Robin Walker Designer Client Size Client CWAPC Client Deli Up Client Moonlight Design Client Hair Loft Client Ciao Bambino! Client Appareo

Kurt T. Miyatake

Vice President Worldwide Sales and Marketing

1425 Koll Circle, Suite 106 San Jose, CA 95112 phone (408) 487-9250 direct (408) 487-9251 fax (408) 487-9260 e-mail: Kurt.Miyatake@flex-p.com

www.flex-p.com

1

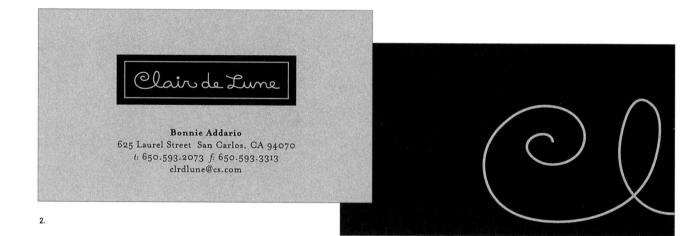

Marcie Adary

Jewelry Designs

3.

Marcie Adary
Marcie Adary Jewelry Designs
p: 650-346-4822
jewelsbymarcie@aol.com
www.jewelsbymarcie.com
500 St. Thomas Lane
Foster City, CA 94404

Al Helmersen

MANAGER

PROJECT DEVELOPMENT AND IMPLEMENTATION

Mail - PO Box 8248 Victoria BC V8W 3R9 Courier - 3rd Flr. 808 Douglas St. Victoria BC V8W 2Z7 Phone 250-356-1675 Fax 250-953-5162

Al.helmersen@gems2.gov.bc.ca www.iafbc.ca

Foundation of British Columbia

DEBORAH HARMACY

DIRECTOR SALES AND MARKETING

655 DOUGLAS ST VICTORIA BC CANADA V8V 2P9

TEL 250-386-1312 EXT.1153 FAX 250-386-0687 DEBORAHH@QVHOTEL.COM

Carolyn Yeager

Senior Manager - Sales & Marketing

Cell: 250 812-3611 cyeager@grantthornton.ca

3rd Floor 888 Fort Street Victoria BC V8W 1H8 Tel: 250 383-4191 Fax: 250 383-4142 www.landings.ca

Landings is operated by GT Hiring Solutions a wholly-owned subsidiary of Grant Thornton LLP

7.

DR RICHARD A SKINNER PRESIDENT AND VICE-CHANCELLOR

2005 Sooke Road Victoria BC Canada V9B 5Y2 Telephone 250-391-2517 Fax 250-391-2538 richard.skinner@royalroads.ca www.royalroads.ca

Design Firm Look Design Firm Trapeze Communications Inc. Client Flex-p

Client Clair de Lune Client Marcie Adary

Client Investment Agriculture Foundation of British Columbia Designer Marianne Unger

5. Client QV Hotel & Suites Designer Joe Hedges

6. Client Landings Designer Joe Hedges

Client Royal Roads University Designer Joe Hedges

TRapeze

Mark Bawden

Trapeze Communications Incorporated 301-852 Fort Street Victoria BC V8W 1H8

Telephone 250-380-0501 Fax 250-382-0501 Email mark@trapeze.ca www.trapeze.ca

Stop.

238 Wellington Street Toronto Ontario M5V 3T5
Telephone 416-596-7723 Fax 416-596-8185

stop.

2.

#103 ~ 561 Johnson Street Victoria, BC V8W 1M2 (Across from Market Square)

250-382-WINK (9465)

Aveda Concept Salon

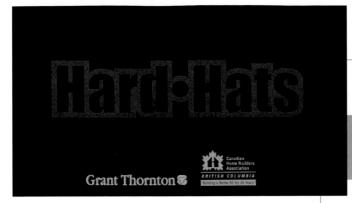

Kim Osborne

Assistant Manager - Lower Mainland

Training & Employment for the Construction Industry

100 535 Thurlow Street Vancouver BC V6E 3L2 Toll Free (888) 430-9911 Tel (604) 893-8566 Fax (604) 893-8833 Cell (604) 782-1995 k.osborne@destinations.ca www.hardhats.ca

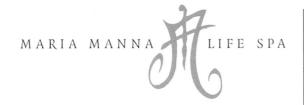

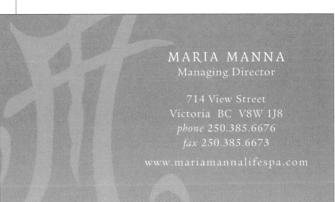

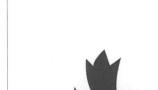

MAPLE LEAF **GIFT STORES**

702 Douglas ST VICTORIA BC V8W 3M6 TEL 250-383-8186 FAX 250-384-9416

www.mapleleafgifts.ca

PROVINCIAL CAPITAL COMMISSION

613 Pandora Ave Victoria, BC V8W 1N8 Tel 250.953.8801 Fax 250.386.1303 Cel 250.514.7258

hnewbury@bcpcc.com www.bcpcc.com

Heather Newbury EXECUTIVE ASSISTANT

Design Firm Trapeze Communications Inc.

Client Designer

Trapeze Communications Inc. Mark Bawden

Client Stop. International for Spa

Mark Bawden, Designers Marianne Unger

Client

Wink Marianne Unger, Designers Joe Hedges

Client

Hard Hats Neil Tran Designer

Client

Maria Manna Life Spa

Neil Tran Designer

Client

Maple Leaf Gift Stores

Designer Joe Hedges

Client

Provincial Capital Commission Joe Hedges

Designer

Su Everts

Solution Centre Agent

GT Hiring Solutions Inc.

764 Fort Street Victoria, BC V8W 1H2

Tel: 1-866-388-4323 or 250-388-0858 Fax: 1-866-388-0814 or 250-388-0814 s.everts@gthiringsolutions.ca

A wholly-owned subsidiary of Grant Thornton LLP

1.

Richard Bassett

Chairman

Cell: (604) 505-8870

rbassett@lonestarnuclear.com

1330 Post Oak Boulevard Suite 1600

Tel: (713) 963-3643

www.lonestarnuclear.com

2 2 C

TWENTY TWO C PARTNERS INC

JOHN O'CONNOR
PARTNER

DIRECT TEL: 416-491-3120 DIRECT FAX: 416-491-8692

CELL: 416-258-2032

E-MAIL: johno@22cpartners.com

TORONTO

THE EXCHANGE TOWER

130 KING STREET WEST PO Box 427

M5X 1E3

TEL 416-410-6380 FAX 416-410-3822 VANCOUVER

SUITE 2300

1066 WEST HASTINGS ST VANCOUVER BC CANADA

V 6 E 3 X Z

TEL 604-681-0990

www.22cpartners.com

3.

CONNECTING PEOPLE WHO CARE WITH CAUSES THAT MATTER

Sandra Richardson Executive Director / CEO

418-645 Fort Street Victoria BC V8W 1G2 Phone [250] 381-5532 Fax [250] 480-1129

www.victoriafoundation.bc.ca sandra@victoriafoundation.bc.ca VICTORIA
CONFERENCE
CENTRE

720 Douglas Street
Victoria BC
Canada V8W 3M7

Phone 250-361-1000
Fax 250-361-1099
Toll Free 1-866-572-1151
www.victoriaconference.com

3

VICTORIA CONFERENCE CENTRE

Lorraine Brewster

Senior Account Executive

Direct Line 250-361-1015
Iorrainebr@victoriaconference.com

brohard design

16045 jonella farm drive purcellville, va 20132

bill brohard

6.

Designer Joe Hedges Client Lone Star Nuclear Designers Joe Hedges Client Twenty Two C Partners Inc. Designer Joe Hedges Client Victoria Foundation Designer Joe Hedges Client Victoria Conference Centre Designers Mark Bawden, Joe Hedges

Design Firm **Trapeze Communications Inc.**7)

Design Firm **Brohard Design Inc.**

GT Hiring Solutions

Client

6.

Client Brohard Design Inc.
Designer William Brohard
7.
Client STAR Products

Designers Michael Drake, William Brohard

one day - one voice - one purpose

 Janna L. Bowman International Director

> T 866.776.6573 T 540.338.1694

F 540.338.1695

E janna@orphansunday.org

PO Box 20263 • Washington, D.C. 20041 • www.orphansunday.org

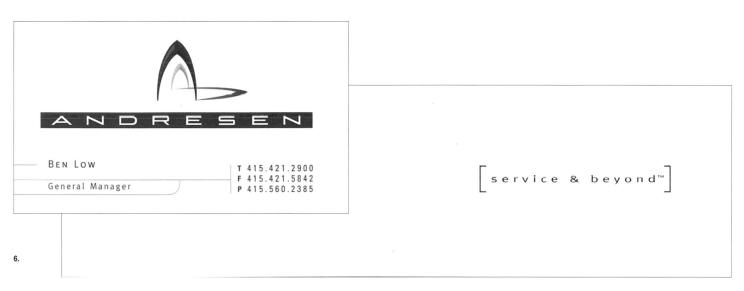

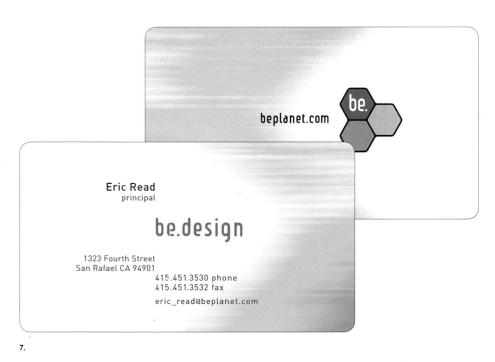

(1-3)
Design Firm **Brohard Design Inc.** Design Firm Be Design Client Orphan Sunday Designer William Brohard E group Michael Drake, Client Designers William Brohard 3. Client Streamline Graphics, Inc. Designer William Brohard Client Designers Eric Read, Yusuke Asaka Client Be Design Designer Yusuke Asaka Client Eric Read, Rick Gaston, Coralie Russo Designers Client Be Design
Designers Eric Read, Coralie Russo

North Second Street • Suite 210 • San Jose • CA • 95113

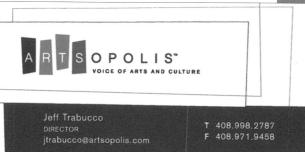

1.

BUILDING SUCCESSFUL BRANDS

2.

GEORGIA MORF THUNES project manager georgia_thunes@bedesign.net

T 415.451.3530 F 415.451.3532 1306 Third Street San Rafael CA 94901

be.design

www.bedesign.net

BUILDING SUCCESSFUL BRANDS

blue sun.

Ralph Abadir Vice President of Eastern Division ralph@bluesuncorp.com

45449 Severn Way Suite 104, Sterling, VA 20166

T 703.444.4900 F 703.444.6080 C 925.683.3359

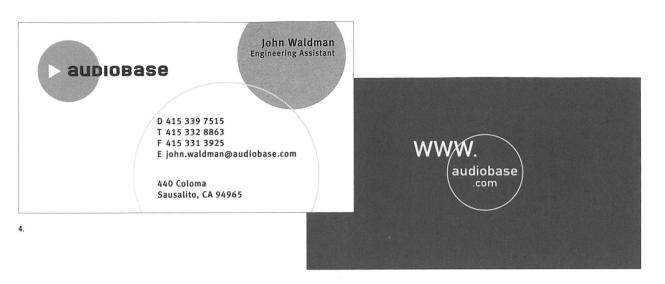

Yusuke Asaka, Designers Monica Schlaug 2. Client Be.Design Yusake Asaka, Yoko Carley Designers Client Blue Sun Eric Read, Designers Kimberly Bell Client AudioBase Designers Will Burke, Eric Read, Yusuke Asaka 5. Client Be.Design Designers Eric Read 6. Client Corrigo Designers Eric Read, Yusuke Asaka

Design Firm Be.Design

Artsopolis

(1-6)

Client

Georgette Marshall

PROPERTY MANAGER

10101 Martin Luther King Jr. Hwy. Lanham, MD 20706

T 301 918 9000

F 301 918 4796

E dln@devonselfstorage.com

R E A T I S 0

101 Main Street, Annapolis, MD 21401 • 410.268.6677 52B Rehoboth Ave., Rehoboth, DE 19971 • 302.227.3544 fax 410.268.4014

www.karmacreations.com

2.

digital image magic

Steve Kimball Principal

> 2 Magnolia Avenue San Anselmo Ca 94960

> > phone 415 453 2828 fax 415 453 0828 e-mail steve@lightrain.com

Women's Challenge, Inc. P.O. Box 299, Boise, ID 83701 314 South Sixth, Boise, ID 83702

> Annie Tucher Director of Marketing and Development atucher@micron.net

208.345.RACE (7223) fax 208.345.5325

www.hplwc.com

MR SWAP (S) COM

7.

MISSION Interpret the desires of our clients To solve the seemingly unsolvable Beautifully

JAMES PHILLIP WRIGHT

ADDRESS 5221 Cochrane Avenue Oakland, California USA 94618

STUDIO

VENICE ATELIER

CONTACT

James P. Wright Architect/Principal

510 653 5555: T 510 653 5550: F JPW archit@aol.com

ARCHITECTS

Design Firm Be Design

Client Designers

Client

Eric Read, Rick Gaston, Yusuke Asaka Karma Creations

Devon Self Storage

Deborah Smith Read Designer Client eliptica

Eric Read, Ken Louis Designers

Client Light Rain Designers Eric Read, Coralie Russo

Hothouse Designer Rick Gaston 6.

> Designers Coralie Russo, James Eli, Yusuke Asaka, Shinichi Eguchi

Client MrSwap.com Designers

Eric Read, Yusuke Asaka, Coralie Russo

Client Hewlett-Packard Women's Challenge Designers Will Burke, Coralie Russo, Yusuke Asaka

Client James Phillip Wright Architects Designer Will Burke

1.

MONICA SCHLAUG designer

monicas@pekoe.com 1325b Pine Street Boulder, CO 54678 €456.273.3234 €456.273.3247

SIP. RELAX. ENJOY.

* DRINK DEEP. TAKE FLIGHT. *

2.

Gordon Antonello Board Member Chair, 2-11GHz Technical Working Group

Wi-LAN Inc. 2891 Sunridge Way NE Calgary, Alberta T1Y 7K7 Canada

403 207 6477 403 273 5100 fax gantonello@wi-lan.com

www wimaxforum are

THE NEW SOURCE OF CORPORATE ENERGY

SKYLAR

HALEY

Ralph Abadir Account Executive

ralph@skylarhaley.com

T 925.600.9397

F 925.600.9357

C 925.683.3359

6601 Koll Center Parkway, Suite 205

Pleasanton, CA 94566

(866) SKYLARH

5.

Amy Fullerton

Operations Manager

Worldwise, Inc.

- A 851 Irwin Street, Suite 200 San Rafael, CA USA 94901-3343
- 1 800 967 5394
- © 415 721 7400 ext.258 © 415 721 7418
- afullerton@worldwise.com
- w worldwise.com

(1-6)Design Firm Be Design

Client Pekoe Siphouse Designer Monica Schlaug

Client Pixie Maté Designer Casey Coyle

WiMAX Forum Client Chris Yin Designer

Client Propello Rebecca Escalera Designer

SkylarHaley Yusuke Asaka Client Designer

Client

Worldwise Eric Read. Designers

Yusuke Asaka, Shinichi Eguchi

joe millor's company 3080 olcott street, suite 210a santa clara, ca 95054

telephone: 408.988.2924 facsimile: 408.727.9941 joecompany@aol.com

2.

Gary Clueit President & CEO

Willow Technology, Inc.
469 El Camino Real, Suite 220
Santa Clara, CA 95050-4372
tel +1.408.296.7400, fax +1.408.296.7700
mobile +1.408.966.9025
clueit@willowtech.com

www.willowtech.com

Lisa A. Cole director of development

4 North Second Street, Suite 210 San José, CA 95113-1305 phone 408-998-2787 ext. 204 facsimile 408-971-9458 lcole@artscouncil.org www.artscouncil.org

Ed Sengstack

director

4 North Second Street, Suite 275, San José, CA 95113 phone 408-998-2787 ext. 220, fax 408-998-4299 esengstack@artscouncil.org www.artscouncil.org/camp

a program of Arts Council Silicon Valley

Renee Vaughn

Director, Women's Residential Program

1796 Bay Road East Palo Alto, California 94303 phone 650.462.6999 fax 650.462.1055 www.freeatlast.org

Danyelle Phillips office manager

ksjs 90.5fm, hgh 121a, san josé state university

san josé, california,95192-0094

phone: 408-924-5762

fax: 408-924-4583

e-mail: prog@ksjs.org

tascha faruqui certified massage therapist 415.289.2049

Design Firm Joe Miller's Company

Client Designer M. Stahl, Inc. Joe Miller

Client Designer Stahl/Davis Joe Miller

3,4. Client Designer

Works/San José Joe Miller

Designer

Arts Council Silicon Valley

Joe Miller

Client

Camp/Arts Council Silicon Valley

Joe Miller Designer

Client

Free At Last Joe Miller

Designer Client Designer

KSJS Radio Joe Miller

Client

Tascha Faruqui

Designer

The Good Shepherd Fund

Linda Fast Office Manager

1641 North First Street, Suite 155

San José, California 95112

408-573-9606 phone, 408-573-9609 fax

lfast@goodshepherdfund.org

Shariff Elsheikh

MANAGING DIRECTOR

6041 Woodmont Road Alexandria, VA 22307-1159 USA

- т 01.703.851.4313
- F 01.703.317.0782
- E selsheikh@norglobe.com

www.norglobe.com

Mia Backman Worrell

1404 14th Street NW . Washington DC 20005 TEL 202.319.1100 FAX 202.319.1110 EMAIL mia@timothypaulcarpets.com www.timothypaulcarpets.com

Design Firm Joe Miller's Company

Design Firm Design Nut

Client Works/San José Joe Miller Designer

Client The Good Shepherd Fund Designer Joe Miller

NorGlobe Brent M. Almond Designer

Client Kelleen Griffin Brent M. Almond Timothy Paul Client Carpets + Textiles

Designer

Brent M. Almond

199

1.

Joseph R. Price, Esq. CHAIR, BOARD OF DIRECTORS

- т 202.775.5769 E price.joseph@arentfox.com
- 6 North Sixth Street, LL3 Richmond, Virginia 23219

- т 804.643.4816 F 804.643.2050 E info@equalityvirginia.org

EqualityVirginia.org

(323) 646-8982 O • (423) 757-4969 F
401 Whitehall Rd. • Chattanooga, TN 37405
jay@whproperty.com www.whproperty.com
LL PRTIES

HALL
PROPERTIES

brianmay
v.p. media services
v.p. marketing services
bmay@st3.com

pob 5414
1516 riverside drive
chattanooga, tn 37406

423.242.6000 n
423.622.4392 f

6.

Marlin payment solutions

Payment Processing Partner

MegTillia president mtillia@marlinpayments.com

toll free: 888.705.2055
www.marlinpayments.com

tel: 407.816.5251
cel: 727.224.3099
fax: 407.816.5257

Design Firm Maycreate Equality Virginia Brent M. Almond Client Designer Design Nut Brent M. Almond Client Designer Marlin Central Monitoring Client Designer Grant Little Advantage Point Telecom Brian May Client Designer 5. Client Whitehall Properties Brian May Designer Client Brian May Designer 7. Marlin Payment Solutions Designer Brian May

Design Firm Design Nut

Elevate Your Presence

Brian May VP Mktg. & Advertising bmav@wvfiber.com

404 488 2572 : mobile 404 222 9911 : office 404 581 9911 : fax

4501 Circle 75 Pkwy. Suite E-5210 Atlanta, GA 30339

www.wvfiher.com

2.

2

Al Victoria

alvaro@core-ltd.com

p.o. box 80723 chattanooga, tn 37414

423.504.6278 t 423.624.0345 f

MARLIN

3600 Commerce Blvd. Kissimmee, FL 34741 407.251.2076 Tel 407.251.2021 Fax www.marlinls.com

6.

Design Firm Maycreate Client Brock Partnerships Brian May Designer Client WVFiber Brian May Designer Preservation Studio South Designer Brlan May Core Painting Brian May Designer Marlin Logistics Brian May Designer RU Vodka Designer Brian May Marlin eSourcing Designer Brian May 8. Client HeadsUp Entertainment Designer

www.maycreate.com

Brian May bmay@maycreate.com 423 752 4018 t 423 752 7859 f 737 Market Street Suite 719 Chattanooga, TN 37402 Scott Sentell

President & CEO

ssentell@marliness.net

3600 Commerce Blvd Kissimmee, Fl 34741 T (407) 582-9422 F (407) 582-9421

a Marlin Group company

2

themāvicgroup

Brian MayManaging Partner

bmay@mavicgroup.com

423 752 4018 office • 423 752 7859 fax • www.mavicgroup.com 737 Market Street • Suite 719 • Chattanooga, TN 37402

3.

www.ivara.com

Peter Neo

DATABASE SPECIALIST peter.neo@ivara.com

935 Sheldon Court Burlington, ON, Canada L7L TEL 905 632.8000 × 254

FAX 905 632.5129

OCK CLOSET FASHION FOREWARD GOLF

Jim Theaker PRESIDENT sales@oakcloset.com

80 Park Lawn Rd, Suite 208, Toronto, ON, Canada M т 416.999.9623 с 416.738.5917 г 416.252.08

WWW.OAKCLOSET.COM

ISLAND QUEEN CRUISE

RON ANDERSON

ron@islandqueencruise.com CELL 705.774.3300

30,000 ISLAND CRUISE LINES INC.

9 BAY STREET, PARRY SOUND ONTARIO, CANADA P2A 154 TEL 705.746.2311 FAX 705.746.9696 TOLL FREE 1.800.506.2628 WWW.ISLANDQUEENCRUISE.COM

riordon design Oakville, ON L6J 3B9 TEL 905.339.0750 FAX 905.339.0753 group@riordondesign.com

Design Firm Maycreate (4-7)
Design Firm Riordon Design

Client Designer

Maycreate Brian May Marlin Nutritional Client

Brian May Designer Client The Mavic Group

Brian May Designer

Client Ivara Corporation Designers Dan Wheaton, Alan Krpan

5. Client Oak Closet

Ric Riordon, Alan Krpan Designers

Island Queen Cruise Designers Ric Riordon, Alan Krpan

Riordon Design Designers Dan Wheaton, Alan Krpan

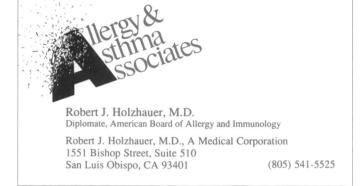

2.

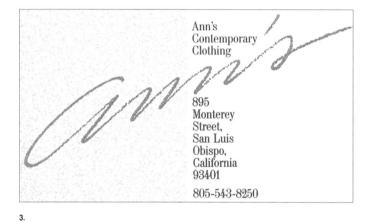

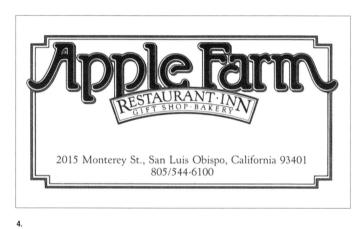

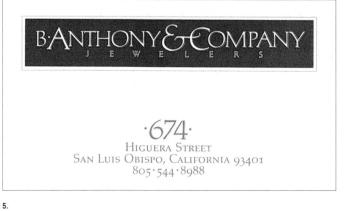

805/543-6843 · FAX 805/543-2982 · 800/234-3320 2222 Beebee Street, San Luis Obispo, California 93401

Brummel, Myrick & Associates, mechanical engineering

3562 Empleo St., Suite A San Luis Obispo, CA 93401 805 544-4269 fax 805 544-4335

Keith D. Brummel, P.E. Principal

7.

Mark Davis Owner 9647 Micron Ave. • Sacramento, California 95827 916/362-3274 • Fax 916/362-9175

10.

Design Firm Pierre Rademaker Design Client Bradshaws Jett Austin, Pierre Rademaker Designers Alpha Video Client Designer Mary Brucken Client Cavalier Oceanfront Resort Designers Debbie Shibata, Pierre Rademaker Allergy & Asthma Associates Client 10. Designer Pierre Rademaker Client Davis Design Group-Porch Home & Garden Debbie Shibata, Pierre Rademaker Ann's Contemporary Clothing Designers Client Pierre Rademaker Designer Client Dr. Chocolate Kenny Swete, Debbie Shibata, Client Apple Farm Designers Jim Nevins, Pierre Rademaker Pierre Rademaker Designers B. Anthony & Company Client Designer Al Treskin Blake Printery Jeff Austin, Pierre Rademaker Client

11.

Designers

Brummel, Myrick & Associates

Randy David

Client

Designer

1.

3.

Kathe Pults, MA, MFT
Licensed Marriage
& Family Therapist

1403 Higuera St.
San Luis Obispo,
California 93401
805/783-1225

)

991 Bennett Avenue • Arroyo Grande, CA 93420 805/473-6834 • Fax 805/473-7767 hmangjardi@midstatebank.com

WWW.MIDSTATEBANK.COM

6

2146 Parker Street, Suite A6 San Luis Obispo, CA 93401 Tel: 805/787-0810 • Fax: 805/787-0825

www.ortmanvineyards.com

Heather North

P.O. Box 990 • 67 Commerce Drive Unit 100 • Buellton, CA 93427

800/553-2400 Fax: 805/693-8682

E-mail: heather@platinumperformance.com

John and Dianne Conner Hôteliers

a Touch of European Charm

1473 Monterey Street San Luis Obispo, CA 93401 www.PetitSoleilSLO.com 805.549.0321

Design Firm Pierre Rademaker Design Client Fossil Creek Designers Anne Bussone, Pierre Rademaker

Greg Wilhelm Client Designers Jeff Austin, Pierre Rademaker

Client Kevin Main Jewelry Debbie Shibata, Pierre Rademaker Designers

Client Insite Associates Designer Pierre Rademaker

Client Kathe Pults Debbie Shibata, Pierre Rademaker Designers

Designers

Client Mid-State Bank & Trust Debbie Shibata, Pierre Rademaker

7. Ortman Family Vineyards Designers Elisa York, Pierre Rademaker Client Designers

Platinum Performance Debbie Shibata, Kenny Swete,

Pierre Rademaker

Client Prime Time Sports TV Debbie Shibata, Pierre Rademaker Designers

Client Petit Soleil

Anne Bussone, Pierre Rademaker Designers

Client Paso Robles Inn Marci Russo, Pierre Rademaker Designers

John Martino, General Manager 3627 Sagunto Street, Box 628, Santa Ynez, CA 93460

> TEL: 805-688-5588 FAX: 805-686-4294 info@santaynezinn.com

2.

Jeff Martin Plant Manager

1200 Union Sugar Avenue • Lompoc, California 93436 805/737-3233

A Limited Liability Company

PATTY OXFORD
Proprietor

1941 Monterey Street San Luis Obispo, CA 93401

RESERVATIONS: (800)593-0333 (805)541-1122 Fax (805)541-2475

www.SanLuisCreekLodge.com

Lauren Winter Owner / Buyer

2905 Burton Drive, Cambria, California 93428 (805) 927-6113 • (805) 927-4747 • Fax (805) 927-6289

Lisa Cameron Sales Manager

lisac@moonstonehotels.com

2905 Burton Drive, Cambria, California 93428 (805) 927-6114 Ext. 203 • Fax (805) 927-1610

8.

Deborah Gran Floral Designer deborah@cambrianursery.com

2801 Eton Road, Cambria, California 93428 (805) 927-4747 • (800) 414-6915 • Fax (805) 927-0437

Robert L. Hunt General Manager roberth@moonstonehotels.com

725 Row River Road, Cottage Grove, Oregon 97424 (541) 942-2491 • (800) 343-7666 • Fax (541) 942-2386

10.

(1-11)Design Firm Pierre Rademaker Design Client Moonstone Hotel Properties Cambria Pines Lodge Debbie Shibata, Pierre Rademaker Client Pressure Tek Designers Elisa York, Pierre Rademaker Designers Moonstone Hotel Properties Cambria Nursery & Florist Debbie Shibata, Pierre Rademaker Client Client Santa Ynez Inn Debbie Shibata, Pierre Rademaker Designers Designers 10. Client Santa Barbara Farms Client Moonstone Hotel Properties Debbie Shibata, Pierre Rademaker Designers Village Green Designers Debbie Shibata, Pierre Rademaker San Luis Creek Lodge Client 11. Debbie Shibata, Pierre Rademaker Xsense Designers Designers Debbie Shibata, Pierre Rademaker San Luis Bay Inn Client Pierre Rademaker, Mary Brucken Designers Client Shelter Cove Lodge Pierre Rademaker Designer Client Moonstone Hotel Properties

Designers Debbie Shibata, Pierre Rademaker

Karl D. Edwards

2623 Veteran Avenue Los Angeles, CA 90064

P 310/234-0148 **F** 310/234-0149 **W** www.boldenterprises.com **E** karledw@boldenterprises.com

Jack C. Wauchope
Chairman, Chief Executive Officer

500 Marsh Street, San Luis Obispo, CA 93401-3845
Tel:(805)541-0400 • Fax:(805)781-3180
jwauchope@coastnationalbank.com

OceanParkHotels Jerry A. Harris Operations Manager 28005 N. Smyth Drive, Suite 121 Valencia, CA 91355 **T** 805.896.8788 **F** 661.295.4649 **■** jharris@ophot.com

Design Firm Pierre Rademaker Design Bold Enterprises Debbie Shibata, Client Designers Pierre Rademaker Client Coast National Bank Debbie Shibata, Designers Pierre Rademaker Client Courtney Architects Designers Pierre Rademaker, Jeff Austin Client Cypress Cafe Street Pierre Rademaker Madonna Inn Debbie Shibata, Pierre Rademaker Designers Client Ocean Park Hotels Anne Bussone, Pierre Rademaker Designers

Alice Crafts CPA PARTNER

111 Westwood Place, Suite 400 Brentwood, Tennessee 37027 acrafts@bpmcpas.com 615.467.7306 DIRECT 615.467.7300 MAIN 615.467.7301 FAX

RICHARD J. MAGER President

8541 BASH STREET, SUITE 102 INDIANAPOLIS, INDIANA 46250 317.585.9538 SFAX 317.585.9647 rmager@walkerfoodsinc.com

Helolly Tashian
Creating Solutions for Homes and Businesses 615.383.1875 615.292.6722 FAX holly@tashian.com www.tashian.com/fengshui

ENVIRONMENTAL MANAGEMENT SERVICES, INC.

William Ney Hansard CET, CHMM, REA

5655 Valley View Road Brentwood, Tennessee 37027 615.370.0907 Fax 370.0908 hansard@emsi-solutions.com www.emsi-solutions.com

(1,2)
Design Firm Pierre Rademaker Design Design Firm Ventress Design Group

Client The Sea Barn Designers

Elisa York, Pierre Rademaker Client StillWaters Vineyards Debbie Shibata, Pierre Rademaker Designers

Client

Ventress Design Group Tom Ventress

Designer Client Designer

Alliance Aviation Tom Ventress

Client Byrd, Proctor and Mills Tom Ventress

Client Walker Foods Designer Tom Ventress

Paul Kingsbury Designer Tom Ventress

Client

Holly Tashian Tom Ventress

Designer

Environmental Management

Designer

Tom Ventress

Patricia Macken | GUIDANCE COUNSELO 600 East 6th Street | New York, NY 10009 phone 212.995.1430 | fax 212.602.9671

1.

3.

TECHNIQUE

Personal Fitness Studio

Spread Eagle Village • 503 West Lancaster Avenue • Wayne, PA 19087 • 610.687.2040

2

Michael Seifert
Partner

One Dock Street
Suite 310
Stamford, CT 06902
203|973|1220...Phone
203|973|1251...Direct
203|973|1221...Fax

4.

a division of Schratter Foods Incorporated

Ralph R. Pottle Mid-Atlantic & Special Markets Sales Manager 973-575-9120 973-575-5010 Fax

0

Paul Zullo
t 718 834 9220
paul@zullocom.com

Zullo Communications
32 Strong Place • Brooklyn, NY 11231 • fax 718 694 0774

DONNADEBS

LYENGAR
YOGA

570 BARTON LANE
WAYNE, PA 19087
(T) 610.341.0434
(P) 610.341.0508
ddebs@comcast.net

٦٥.

Client Tompkins Square Rebecca Uberti Designer 2. Client La Technique Donna Bonato Designer Client New England Reunions Designer Donna Bonato Client Concept Information Designer Donna Bonato Client Yohay Baking Co. Designer Donna Bonato Client NSC Designer Donna Bonato Client Flavorbank Designer Donna Bonato

Design Firm Silver Creative Group

Client SFI-Anco Fine Cheese Designer Donna Bonato Client Zullo Communications Designer Donna Bonato 10. Client Donna Debs Yoga Designer Donna Bonato 11. Client Safety Light Designer Donna Bonato

(1-11)

THE KINGSLEY GIRAFFE

212.260.7224 phone 212.533.8002 fax New York, New York

sales@kingsleygiraffe.com www.kingsleygiraffe.com

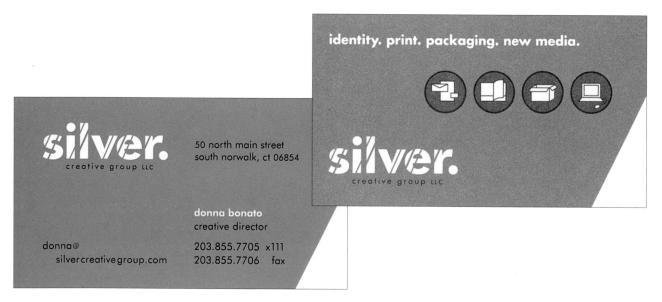

- Voice & Data Networking
- Hardware & Software Sales
- Multimedia & Web
- Email & Web Hosting

eperienced • Responsible • Ethical

Futurological

Matias Zadicoff Animation

mzadicoff@futurological.com

45 MAIN STREET, SUITE 707 BROOKLYN, NY 11201

P 866.4.FUTURO x217 F 708.260.9593

www.futurological.com

3197 Beaver Vu Drive Beavercreek, OH 45434-6366 937.320.0599 937.320.0665 fax

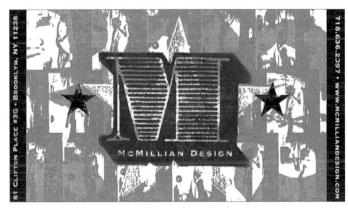

6

98 Brooklyn Road Brooklyn NSW 2083 ph 02 9985 7609 fax 02 9985 7000 mobile 0413 808 989 email mareac@cia.com.au 1-4)
Design Firm Silver Creative Group

Design Firm VMA, Inc.

Design Firm McMillan Design

(7)
Design Firm Jennifer Shanley

Client Kingsley Giraffe
Designer Robin Bonato

Client Bonato Design Designer Donna Bonato

Client Silver Creative Group
Designer Donna Bonato

Client Futurological
Designer Donna Bonato

Client Zenergy
Designers Al Hidalgo,
Kenneth Botts

Client Designers McMillian Design Bill McDevitt, William McMillian

Client Designer

Marea Fowler Jennifer Shanley

7

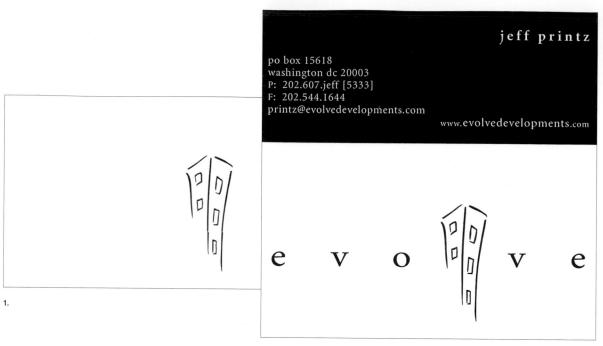

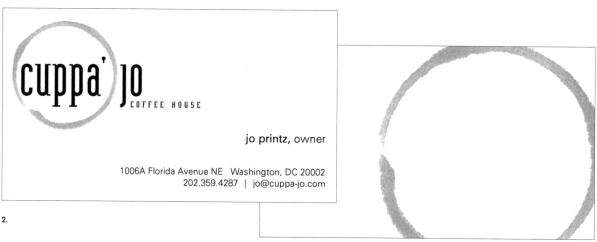

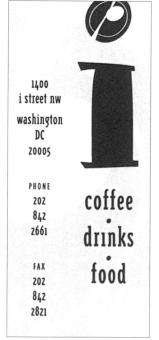

Charles P. Marsh

PHONE: 502.339.7979 FAX: 502.327.7123 summit@iglou.com

420 SOUTH HURSTBOURNE PARKWAY, SUITE 205 LOUISVILLE, KENTUCKY • 40222

4

Stephen Brown Art Director

steve@earthlygoods.com

On Target. On Time. On Budget.

Mind's Eye Creative

P 812 944 3283

620 East Main Street

C 502 338 4285

New Albany, IN 47150

F 812 944 2903

5.

The Loop Island Wetlands is located at the corner of East Main and Silver Streets in New Albany, Indiana.

For more information visit: www.loopislandwetlands.com

New Albany

Lust Muin

OHIORIVER

Louisville, Kentucky

6.

Chesapeake PERL

Nathan DeCarolis Research Associate

Chesapeake PERL, Inc. Protein Expression and Recovery Labs 8510A Corridor Road, Savage, MD 20763 301.317.9300 x107 Fax: 301.317.9343 ndecarolis@c-perl.com www.c-perl.com

_

(1-3)
Design Firm Pensaré Design Group
(4-6)
Design Firm Mind's Eye Creative

7) Design Firm Martin-Schaffer, Inc.

Client Evolve Developments
Designer Kundia D. Wood

Client cuppa' jo Designer Kundia D. Wood

Client

Designer Amy E. Billingham

Client Summit Construction
Designer Stephen Brown

Client Mind's Eye Creative Designer Stephen Brown 6. C

Client Loop Island Wetlands Designer Stephen Bowman

Client Cl Designers St

Chesapeake PERL, Inc. Steve Cohn, Tina Martin

ACME COMMUNICATIONS, INC.

200 PARK AVENUE SOUTH

NEW YORK, NEW YORK 10003

212 505-0048

Fax: 212 202-4412

Email: kboucher@acmeny.com

Portfolio: www.acmeny.com

KIKI BOUCHER

1.

V CONSTRUCTION CORP. FRANK WISNIESKI

200 Park Avenue South

New York, NY 10003

Ø 212.505.3190

fax 212.505.0904

fawizzl@verizon.net

WE WOULD LIKE TO TALK TO YOU, IF YOU ARE:

- a self-starter with a positive attitude.
- looking for a rewarding career,
- seeking above average earnings potential,
- and is someone who likes working with people

WE WILL PROVIDE:

- · professional training,
- ongoing supervisory support,
- · an established client base.
- benefits, include: annual seminars hospitalization insurance

group ter 401K pla

 and an opp successful f

SECURITY PLAN

LIFE INSURANCE CO. | FIRE INSURANCE CO. 914 East 70th Street | Shreveport, Louisiana 71106

Ronald E. Smith District Manager

318.868.2768

Fax 318.868.2796 dst51em@securityplan.com

CALL the number on this card for further

MICHAEL RUBIN

200 PARK AVENUE SOUTH NEW YORK, NY 10003

> T 212.505.0801 F 212.505.0904

MAIL@MICHAELRUBINARCHITECTS.COM

DIRTWORKS, PC LANDSCAPE ARCHITECTURE

200 PARK AVENUE SOUTH NEW YORK, NEW YORK 10003 TEL 212-529-2263 FAX 212-505-0904 **DKAMP@DIRTWORKS.US**

DAVID KAMP, ASLA, LF **PRESIDENT**

Lea Turner-Betts Broker

DIRECT: 503.803.7969

LTURNERBETTS@PEARLREALESTATE.COM

1001 NW 14th Avenue Portland, Oregon 97209 Phone: 503.223.2255 Fax: 503.224.2255 www.pearlrealestate.com

JEFF FISHER Engineer of Creative Identity

Fax: 503.283.8995 • Phone: 503.283.8673

Email address: jeff@jfisherlogomotives.com

Web site URL: www.jfisherlogomotives.com

P.O. Box 17155 • Portland, OR 97217-0155

Helping businesses and organizations stay on track through creative, innovative, affordable and award-winning identity design.

Design Firm Acme Communications, Inc.

(6,7)
Design Firm Jeff Fisher LogoMotives

Client Acme Communications, Inc. Designers

Kiki Boucher,

Jon Livingston

Client Designer

Crew Construction Corp.

Kiki Boucher

3. Client

Security Plan Kiki Boucher,

Designers

Andrea Ross Boyle

Client

Michael Rubin Architects

Designer Kiki Boucher 5.

Dirtworks, P.C. Designer Kiki Boucher

Client

Pearl Real Estate Jeff Fisher

Designer

Client

Jeff Fisher LogoMotives Designer Jeff Fisher

1.

Brady V. Hoag Principal

Direct 612.381.8942 Cell 612.384.275<u>5</u>

2501 Wayzata Bo Minneapolis, MN bhoag@jbscottse www.jbscottseard

Chris Olson, Minister of Divinity Academic Dean

[e]colson@horizoncollege.org

P.O. Box 17480 San Diego, CA 92177 [P]858.277.4991 [f]858.277.1365

www.horizoncollege.org

2.

Design North

BRANDING FOR THE RETAIL ENVIRONMENT

GWEN GRANZOW

Vice President/Creative Director Principal

Design North, Inc. 8007 Douglas Avenue Racine, Wisconsin 53402 www.designnorth.com

Phone 262.639.2080 Toll Free 800.247.8494 Fax 262.639.5230

gwen@designnorth.com

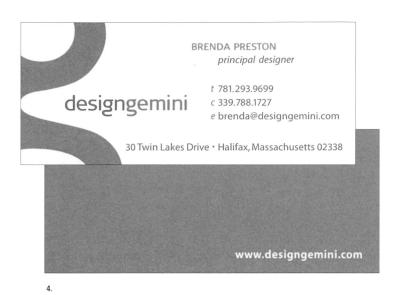

MAX GRAPHICS

BOB SCHONFISCH Creative Director

1820 POPLAR AVENUE REDWOOD CITY, CA 94061-2102 PHONE: 650. 568. 3238 E-MAIL: MAXGRAPHICS@RCN.COM

DAINIUS BALCIUNAS . MICROSURGEON

5.

PLASTIC & RECONSTRUCTIVE · AESTHETIC SUR

 $M \cdot (+370)687$

E · MIKROCHIRURGIJA@TAKAS.LT

www.kriste.lt

LITHUANIAN ASSOCIATION OF GRAPHIC DESIGNERS KRISTINA ŽALNIERUKYNAITĖ

(3) Design Firm Design North, Inc. Design Firm Design Gemini Design Firm Max Graphics (6,7)Design Firm Kristina Zalnierukynaite Client J.B. Scott Craig Franke, Rich Ketelsen Designers

Design Firm Franke + Fiorella

Design Firm Wheeler Design

Client Horizon College Designer Stephanie Wheeler Client Design North, Inc. Designers Gwen Granzow, Design North, Inc. Client Design Gemini Designer Brenda Preston 5. Client Max Graphics Designer Bob Schonfisch 6. Dainius Balciúnas Designer Kristina Zalnierukynaite 7.

Client Kristina Zalnierukynaite Designer Kristina Zalnierukynaite

2.

AUDRV + 370 682 37897 audram@muza.lt

Regional Sales Manager miket@cmpaper.com

Main 616 676-9203 Toll Free 800 632-4910 Direct 616 676-3965 ext. 209 Mobile 616 318-4135 Fax 616 676-2637

CMP

6194 E. Fulton Rd. Ada, MI 49301 www.cmpaper.com

John W. Gurrlson Regional Sales Manager

Main 616 676-9203 Toll Free 800 632-4910 Mobile 616 490-2819 Home Office 231 266-5362 Home Fax 231 266-8720 Fax 616 676-2637

CMP

6194 E. Fulton Rd. Ada, MI 49301 www.cmpäper.com

Fax 616 67 CMP

Liz Zezulk Sample D

lizz@cmpc

Main 616

Toll Free 8 Direct 616

6194 E. Ful Ada, MI 4 www.cmp

Harlan J. Wenner www.sportsplacement.com 5458 Wilshire Bivd. Los Angeles, CA 90036

SPORTS PLACEMENT SERVICE, INC. REPRESENTING ATHLETES WORLDWIDE

Design Firm Kristina Zalnierukynaite

Design Firm WEBDESIGNS-STUDIO.com

Design Firm BBKstudio

Client Designer

Kazys Svidenis Kristina Zalnierukynaite

Client Designer 3.

Altesa Kristina Zalnierukynaite

Client Designer

Audr∀ Kristina Zalnierukynaite

Client Designer

Rasa Tornau Kristina Zalnierukynaite

Client Designers

Caroline Corv Madeline Y. Arenas, Juan Magdaraog

Client

Sports Placement

Designers

Service, Inc. Madeline Y. Arenas, Bernard Aquino

Client

CMP Michele Chartier Designer

Your next appointment is:

Mary R. Pfitzinger, B.S.N., R.N.F.A. 969 North Mason Road, Suite 170 . St. Louis, Missouri 63141 314-628-8200 phone = 314-628-9504 fax mpfitzinger@bodyaesthetic.com • www.bodyaesthetic.com

Jennifer Olmstead, AICP Project Manager jolmstead@greatrivers.info

1000 St. Louis Union Station Suite 102

> St. Louis, MO 63103 Phone: 314.436.7009 Fax: 314.436.8004

109

www.greatrivers.info or a clean, green, connected St. Louis region

Anne Ainslie

Vice President of Operations

Love it LLC 1123 BROADWAY **SUITE 1211** NEW YORK, NY 10010 www.loveitretail.com

T 212.367.3727 F 212.367.3726 aainslie@loveitretail.com

Smart retail

Love it LLC

Owned, leased and managed by

■ STOLTZ

Susan Belgam Hunt General Manager 772.770.6097 fax 772.770.5787 shunt@stoltzusa.com

The Outlets at Vero Beach 1824 94th Drive Vero Beach, FL 32966 www.verobeachoutlets.com www.stoltzusa.com

EAST HAMPTON PICTURE FRAMING

> 374 Montauk Hwy. PO Box 560 Wainscott New York 11975 631 537-0012

Nina Bataller, GCF, CPF

Gabriel Conte, DDS David J. Green, DDS

877 Stewart Avenue, Suite 26 Garden City, NY 11530

(516) 222-1717 Phone (516) 222-1867 Fax

www.contegreen.com

Design Firm Kiku Obata & Company

(6-8)
Design Firm Fleury Design

Body Aesthetic Designer Amy Knopf

Great Rivers Greenway Client Designers Troy Guzman, Teresa Norton-Young

Client Designer

Eleanor Safe

Client Stoltz/The Outlets at Vero Beach Designer Amy Knopf

Designer Jennifer McBath

Client East Hampton Picture Framing Ellen Fleury Designer

Charlene Bry

8

Tel. 314 • 994 • 0445 Cel. 314 • 401 • 1848 Fax 314 • 961 • 3612

Client Pat Dillon Photography Designer Ellen Fleury

Conte & Green Client Designer

Mary English, PT DPT Dave Hynds, PT MA Dave Fontana, PTA

232 East Main Street Huntington, NY 11743

Tel (631) 427-7807 Fax (631) 427-7887

Win Thin, Ph.D. President

223 Wall Street Huntington, NY 11743-2060

Tel: 631-425-1955 Fax: 631-425-1975

wthin@mandalayadvisors.com

1.

۷.

Tangram Strategic Design

Enrico Sempi Partner

Tangram Strategic Design s.r.l. viale Michelangelo Buonarroti 10/C 28100 Novara, Italia 032 135 662/0321 392 232 f. 0321 390 914 esempi@tangramsd.it

3.

Antonella Trevisan

Senior designer

Tangram Strategic Design s.r.l. viale Michelangelo Buonarroti 10/C 28100 Novara, Italia 032 135 662/0321 392 232 f. 0321 390 914 atrevisan@tangramsd.it

www.tangramsd.it c.f. e partitá IVA 01209370038

Emilio Barlocco

President

IFM Infomaster S.r.l.

Sede Legale: Via V Maggio 81 16147 Genova, Italy Tel. +39 0103 747 811 (r.a.) Fax +39 0103 747 861

E-mail: emilio.barlocco@ifminfomaster.com

Fusako Miyakawa 宮川 房子

DAIDAI FUTURE PLANNING PARTNERS

Piazza Castello 23 T1222 Castello 25 20121 Milano, Italy T+39 02 89 289 720 (reception) T+39 02 89 289 722 (direct) F+39 02 89 289 724 fusako@futureplanningpartners.com

CONSTRUCT

402 477-3606 voice www. ecospheres. com Nebraska Center 530 West P Street for Sustainable Nebraska 68528-1542 Construction

STEVE WOODS PRINTING COMPANY

2205 EAST UNIVERSITY PHOENIX ARIZONA 85034 MAIN 602 484 8888 DIRECT 602 625 2222 FAX 602 484 8899 TOLL FREE 888 484 2448 STEVE & STEVEWOODSPRINTING.COM

> STEVE WOODS RELATIONSHIP GUY

Design Firm Fleury Design (3-5)
Design Firm Tangram Strategic Design Design Firm Ron Bartels Design

Design Firm Mires

Client Harbor Physical Therapy Designer Ellen Fleury 2.

Client Mandalay Advisors Designer Ellen Fleury 3.

Tangram Strategic Design Client Enrico Sempi, Andrea Sempi Designers

Client IFM Infomaster Enrico Sempi, Anna Grimaldi Designers

Client Dai Dai Designers Enrico Sempi, Antonella Trevisan

Client Ron Bartels Design

Designer Ron Bartels

Steve Woods Printing Company Scott Mires,

Designers Mario Porto

TODD SCHAFER ext.259

408.776.8633
fax:408.776.8610
toddschafer@shiftmx.com

18400 SUTTER BOULEVARD MORGAN HILL, CA 95037

Cultivating
SUCCESS through
SCIENCE

2.

Jennifer A. Smith
Manager of Corporate
Communications
jennifer@vicam.com

www.vicam.com

VICAM.

313 Pleasant Street
Watertown, MA 02472 USA
Tel: 800.338.4381
+1.617.926.7045
Fax: +1.617.923.8055

PATRICK FOSTER
HIRED GUN DESIGN
PRINT & WEB GRAPHIC DESIGN
505 310 1744 | FOSTER@HIREDGUNDESIGN.COM
BECAUSE TALK IS CHEAP.

4.

5.

9.

1656 WASHINGTON, SUITE 210 KANSAS CITY, MO 64108 ® 816/283.8480 ® 816/283.8475 © 816/807.2539

HELEN E. MILLER SENIOR MANAGEMENT CONSULTANT

HEALTHCARE CONSULTING & MANAGEMENT SERVICES

hmiller@thebuckleygroupllc.com

(1)		
8 8	Design Firm	Mires
(2,3)		
	Design Firm	Schafer Design
(4)		
	Design Firm	VICAM
(5-7		
		Hired Gun Design
(8,9		Ladiata Baataa Iaa
	Design Firm	Indicia Design, Inc.
1.		
١.	Client	Bochner Chocolates
		José Serrano,
	3	Miguel Perez
2.		
	Client	Schafer Design
	Designer	Todd Schafer
3.		
		Shift
	Designer	Todd Schafer
4.	Client	VICAM
		Jennifer Smith/VICAN
	Designers	Dave Phoenix/
		TRIAD Communication

Patrick Foster

Designer

Client Bare Feet Studios Designers Patrick Foster, Roxanne Darling Client Single Gourmet Hawaii Designer Patrick Foster 8. Client The Buckley Group, LLC Designers Ryan Hembree, Ryan Glendening Client SureMerchant, LLC Ryan Hembree Designers Hunter Eshelman Client Hired Gun Design

The Trusted Voice in Client Communications

Gareth Taube

15 New England Executive Park, Suite 135

Burlington, MA 01803

www.silverlink.com

Robert S. Schwarz, A

rob@RSP-Associates.com www.RSP-Associates.co

PH 913.963.5967

FX 913.438.1984

2.

colby garrelts megan garrelts

CHEFS/OWNERS

900 WESTPORT ROAD KANSAS CITY, MO 64III P 816 561 1101

Master Designer

Advanced Color Specia

T CHESTER CHAMBER ALLIANCE

...connecting people and possibilities

7 Voice of America Centre Drive • West Chester, OH 45069 513,777,3600 P • 513,777,0188 F • 877,WCHESTER

- www.westchesterchamberalliance.com
- kzisler@westchesterchamberalliance.com

Bill Walsh Agency

BUSINESS MANAGEMENT SOLUTIONS

7723 Tylers Place Blvd. Suite 129 WEST CHESTER, OHIO 45069 DIRECT: 513 608.6005 Fax: 513 779.1668

E-Mail: Manage1@fuse.net

SALON . MINI SPA

MARILYN COMBS

513.398.9722

1072 READING ROAD MASON, OHIO 45040

6215 CENTRE PARK DRIVE WEST CHESTER, OH 45069 USA

P 513 759.4333 EXT. 138 F 513 759.3312 TOLL FREE 888 387.8425

MHOSKINE @CARDIOQUICKSYS.COM WWW.CARDIOQUICKSYS.COM

Design Firm Indicia Design, Inc.

MICHAEL HOSKINS SALES SPECIALIST

CELL 773 383.8678

Design Firm Five Visual Communication & Design

Client

Silverlink Communications Designers Rvan Hembree

Client

Ryan Glendening RSP & Associates

Designers

Ryan Hembree, Hunter Eshelman

Client

BlueStem Restaurant

Designers

Ryan Hembree, Ryan Glendening

Client

Designer Rondi Tschopp Bill Walsh Agency

Rondi Tschopp

5. Client Designer West Chester Chamber Alliance

Client Designer CardioQuickSys, LLC

Client Designer

Designing Women Rondi Tschopp

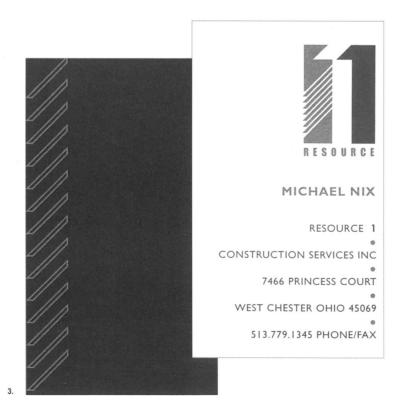

Richard S. Burrows, Ph.D. Director, Product Development rburrows@diytheatre.com

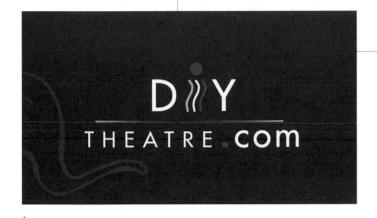

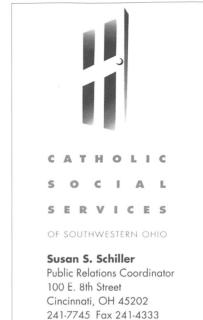

5

323.906.2726

TE(H)OUR(E
THE MAC SUPERSTORE

Laine Amireh Technician Apple Service Certified 128 W. Nees Ave. Suite 103 Fresno, CA 93711

Tel 209-438-6227 Fax 209-451-0300

7.

DIGITAL PRODUCTION GROUP
California State University, Fresno

5201 North Maple M/S SA50
Fresno, California 93740-8027
Phone 559 278 5268
Fax 559 278 7311

Nancy Kobata
Production Assistant
nancyko@csufresno.edu

(1-5)
Design Firm Five Visual Communication & Design

(6-8)
Design Firm Shields Design

1.
Client Moening Presentation Group Designer Rondi Tschopp

Client SEBC Workforce Academy
Designer Rondi Tschopp

Client Resource 1
Designer Rondi Tschopp

Client DIY Theater.com Designer Rondi Tschopp

Client Catholic Social Services
Designer Rondi Tschopp

Client Water's Edge Gardening
Designer Charles Shields

Client TechSource
Designers Charles Shields,

Designers Charles Shields, Juan Vega

Client Digital Production Group
Designers Charles Shields,
Tom Kimmelman

Christopher Johnson

2037 W. Bullard Ave. Suite 186 Fresno, CA 93711 T (209) 2 SPORTS F (209) 431-4934

2.

3.

RH biosciences "Accelerate Success."

Susan A. Bridges

Marketing Communications Manager susan.bridges@jrhbio.com

JRH Phone 913-469-5580 Ext. 6796 Toll free-USA 800-255-6032 Ext. 6796 JRH Fax 913-469-5584

JRH Biosciences, Inc. 11296 Renner Blvd. Lenexa, Kansas 66219 USA www.jrhbio.com

Jake Lord

Director of Visual Interface Design jake@cniadvertising.com

913.341.6095 fax

10261 W. 87th St., Suite 200 Overland Park, KS 66212

creating new ideas

cniadvertising.com

ARL'S Donuts

Keith Sanders

6350 Sunset Corporate Drive Las Vegas, Nevada 89120 www.carlsdonuts.com

702.382.6138 TEL 702.382.6183 FAX 702.338.3899 CELL

TRISTA PEREZ Marketing/PR Coordinator trista@aqueadesign.com

4933 West Craig Road #377 Las Vegas, Nevada 89130

TEL 702.646.9067 FAX 702.646.9087 www.aqueadesign.com

Design Firm Shields Design Design Firm Jenny Kolcun Design Design Firm CNI Advertising Design Firm Aquea Design Camerad, Inc. Designer Charles Shields Designer Charles Shields Attitude Online Designers Charles Shields, Juan Vega Ojo Photography Client

Jenny Kolcun

Designer

Client JRH Biosciences Designers Tim McNamara, Corey Shulda,

Jake Lord. Abby Bock

Client CNI Advertising Tim McNamara, Designers

Corey Shulda, Jake Lord

Client Carl's Donuts Designer Raymond Perez

Client Aquea Design Designer Raymond Perez

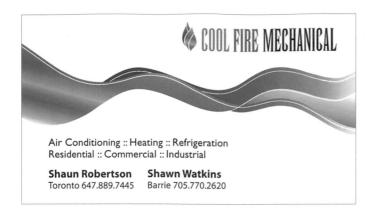

Custom Residential Cabinetry Designed, Manufactured and Installed By Us.

Lorna Brown

Six Main Street North Campbellville, ON LOP 1B0 Ph: (905) 854-0951 Fax: (905) 854-3523

www.cranberryhillkitchens.com

Mark Hallis

Ice Life Canada Inc. Toronto ON Canada M2M 3X1

Toll Free: 1.800.477.0628 T. 416.590.1919 C. 416.278.0093 F. 416.225.3071 E. mark@icelife.com

5174 Yonge Street Suite 200

:: skate the world ::

deb can't design

deb can't design

deb can't design

www.icelife.com

unless you hire her.

deb von sychowski

- e. debsfreelance@yahoo.ca
- c. 416.892.5874

1376 BAYVIEW AVENUE TORONTO, ON M4G 3A1 T: 416.481.1175

F: 416.481.0774

www.iQinc.ca

iw inc

PATRICE BANTON

patrice@iQinc.ca

1376 BAYVIEW AVENUE TORONTO, ON M4G 3A1

T: 416.481.1175

F: 416.481.0774

www.iQinc.ca

iw inc

[keep an open mind]

PATRICE BANTON

patrice@iQinc.ca

Pattl-Anne Filzpalrick Design Consultant

CLOSETS

e: 905.584.0617

e: 416.409.5464

Design Firm Deb's Freelance (5,6)
Design Firm iQ inc

Client Cool Fire Mechanical Deb Von Sychowski Designer Client Cranberry Hill

Kitchens Designer Deb Von Sychowski

Client Ice Life Canada Inc. Designer Deb Von Sychowski

Client Deb's Freelance Designer Deb Von Sychowski 5.

Client iQ inc Designers Patrice Banton, Samantha Murray,

Michelle Allard. Julie Cairns Caledon Closets Patrice Banton, Client Designers

David Banton

241

CHRIS WASS

cwass@fireflyliving.com

8525 E Pinnacle Peak Rd Scottsdale, Arizona 85255

FIND ME ANYWHERE // VOICE & FAX 800.704.1263

> enlightened living fireflyliving.com

Proud member of Keller Williams High Desert Realty

DANIEL R. BROWN
President/CEO
dbrown@browncommercialgroup.com

1550 Higgins Road, Suite 118 // Elk Grove Village, Illinois 60007 T 847.758.9200 F 847.758.9292

2.

THE AIT OF BEAUTY

RUTH MIRZA ruth.mirza@vasaiolifespa.com

1100 East Paris Ave. SE | Grand Rapids, MI 49546 616-942-2966 | vasaiolifespa.com

DAN COLLINS

GENERAL CONTRACTOR & BUILDER dan@ccghome.com

1224 NARY COURT BATAVIA, IL 60510 TEL 630.406.8434 FAX 630.406.0528

CELL 630.561.3511

ç jimcraig™

P.O. BOX 2740 GLEN ELLYN, IL 60138-2740 jimcraigcartoons.com

jim@jimcraiqcartoons.com

aic Call

Cradles & All

Kristina S. Garcia 407 South 3rd Street · Geneva · IL 60134 tel 630 · 232 · 9780

fax 630 · 232 · 4096

Distinctive furnishings from infant to Baby registry & custom orders available

.

5.

(1-6) Design Firm Rule 29

Client Firefly Designers Justin Ahrens, Kerri Herner Client Brown Commercial Group, Inc. Designer Justin Ahrens Client Vasaio Designer Justin Ahrens Client Collins Construction Group Justin Ahrens Designer Jim Craig Justin Ahrens Client Designer Client Cradles and All Designers Justin Ahrens. Kerri Herner

2177 Jerrold Avenue, Building D - San Francisco, CA 94124 Reservations: (415) 824-8888

info@luxorexecutivecar.com www.luxorexecutivecar.com

LUXOR EXECUTIVE CAR SERVICE ELITE TRANSPORTATION FOR BUSINESS OR PLEASURE RESERVATIONS: (415) 824-8888

HAIGHT STREET GARAGE

1.

DAVID ADAMS GENERAL MANAGER

2177 Jerrold Avenue – San Francisco, CA – 94124 Phone (415) 282–1242 – Fax (415) 282–5422 www.haightgarage.com – dadams@haightgarage.com

2.

Michelle Johnson D.D.S., M.S., P.C.

6551 Stage Oaks Drive, Ste. 2 Bartlett, Tennessee 38134

> phone: 901.386.5800 fax: 901.386.9604 emergency: 901.534.9622 www.johnsonortho.com

Orthodontics for Children and Adults

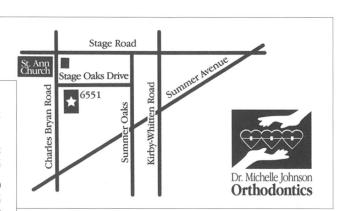

somamotors.com

1.888.425.SOMA

p: 415.701.7662 f: 415.701.7606

randy@somamotors.com

Andrew Dennis
PRESIDENT & CEO

NewBuyer.com, LLC
Phone: (203) 262-6266 • Fax: (203) 264-6579
andrewdennis@newbuyer.com • www.newbuyer.com
9 Union Square #250 • Southbury, CT 06488

corporate identity

package design

publications

advertising

illustration

consulting

education

marketing

copywriting

Design Firm MFDI Client Luxor Executive Car Service Mark Fertig Designer Client Haight Street Garage Designer Mark Fertig Dr. Michelle Johnson Designer Mark Fertig SOMA Motors Designer Mark Fertig Advanced Audi Volkswagen Mark Fertig Designer Client New Buyer Designer Mark Fertig Client Mark Fertig Design and Illustration Designer Mark Fertig

ROD M. EGNASH

13040 N. 48th Place • Scottsdale AZ 85254-3517 voice: (602) 826-9147 • fax: (602) 953-7325 e-mail: phxofficemaint@aol.com • www.phxofficemaint.com

2.

Teresa Blanton

1227 Tara Ridge Drive Collierville, TN 38017

toll free: (866) 332-6224 phone: (901) 210-3039 fax: (800) 404-3895

teresa@dentalgenius.com www.dentalgenius.com

Your Genius At Worl

Kurt Winters Partner

kwinters@tatecapital.com

TATE CAPITAL PARTNERS

PO Box 24499 Minneapolis, Minnesota 55424

T 612 210 1940

3.

jculligan@cva.edu

1.

COLLEGE of VISUAL ARTS 344 Summit Ave, St Paul, Minnesota 55102

T 651.224.3416 F 651.224.8854 www.cva.edu

www.cva.edu

John Farrell john@johnfarrell.biz

John Farrell, LLC 18050 Langford Blvd Jordan, MN 55352

TEL 651 690 10 CELL 651 331 99

FAX 888 522 29 www.johnfarrell

work relationships that

mesh

click

rock

work

33 MAIN STREET psymark COMMUNICATIONS OLD SAYBROOK CT 06475 phone 860.395.0512 fax 860.395.0514 THOMAS G. FOWLER PARTNER tom @ psymark com

A E R NORTHERN INDIGENOUS ART AND ANTIQUITIES THOMAS G. FOWLER NINE WEBBS HILL ROAD STAMFORD, CT 06903 USA P 203-329-1105 F 203-847-1138 E TGF@INUAGALLERY.COM WWW.INUAGALLERY.COM

TOM FOWLER, INC. Graphic Communicators

ELIZABETH P. BALL VICE PRESIDENT

111 WESTPORT AVENUE Norwalk, Connecticut 06851 T: 203·845·0700 EXT: 11

F: 203.846.6682

E: LIZ@TOMFOWLERINC.COM

W: TOMFOWLERING.COM

(1,2)Design Firm MFDI (3-5)Design Firm Larsen (6-8)

Design Firm Tom Fowler, Inc.

Client Dental Genius Designer Mark Fertig 2.

Client Phoenix Office Building Maintenance Mark Fertig

Designer 3. Client Designers

Tate Capital Jo Davison, Bill Pflipsen. Jules Miller

Client Designers

College of Visual Arts Nancy Whittlesey, Nick Zdon, Liina Koukkari

Client

Farrell Designers

Jo Davison, Mark Saunders Trish Adams

Client Designers

Psymark Communications Thomas G. Fowler, Brien O'Reilly

Inua Gallery Thomas G. Fowler Client Designer

Client Designer

Tom Fowler, Inc. Thomas G. Fowler

MARKETING EXCELLENCE

Market Research

Opportunity analysis Commercial potential assessment Competitive intelligence Surveys

Marketing Plans

ing

ons

rals ign

ent

Strategic and tactical plan development

Mike Aistrup

957 Ashland Avenue St. Paul, MN 55104-7019 651-222-2660 Mobile 612-581-1333

Karen Walkowski Executive Director

1111 Nicollet Mall Minneapolis, MN 55403-2477 p. 612.371.5694 f. 612.371.7176 email. kwalkows@mnorch.org

2.

jeff kaphingst

designer/webmaster

P: 952-927-5425 F: 952-927-7034 415 BLAKE ROAD NORTH HOPKINS, MINNESOTA 55343 E: JEFF@SPANGLERDESIGN.COM WWW.SPANGLERDESIGN.COM

e: info@riverwestliving.com 401 south first street, minneapolis, minnesota 55401 **p:** 612.436.7600 **f:** 612.436.7601 **w:** riverwestliving.com

DREW PALMER

3131 excelsior boulevard minneapolis, minnesota 55416 ph: (612) 922.3111 f: (612) 922.3115 e: djpalmer@cbburnet.com

www.calhounplace.com III 企

To schedule a presentation with Cea, please contact her at the following numbers:

937.429.9201

2370 Clubside Drive Dayton, Ohio 45431

(laughter is Cea's prescription for life!)

cheryl roder-quill

angryporcupine_design 1720 creekside lane park city utah 84098 435 655 0645 tel 435 604 6970 fax angryporcupine.com

breathe 408 921 2307

315 2 University Avenue Los Gatos, CA 95032

Your next appointment is

Date ____

Time ____

Please give 24 hours notice for cancellations.

healing, skin & body treatments **Kimberly Kutler** licensed esthetician certified Reiki & massage practitioner

(1-5)
Design Firm Spangler Design Team

Design Firm angryporcupine_design

Client

Everest Marketing Scott Miller

Designer Client

WAMSO Minnesota Orchestra

Volunteer Association Julie Mitchell Designer

Client

Spangler Design Team Julie Mitchell

Designer

Turnstone Group/RiverWest

Client Designer

Julie Mitchell

Client Turnstone Group/Calhoun Place Julie Mitchell

Designer

Client Cea Cohen-Elliott Cheryl Roder-Quill Designer

Client Designer

angryporcupine_design Cheryl Roder-Quill

Designer

Cheryl Roder-Quill

Brent Ramsby | President / CEO

877.919.6700 ext. 501 510.919.6700 mobile 877.919.6700 fax

brent@streamworksconsulting.com

it pays to be organized.

Cindy Gunderson Professional Organizer

3548 Eagle Beach Circle Port Clinton Ohio 43452

419 732 1560 shadgun@infinet.com

Lipkesgade 14 2100 København Ø

tel: 35-26-04-14

3.

Birtna Jerlang

Klinisk psykolog Cand. psych. aut., Ph.d. Specialist i sundhedspsykologi og supervisor Kronprinsensgade 5, 1, th. 1114 København K tlf. 33-15-29-15

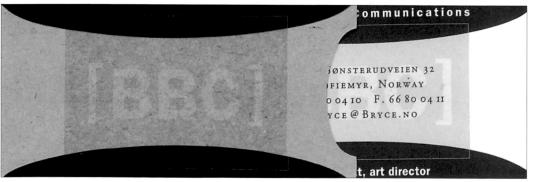

THERE'S NO BUSINESS LIKE DOG BUSINESS.

6.

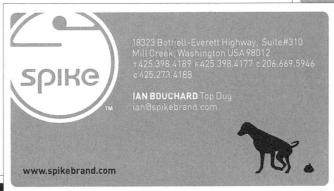

IT'S RAINING CATS AND DOGS AND I JUST STEPPED IN A POODLE. THANK YOU, GOODNIGHT.

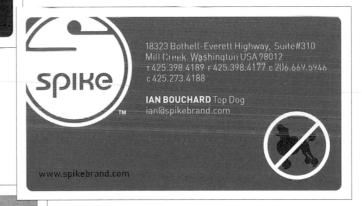

JUST SAY "NO" TO BIG HAIR.

Design Firm angryporcuplne_design
(3.4)
Design Firm AD WORKS
(5)
Design Firm Bryce Bennett Communications
(6)
Design Firm Karacters Design Group

1.
Client StreamWorks Consulting

Client StreamWorks Consulting
Designer Cheryl Roder-Quill

Client the organization

Designer Cheryl Roder-Quill

Client Peter Jerlang, Tandlaege Designer Anna Björnsdóttir 4.
Client Birtna Jerlang,
Klilnisk Psykulog
Designer Anna Björnsdóttir
5.
Client Bryce Bennett Communications
6.

Client Spike Designer Jeff Harrison

Vancity

Karen Hoffmann LL.B

Vice President, Investments & Insurance

Vancity Centre 183 Terminal Avenue Vancouver, BC V6A 4G2 T 604 871 5353 F 604 877/7920 karen_hoffmann@vancity.com

Vancouver City Savings Credit Union

vancity.com

frank palmer chief executive officer

frank.palmer@zygo.ca telephone 604 816 9713 1600-777 hornby street

1600-777 hornby street vancouver british columbia v6z 2t3 canada

ZYgo STRATEGIES INC.

2.

travelsignposts

SHOWS YOU WHAT PLACES ARE REALLY LIKE

ANTHONY J PAGE

Chief Executive Officer

Travel Signposts

29/4-8 Kareela Road, Cremorne Point, NSW 2090, Australia tel: +61 (2) 9953 4425 fax: +61 (2) 9909 8534 tonypage@travelsignposts.com

travelsignposts.com

MALMSTROM ASSOCIATES ORIENT

KARIN MALMSTROM CEO

Hong Kong tel +852 9135 5435 Beijing tel +86 1360 125 0297 karin@malmstrom.biz

M ASSOCIATES ORIENT CO. LTD.

Communications Consultancy

毛東行有限公司—市場策劃顧問

MICHAEL TANG

DIRECTOR

CORPORATE ID

CORPORATE ID ASSET MANAGEMENT LIMITED

SUITE 701, BARTLOCK CENTRE 3 YIU WA STREET CAUSEWAY BAY HONG KONG

TELEPHONE 2831 9902 FACSIMILE 2831 9907

鄧子豪

高達物資管理有限公司

香港銅鑼灣耀華街3號百樂中心701室 電話 2831 9902 傅真 2831 9907

AUTHORISED DISTRIBUTORS OF KODIT SECURITY TAGGING AND ASSET IDENTIFICATION SYSTEMS

MEY JEN STAGE PRODUCTIONS

BELLY DANCE * FLAMENCO * HAWAIIAN CLASSES & COSTUMES & SHOWS & STUDIO HIRE

5.

(OPPOSITE PACIFIC PLACE 3) I Anton Street Wanchai Hong Kong

tel/fax 2522 6698 oasisdance_hk@yahoo.com.hk www.oasis-dance-centre.com

MEY JEN TILLYER

ARTISTIC DIRECTOR

Design Firm Karacters Design Group Design Firm Graphicat Limited

Client

Designer

Vancity Kara Bohl

Client Designer Zygo & Michael Michael Borodiansky

Client

Designer

Designer

Travel Signposts Colin Tillyer

Client

Malmstrom Associates Orient Co. Ltd. Colin Tillyer

Client

Corporate ID Asset

Designer

Management Limited Colin Tillyer

Client

Mey Jen Stage Productions

Designer Colin Tillyer

253

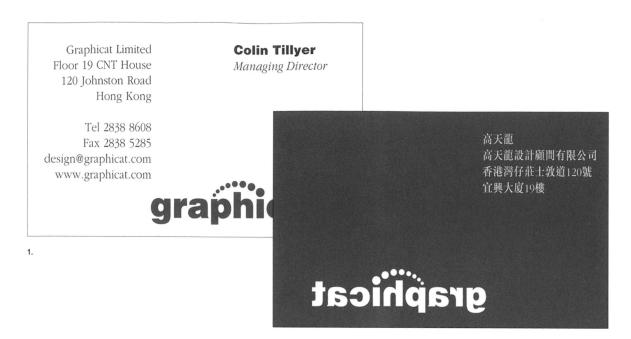

Pam Sefrino, president

referral work

Pre-screened professionals for jobs large and small, inside and out...residential and commercial. All contractors are stringently pre-qualified, licensed and insured.

We match your project or task with the contractors who meet your specific needs.

Builders, Painters, Electricians, Landscapers, Plumbers, Decorators and much more.

Won't cost a dime... just saves you time!

www.referralworksinc.com referralworks@comcast.net

(1) (2-	5)	Graphicat Limited Im-aj Communications & Design, Inc.	4.	Client Designers	The Spa at Salon Milano Jami Ouellette, Amy Medina, Katie Wetherby
1.			5.		
	Client Designer	Graphicat Limited Colin Tillyer		Client	Fine Catering by Russell Morin
2.				Designers	Jami Ouellette,
	Client	City Finds, Inc.			Mark Bevington,
	Designer	Jami Ouellette			Lee Kosa
3.			6.		
	Client Designers	Crossroads Jami Ouellette, Amy Medina, Katie Wetherby		Client Designer	Referral Works Jami Ouellette

THE TAPESTRY GROUP

SUSAN JONES MILLER
GENERAL CONTRACTOR
404.787.7499

FAX: 770.594.8983

ERIC DATRY Owner

SELIQUEY PLANTATION 814 McMath Mill Road AMERICUS, GEORGIA 31719 T: 229.924.5470

C: 404.931.2698

SOUTHERN UPLANDS, LLC

PRESCHOOL

MINISTRY

Linda Pirkle Assistant Wieuca Road Baptist Church 3626 Peachtree Rd, NE Atlanta, GA 30326 (404) 261-4220

7.

DIANA HARRIS PRESIDENT

GLORIOUS EVENTS, INC. 4048 FLOWERS ROAD, SUITE 200 ATLANTA, GA 30360 (404) 455-6600

FAX: (404) 455-6744

Design Firm Im-aj Communications & Design, Inc.

(4-8)Design Firm Young & Martin Design

Client Designers Rhode Island Children's Crusade Jami Ouellette, Robin Gerardi-Sarro

Client Im-aj Communications & Design, Inc. Jami Ouellette Designer

Client LISC Rhode Island Jami Ouellette, Robin Gerardi-Sarro Designers

Client Pete's Ladies & Mens Alterations Young & Martin Design Designer

Client The Tapestry Group Designer Young & Martin Design 6. Seliquey Plantation Client Designer Young & Martin Design 7. Wieuca Road Baptist Client Young & Martin Design Designer

Client Glorious Events Designer Young & Martin Design

8.

257

Marcia Shawler

Silk Road Collections, Inc. 411 Pembrooke Circle Alpharetta, Georgia 30004

> 770.569.1256 fax 770.569.8133

f: (404) 237-4329

david@davidharrell.com

.....

2.

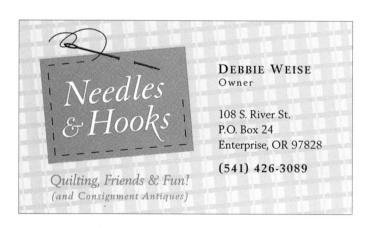

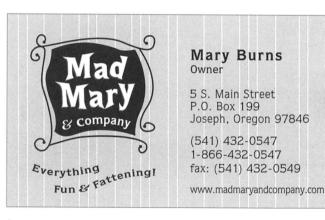

4.

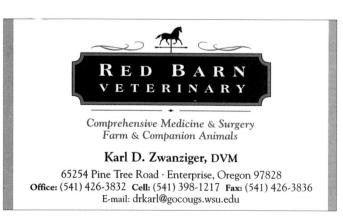

- 2300 Leo Harris Parkway
- P.O. Box 1518
- Eugene, OR 97440(541) 682-7888
- fax: (541) 484-9027 sciencefactory.org

6

8

Annette Hanson Social Services

1012 S. 3rd Street Dayton, WA 99328 (509) 382-3212 Fax: (509) 382-3217

email: AnnetteH@cchd-wa.org

HEALTH SYSTEM www.cchd-wa.org

Therapeutic & Relaxation Massage

Nancy Greene, LMT
Lic. #5779

306 NE 1st · Enterprise, OR 97828

(541) 398-0211
by appt. only

10.

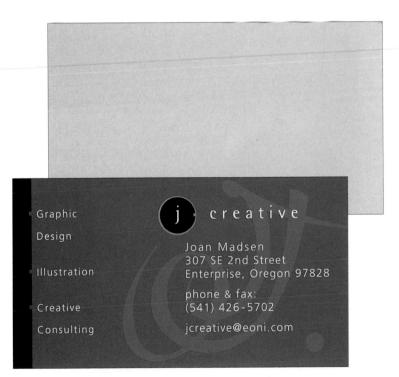

Design Firm Young & Martin Design . Design Firm j. creative Silk Road Collections, Inc. Young & Martin Design Client Designer David Harrell Young & Martin Design Designer Needles & Hooks Client Designer Joan Madsen Client Mad Mary & Company Joan Madsen Designer Red Barn Veterinary Client Designer Joan Madsen The Science Factory Client Joan Madsen Designer Collett Collett Client Joan Madsen Designer Lunine Annie's Client

Joan Madsen

Designer

Client Dayton General Hospital
Designer Joan Madsen

10.
Client Therapeutic & Relaxation
Massage
Designer Joan Madsen

11.
Client j. creative
Designer Joan Madsen

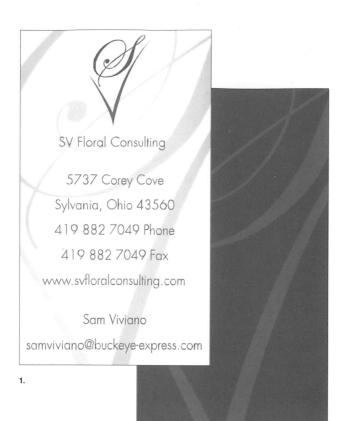

LAWRENCE P. SCHMAKEL, DDS

Lawrence P. Schmakel, DDS Oral Surgeon

General and Cosmetic Dentistry

709 Madison Avenue 315 Bell Building Toledo, Ohio 43624 419.241.3757

2.

Racing for Recovery A non-profit organization

6936 Clare Court Sylvania, Ohio 43560 419-824-8462 phone 419-824-8473 fax www.racingforrecovery.com

Todd Crandeli racing4recovery@aol.com

Racing for Recovery

Rob Pettrey President

728 W Samaria Rd Temperance, MI 48182 419.466.0248 phone rob@smallbiznetworks.biz www.smallbiznetworks.biz

network solutions for small businesses

www.small biznetworks.biz

Vice President

JAMIESONS (U)

5421 Monroe Street

419 882 2571

Toledo, Ohio 43623

c 419 351 5420

ric@jamiesonsaudiovideo.com

f 419 841 8303

near. See. Believe.

www.jamiesonsaudiovideo.com

Toledo Public Schools

420 E. Manhattan Blvd. Toledo, Ohio 43608-1267 419.729.8281 419.729.8392 Fax S;

tos ora

Of Learning

Eugene T. W. Sanders, Ph.D.

Superintendent and CEO

EMILY C. KELLER

INDIGO MARKET LTD. 25671-H FORT MEIGS ROAD PERRYSBURG, OHIO 43551 USA 419.872.7146 TELEPHONE 419.872.7147 FAX

7

(1-7)
Design Firm Lesniewicz Associates Client SV Floral Consulting Dosigner Amy Lesniewicz Client Schmakel Dentistry Les Adams Designer Racing for Recovery Amy Lesniewicz Client Designer Small Biz Networks Client Jack Bollingers Designer Client Jamiesons Audio/Video Jack Bollingers Designer Client Toledo Public Schools Les Adams Designer

Indigo

Jack Bollingers

Client

Designer

5535 Greenridge Drive Toledo, Ohio 43615 p 419.343.0776 f 419.868.1736 tyost@payxact.com www.payxact.com

Todd W. Yost President

Medical Malpractice Attorneys 7150 Granite Circle Toledo, Ohio 43617 Gary W. Osborne go@garyosbornelaw.com 419.842.8200

1

JZeisloft EUSTOM BUILDERS

2.

J Zeisloft Custom Builders, Ltd. 2632 Sherbrooke Rd. Toledo, OH 43606 419.486.9284 phone/fax 419.367.9284 cell jason@jzeisloft.com

Jason A. Zeisloft **President**

www.jzeisloft.com

3.

Alliance Venture Mortgage, LLC 3600 Briarfield Blvd. Suite 100 Maumee, Ohio 43537 MB#1888 419.930.5656 phone 419.930.5627 fax 419.704.5656 mobile

Alliance Venture Mortgage

Gregory L. Cepek
Partner/Lending Consultant
gcepek@AVMHomeLoan.com

www.avmhomeloan.con

LINDA EVERSOLE CUSTOMER SERVICE REPRESENTATIVE

1755 INDIAN WOOD CIRCLE SUITE 200 MAUMEE, OHIO 43537

419.891.5206 Ext.148 419.891.5210 Fax 888.232.5800

leversole@frontpathcoalition.com

ition.com

www.frontpathcoalition.com

WWW.GRROM.COM

GRROM

P.O. Box 250583

Franklin, MI 48025

Hotline 248.988.0154

www.gitoin.com

GOLDEN RETRIEVER RESCUE OF MICHIGAN

Laura Culp

6

Rob Cendol

State Certified Building Inspector

Preview Home Inspection

2422 Bar

Toledo, O

419.246.

Additional Certifications Offered:

■ Roofing

■ Structural

■ Electrical

Mechanical Heating

Plumbing

(1-7)
Design Firm Lesniewicz Associates

Client

6.

PayXact Jack Bollingers

Client Designer

Designer

Gary Osborne & Associates Jack Bollingers

Client J Zeisloft Custom Builders

Designer Amy Lesniewicz

Client Alliance Venture Mortgage Designer Amy Lesniewicz

5.
Client Frontpath
Designer Jack Bollingers

Client Golden Retriever Rescue of Michigan

Designer Amy Lesniewicz

Client Preview Home Inspection
Designer Amy Lesniewicz

Erie Bleu AlpacaFarm 1020 Gentry Medina, Ohio 44256 303-721-7938 phone 303-725-6316 fax ahirt@ohio.net

MAYER BROS.

Since 1852

FINE BEVERAGES

KENT WAKEFIELD

PLANT SUPERINTENDENT-SOMERSET DIVISION

P.O. Box 277, 7389 Lake Road, Barker, New York 14012 716.795.9930 ext.1 Fax 716.795.3901 www.mayerbrothers.com

2.

3121 Oak Orchard Road North of Five Corners Albion, New York 14411 (716) 589 . 8000

Fax: (716) 589 . 8001 1.800.274.5897

Lauren Kirby Store Manager

e-mail: kwatt@eznet.net

McElveney&Palozzi

1255 University Avenue - Suite 200 Rochester, New York 14607 (585) 473-7630 fax (585) 473-9506

Gloria Kreitzberg

gloriak@mandpdesign.com

ACCOUNTEXECUTIVE

3.

Building Machines with Ingenuity

Paul R. Barrett

Design Engineer 585-546-8868 1-800-799-8868 Fax: 585-546-4918

750 St. Paul Street Rochester, New York 14605 Web: www.rapidac.com e-mail: paul@rapidac.com Quality Vision Services, Inc. 1175 North Street Rochester, New York 14621 USA 716-555-1212 Fax: 716-555-1313 www.qvsmeasurement.com

Frederick Mason

Marketing Communications Manager

5

6

FORMS LABELS

APPAREL

INDUSTRIAL SILK SCREENING

Finger Lakes

Beulah Decker Marketing

Finger Lakes Tourism 309 Lake Street Penn Yan, New York 14527 Phone: 315.536.7488 ext. 16 800.530.7488 Fax: 315.536.1237

beulahd@fingerlakes.org

www.fingerlakes.org

PAT.DUGGAN@IMPACTPRINTSOLUTIONS.COM

PATRICK J. DUGGAN PRESIDENT

3U6 STAFFORD WAY ROCHESTER, NY 14626

PHONE: (585) 227-6850 FAX: (585) 227-6939

8.

WORLD CLASS PINOT NOIR FROM THE NIAGARA ESCARPMENT

Warm Lake Estate V 3868 Lower Mountain R www.WarmL

Michael J. VonHeckler Certified Wine Judge · Diploma in Wine office 716.731.5900 cell 716.471.5108 fax 716.731.2926

Design Firm Leenicwicz Associates Design Firm McElvency & Palozzi Design Group, Inc. Client Erie Bleu Alpaca Farm Designer Amy Lesniewicz 2. Client Mayer Bros. Lisa Parenti, Bill McElveney Designers 3. Client Watt Farms Steve Palozzi Designer Client McElveney & Palozzi Design Group, Inc. Designers Bill McElveney, Steve Palozzi Client Rapidac Machine Corporation Designers Matt Nowicki, Lisa Gates Client Quality Vision Services, Inc. Matt Nowicki Designer Finger Lakes Tourism Client Matt Nowicki Designer Client Impact Print Solutions Designer Matt Nowicki Client Warm Lake Estate

Mike Johnson

Designer

OUR MISSION

To maintain our stature as a first-class resort and conference center dedicated to consistently providing our guests with outstanding personal service and exceptional quality

199 Woodcliff Drive Box 22850 Rochester, NY 14692 Ph. (716) 381-4000 Fax (716) 381-2673

Peter R. McCrossen, C.H.A. General Manager (716) 248-4820

e-Mail:pmccrossen@woodclifflodge.com Visit us at: www.woodclifflodge.com

PATRICK WHITE | PRESIDENT/CEO PATRICK.WHITE@DOCUMENTSECURITY.COM

WWW.DOCUMENTSECURITY.COM

28 MAIN STREET EAST, SUITE 1525 | ROCHESTER, NY 14614 PH: 585.325.3610 | 1.877.276.0293 | FAX: 585.325.2977

3.

10 Munson Street LeRoy, New York 14482 (716) 768-2561 Fax (716) 768-4335

Catherine M. Caito Admissions Coordinator

John J. Doe • Director of Sales

17 Holland Street • Alexandria Bay, New York 13607 Phone: 1-800-ENJOY-US • Fax: (315) 482-5010 www.riveredge.com + e-mail: Enjoyus@Riveredge.com

3075 New Castle Avenue New Castle, DE 19720-2245

President

Phone: 302.429.8000 Fax: 302.429.8008

E-mail: wdupak@thelegacycorp.com www.thelegacycorp.com

Ieff Bruce MANAGER MATERIAL CONTROL

Injection Molding

BUSINESS GROUPS

2278 WESTSIDE DRIVE ROCHESTER, NEW YORK 14624-1996 716.594.9422 Fax: 716.594.9486

266

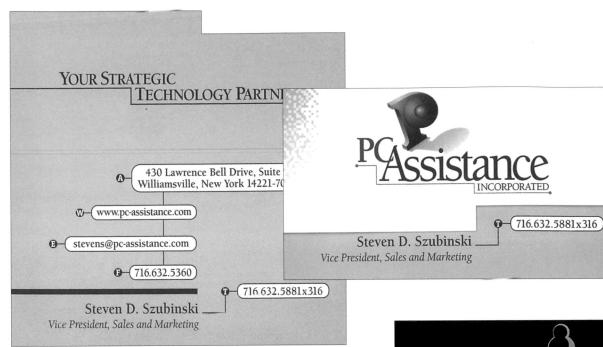

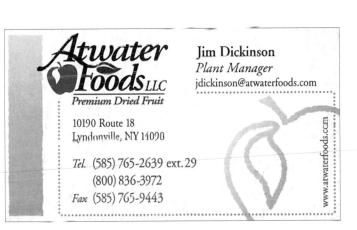

7.

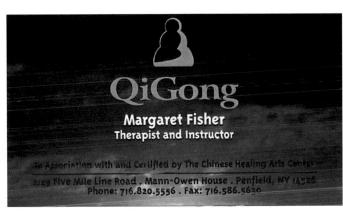

(1-10)

10.

Client

Designer

The Lodge at Woodcliff Client Ellen Johnson, Bill McElveney Designers Riveredge Resort Client Lisa Gates Designer Client Document Security Systems, Inc. Designer Lisa Gates Client Legacy Construction Corporation Designers Jon Westfall, Matthew Dundon LeRoy Village Green Client Lisa Parenti, Jan Marie Gallagher Designers Client CPI Business Groups Designer Jon Westfall PC Assistance, Inc. Client Designer Lisa Gates Atwater Foods LLC Client Designer Lisa Gates Client Margaret Fisher-QiGong Designer Lisa Parenti

Zoetek Medical

Lisa Gates

Design Firm McElveney & Palozzi

Design Group, Inc.

10.

2.

3.

Lisa T. Buyuk

177 Newbury Street Boston, MA 02116 617 262 • 0780

ARCHIVES FOR
HISTORICAL
DOCUMENTATION

LINDA CHRISTIAN-HEROT TREASURER AND CLERK

> 25 ARLINGTON STREET BRIGHTON, MA 02135-2197 TELEPHONE 617.562.0754 TELEFAX 617.562.0832

Paula Tursi Executive Director

NOK Foundation Inc c/o Quest Partners LLC 126 East 56th Street 19th Floor New York NY 10022

Telephone 212 838.7222 Telefax 212 838.4440

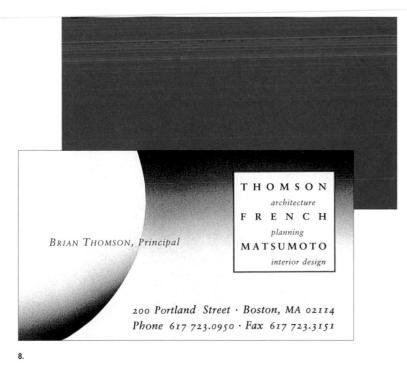

Design Firm McElveney & Palozzi Design Group, Inc. (2-8)Design Firm Nassar Design 1. Client Lucas Vineyards Designer Mike Johnson 2. Client Nassar Design Designers Nélida Nassar Margarita Encomienda Client Westgate Biological Ltd. Nélida Nassar, Designers

Designers Nélida Nassar,
Margarita Encomienda

4.
Client Marcoz Antiques •
Decorations
Designer Nélida Nassar

Client Archives for Historical Documentation Nélida Nassar Designer 6. Client Brave Heart Fund Nélida Nassar, Designers Margarita Encomienda Client NOK Foundation Inc. Designers Nélida Nassar, Jon Walters 8. Client Thomson French Matsumoto Nélida Nassar Designer

FEVZI GANDUR DENIZCILIK A.Ş.

Ali Fuad Gandur

Eski Büyükdere Caddesi Ayazaga Yolu Iz Giz Plaza 34398 Maslak İstanbul

P +90 (212) 290 6565 **F** +90 (212) 290 6555 fgm@seahorsenet.com

Chris Leary, AIA

Vice President . LEED $^{\text{IM}}$ 2.0 Accredited Professional

Architecture

2.

STUBBINS ASSOCIATES

 $Architecture \ I \ Planning \ I \ Interior \ Design$

T 617 491.6450 F 617 491.7104 Direct 617 250.4910

1030 Massachusetts Avenue Cambridge Massachusetts 02138-5388

www.stubbins.us cleary@stubbins.us

The Stubbins Associates, Inc.

CONSULTING

N2

NADINE NASSAR N2_consulting@yahoo.com

MARKETING STRATEGY . VISUAL DESIGN 231 West 26th Street Suite 6 New York NY 10001 T 917 992.8376

KEN VIALE PHOTOGRAPHY

415 497 1995 photos@kenviale.com

www.kenviale.com

still

R J M U N A

PICTURES

AMY AUERBA

225 INDUSTRIAL STREET SAN FRANCISCO, CALIFORNIA 9 4 1 2 4 - 8 9 7 5

pictures@rjmuna.com NET

5.

Shanrock Ranch

Kennels & Stables

Peter Voskes

Pacifica, CA 94044-4099 t. 650.359.1627 f. 650.359.1670

BEACH HOUSE INN & CONFERENCE CENTER

4100 North Cabrillo Highway HALF MOON BAY, CALIFORNIA 94019

> TEL 415.712.0220 Fax 415.712.0693 800.315.9366

VIEW@BEACH-HOUSE.COM

CARRIE FLYNN

ocean lofts

OR OF SALES & MARKETING

Design Firm Nassar Design

(4-7)
Design Firm Studio Moon

Client Fevzi Gandur Denizcilik A.S.

Designer Nélida Nassar Client The Stubbins Associates, Inc.

Nélida Nassar, Margarita Encomienda Designers

Client N2 Consulting Nélida Nassar, Designers Margarita Encomienda

Client Designer Tracy Moon Client

R.J. Muna Tracy Moon

Designer Client

Dana Denman, Shamrock Ranch

Designers Tracy Moon, Sheila Buchanan

Client Carrie Flynn, Beach House Designer Tracy Moon

Ken Viale, Photography

VINEYARD CREEK HOTEL Spa & Conference Center

SANDY L. GIBBONS

170 Railroad Street Santa Rosa CA 95401

tel 707.528.4542 fax 707.528.1554 toll free reservations 888.920.000 sgibbons@vineyardcreek.com

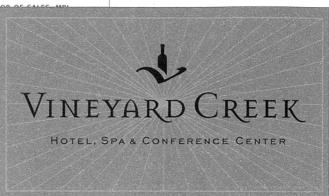

leno☆

1278 third ave. new york 10021 t 212 772 0404 f 212 772 3229 lenoxrestaurant.com

eat.drink.lounge.lenox

dog days

Marin Dog Walking Services

Raquel Barrios > Alpha Dog

415-518-4761 raquel@dogdaysmarin.com { Insured > Licensed > Bonded }

6.

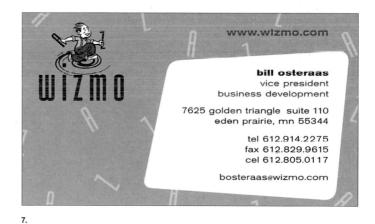

(1-7)
Design Firm Studio Moon

Client Designer Tracy Nichols Tracy Moon

Client Designer Amy Jo Kim, NAIMA Tracy Moon

Client Designer Cindy Eksuzian Tracy Moon

Client Designers Vineyard Creek Hotel & Spa Tracy Moon, Justine Descollonges Client Designers Tony Fortuna, Lenox NY Tracy Moon, Justine Descollonges

6. Client

Raquel Barrios, Dog Days Tracy Moon

Designer Tra

Client Wizmo, Inc. Designer Tracy Moon

FAB LOGISTICS GLOBAL LOGISTICS | AND TRANSPORTATION SERVICES

THOMAS H. MOON President

437 Rozzi Place № 112, S. San Francisco, CA 94080
tel 650 827 1050 fax 650 827 1049 cel 415 999 3127
email tmoon@fablogistics.com www.fablogistics.com

GERALD A. EMANUEL

97 EAST ST. JAMES STREET SUITE 102 SAN JOSE, CA 95112 TEL 408.286.3710 FAX 408.292.4436

LISA SEWELL
MILL VALLEY BABY COMPANY

11 THROCKMORTON
MILL VALLEY, CA 94941
TEL 415 389 1312
FAX 415 389 1328
LISA@MILLVALLEYBABYCO.COM
MILLVALLEYBABYCO.COM

vw.violet.com

STUDIOMOON

IDENTITY DESIGN

77 DE BOOM
SAN FRANCISCO 94107
T 415 957 9761 F 957 9739
TRACY@STUDIOMOON.COM
WWW.STUDIOMOON.COM

TRACY MOON

6.

MILL VALLEY KIDS COMPANY

12 MILLER AVENUE

MILL VALIFY, GA 94941

TEL 415 389 1312

FAX 415 389 1328

STOP-OMMBAPYANDKIDS.COM

OKIDS.COM

RIDS.COM

8.

Design Firm Studio Moon

1. Client Designers Tracy Moon, Justine Descollonges

2. Client Designers Tracy Moon, Justine Descollonges

3. Client Designer Jacob Rosenberg Tracy Moon

4. Client Designer Output Forestel

(1-9)

Client Jacob Rosenberg
Designer Tracy Moon

Client Gerald Emanuel
Designer Tracy Moon

Client Lily Kanter Sarosi
Designers Tracy Moon,
Sheila Buchanan

Client Tracy Moon Designer Tracy Moon Client Violet Online Gifts Designer Tracy Moon Client Lily Kanter Sarosi Tracy Moon, Designers Sheila Buchanan Client Jacob Rosenberg Designer Tracy Moon

You Have an Appointment With Lisa

Name:

Time: _____

Date:

t. 650.359.1627 f. 650.359.4 www.shamrockranchkennels hamrock Ran

Lisa Rhodes

Director of Training

Pacifica, CA 94044-4099 650/359.1627 ext. 308

DOUGLAS MADELEY GENERAL MANAGER

CALYPSO IMAGING, INC. 2000 MARTIN AVENUE SANTA CLARA, CALIFORNIA ZIP 95050.2700

DOICE MAIL 408.450.2136

TEL 408.727.2318
TOLL FREE 800.794.2755
FAX 408.727.1705

IMAGES/EUERYTHING...

2.

Peter Douglas

President and CEO

salusmedia

14529 Dickens Street • Sherman Oaks • California 91403 tel 818.990.0607 • fax 818.990.4408 pdouglas@salus.net salusmedia

EPHRAIM GREENWALL

51 FEDERAL STREET SUITE 303 SAN FRANCISCO CA 94107

telephone 415.357.1005 facsimile 415.357.1006

cgrccnwall@talcottholdings.com

C2 team Communication · Coaching · Training

Karin Dölla-Höhfeld

Am Römerberg 38 D-55270 Essenheim/Mainz Fon 0.61 36/95 34 80 Fax 0.61 36/95 34 84

info@C2team.de · www.C2team.de

5.

Sei, der Du bist und werde, der Du sein kannst.

Am Hang 2 27711 Osterholz-Scharmbeck Fon 047 91.96 62-44 Fax 047 91.96 62-77 www.ziegeler-web.com a.ziegeler@ziegeler-web.com

Andreas Ziegeler Geschaftsführer

Unsere Filiale im Haven Höövt Center in Bremen-Vegesack www.leichtsinn.com

Leicht Sun Schöner schenken

Design Firm Studio Moon (5,6)
Design Firm Buttgereit und Heidenreich GmbH Client Client Lisa Rhodes, Shamrock Ranch Dog Training Tracy Moon, Kevin Bonner Client Joseph Levine Tracy Moon Designer Peter Douglas Tracy Moon, Justine Descollonges Designers Client Talcott Holdings Designer Tracy Moon

C2 Team

Ziegeler Home & Garden

Wort und Tat

Allgemeine

Missions-Gesellschaft e. V. Postfach 110111 · 45331 Essen Telefon: 0201-678383

Spendenkonten: Deutschland:

Deutsche Bank Essen, 3 400 488 (BLZ 360 700 50¹) Postbank Essen, 5418-4; **Schweiz**:

UBS Schweizerische Ba 8021 Zürich

Wort und Tat Hilfswerk Entwicklungsländerproj 8953 Dietikon UBS AG, § 230-391683.01X

Österreich:

Österreichische Postsp 90.230.969 (BLZ 60 000) Helfen Sie mit

Wortundtat

www.wortundtat.de

st die "Bodenhaftung", die an I Imfelds Arbeiten überzeugt, sichere Gefühl für Form und erial, die virtuose, spannungshe Bearbeitung. Dabei wird die ftvolle Präsenz eines Werkes och immer transparent für eine ite Wirklichkeit: die Wirklich-Gottes. Karl Imfelds Arbeiten ottesdienstlichen Räumen chen diese geistliche Qualität ihrbar.

Siegmar Rehorn Künstlergruppe DAS RAD

Herengracht 341 · 1016 az Amsterdam Telefoon +31 (0) 20 626 23 33 · Fax +31 (0) 20 624 53 21

Eine unglaubliche Kirche.

Expowal

Chicago Lane 9 · 30539 Hannover Fon: 05 11 - 8 76 57 69 · Fax: 05 11 - 8 76 57 74

 $info@expowal.de \cdot www.expowal.de \\$

3

kickoff2006 Kölner Str. 23a 57610 Altenkirchen Tel. 0700-96972006 info@kickoff2006.org

kickoff2006 in Deutschland – Gastgeber der Welt zur Fussball-WM 2006.

www.kickoff2006

5.

7.

Christliche Ehe- und Familienseminare

Short If your life

Michaela Lück

Produktmanagement

Einfacher und glücklicher Leben

VNR Verlag für die Deutsche Wirtschaft AG Theodor-Heuss-Str.2-4 53177 Bonn Tel.: (02 28) 82 05-73 54 Fax: (02 28) 36 67 07 mlue@vnr.de TEAM.F

Neues Leben für Familien e.V. Christliche Ehe- und Familienseminare Honseler Bruch 30 · 58511 Lüdenscheid Fon 0 23 51.8 16 86 · Fax 0 23 51.8 06 64 info@team-f.de · www.team-f.de Wir sind für Sie da!

8.

(1-9) Design Firm Buttgereit und Heidenreich GmbH

Client Wort und Tat

Client Karl Imfeld

Client Ambassade Hotel

4.

Client expowal

Client Kick Off 2006 TM

Client Zoom
7.
Client Holle
8.
Client Team.F

Client Simplify your life

Wouter Schopman

directeur

Koan Float Technologies b.v.

Oude Spiegelstraat 7 1016 BM Amsterdam Telefoon +31 (0) 20 5 55 03 00 Fax +31 (0) 20 5 55 03 77 info@koan-float.com www.koan-float.com

1.

Andreas Baumann

Pferdewirtschaftsmeister

Klixdorf 51 D-47906 Kempen Tel.: 0 21 52/5 13 36 Fax: 0 21 52/51 88 82

mail@hulingshof.de www.hulingshof.de

Der Ausbildungsstall für Vielseitigkeits-Pferde.

Hotel Rössli Familie B. und D. Caluori-Imfeld CH-6078 Lungern am See Telefon 041/69 11 71 Fax 041/69 11 81

2.

Bernd Peters Dipl.-Betriebswirt (FH) Steuerberater Rechtsanwalt

Chemnitzer Straße 11 45699 Herten Fon 0 23 66/18 07 44 Fax 0 23 66/18 07 45 info@beratung-peters.de www.beratung-peters.de

Dave Gilman

your company Phone 781 891 4162

Fax 781 891 4162 Fax 781 891 4557 Mobile 617 947 5661

dgilman@cognitocreative.com www.cognitocreative.com 99-B Charlesbank Way Waltham, MA 02453

Chris McCann

chris@print-resource.com

Ph 508-424-1177 **Cell** 508-400-4411

Fax 508-424-1188

965 Concord Stree Framingham, MA

Chris McCann

chris@print-resource.com

Ph 508-424-1177 **Cell** 508-400-4411

Fax 508-424-1188

965 Concord Street Framingham, MA 01701

Heidi Mercer Principal 8 Notre Dame Road Bedford, MA 01730 781.276.7993

hmercer@brandscendconsulting.com www.brandscendconsulting.com

7.

(5-8)

Linda R. Plaut Consultant

70 Crescent Street Newton, MA 02466 617.527.8283 Phone 617.552.7133 Facsimile www.ci.newton.ma.us

Design Firm Cognito 1. Client Koan Float Technologies 2. Hulingshof Client Client Hotel Rössli Client Haus der Beratung Cognito Dave Gilman Client Designer Print Resource Client Dave Gilman Designer Client Brandscend Designer Dave Gilman Newton Pride Committee Designer

Design Firm Buttgereit und Heidenreich GmbH

Robyn Andelman Event Planner

100 Commerce Way, Woburn, MA 01801 1-888-MAK-MEET(ings) 781-994-1200

r.andelman@meetingmakers.com • www.meetingmakers.com

Steve Lentini
President

Phone 781-592-9129 Mobile 978-257-0610

129 Lynn Shore Drive Lynn, MA 01902

2.

Stephen R. Shane

owner

369 Littleton Road Westford, MA 01886

Hours:

Mon. – Fri. 8:00–5:00 Saturday 9:00–2:00

1-800-320-2213 1-978-692-5655

Evening Appointments Available

3.

FAX 781.890.0065

"LINKING 960 W. Hedding

PEOPLE Suite 164

AND IDEAS, San Jose

FINDING CA 95126

CONTEMPORARY Tel: 408.452.4700

Fax: 408.452.4636

Community Partnership of Santa Clara County

www.castileventures.com

ROLAND A. VAN DER MEER

rvandermeer@comven.com

COMVENTURES

T 650.325.9600 F 650.325.9608

SHITE 305

505 HAMILTON AVENUE PALO ALTO, CA 94301

www.comven.com

7.

www.exponentcap.com

NANOCOS TECHNOLOGIES, INC. Design Firm Cognito

Design Firm Gee + Chung Design

Client Designer MeetingMakers.com Dave Gilman

Client Designer

Boost Your Sales Club Dave Gilman

Client

Alpine Glass Dave Gilman

Designer

Designer

Community Partnership of Santa Clara County Fani Chung

Client

Castile Ventures Designers Earl Gee, Fani Chung

Exponent Capital, LLC

Designer Earl Gee

Earl Gee, Fani Chung Designers

Nanocosm Technologies, Inc. Designers Earl Gee, Fani Chung

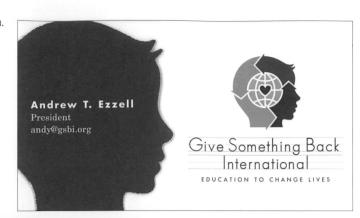

eldersupport

Christy Stangler, MA, NHA Geriatric Consultant

777 S. New Ballas Rd.

(p) 314.989.1000

Suite 301E

(f) 314.989.1133

St. Louis, MO 63141

(e) eldsupservinc@aul.com

Charlie Smith Building Engineer

tel: 314.241.1175

701 Market Street Suite 1230

Saint Louis, MO 63101

realty advisors, inc.

fax: 314.241.4867 web: evsra.com

e-mail: charlie.smith@evsra.com

FIRST& MAIN PROPERTIES

Richard M. Robinson PRESIDENT

3405 Hawthorne Blvd. t 314.405.2664 St. Louis, MO 63104

f 314.732.4199

rmr@firstandmainproperties.com

(1,2)
Design Firm Gee + Chung Design

Design Firm Paradowski Creative

Client Give Something Back International Earl Gee Designer

Client

Designer

Xinet, Inc. Earl Gee

Steve Cox

Designer Client Eldersupport Services, Inc.

5.

First & Main Properties Designer

Shawn Cornell

Client Designer

EVS Realty Advisors, Inc. Steve Cox

2.

Richard Lewis

Maintenance Engineer
Insignia/ESG, Inc.

RIVERPORT
LAKES

The Natural Place for Busines
Suite 102

Maryland Heights, MO 63043

tel: 314.770.1700 fax: 314.770.2992

standing

strategic communications issues management

LAURA MCALLISTER vice president

540 maryville centre drive suite 100 st. louis, missouri 63141

314.469.3500 314.469.3512 [fax] Imcallister@standingpr.d www.standingpr.com

account manager heather m. wolfe

303 north broadway saint louis, missouri 63102 www.paradowski.com (email) heather@paradowski.com (fax) 314.241.0241 (phone) 314.241.21

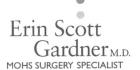

skin cancer & cutaneous surgery

www.DrErinScottGardner.com

5000 Cedar Plaza Parkway Suite 240 Saint Louis, Missouri 63128

314/849-7546

(f) 314/849-7558

Design Firm Paradowski Creative

Client Designer HERA Joy Marcus

Client Designer

Tango Cat Shawn Cornell

Client Designer

Riverport Lakes Shawn Cornell

Client Designers

Standing Partnership Alex Paradowski, Steve Cox

Client Designers

Paradowski Creative Alex Paradowski, Steve Cox

Client

Erin Scott Gardner, M.D.

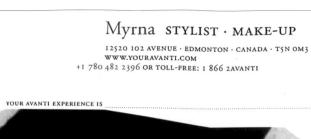

Myrna stylist · make-up

12520 102 avenue · edmonton · canada · t5n 0m3 www.youravanti.com +1 780 482 2396 or toll-free: 1 866 2avanti

YOUR AVANTI EXPERIENCE IS

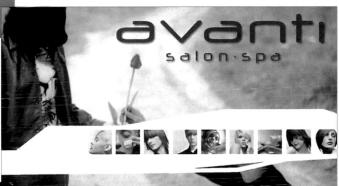

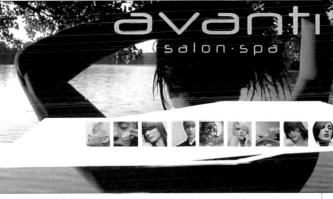

Myrna stylist · make-up

12520 102 AVENUE · EDMONTON · CANADA · T5N OM3 WWW.YOURAVANTI.COM +1 780 482 2396 OR TOLL-FREE: 1 866 2AVANTI

Myrna stylist · make-up

12520 102 AVENUE · EDMONTON · CANADA · T5N OM3

WWW.YOURAVANTI.COM +1 780 482 2396 OR TOLL-FREE: 1 866 2AVANTI

GUINOT [comfort zone] AVEDA

YOUR AVANTI EXPERIENCE IS chwarzkopf YAN GUINOT [comfort zone] AVEDA

(1)
Design Firm Don Eglinski

Client Avanti Salon Spa Designer Don Eglinski

MARY CORKELL

FORTRESS TECHNOLOGIES. INC.

voice: 630.455.9360 ext: 323

fax: 630.455.9365

email: mcorkell@fortress-im.com

907 NORTH ELI SUITE 300 HINSDALE, ILLI

www.fortress-im

ARTISAN INTERACTIVE

SOUTH SAWTELLE

LOS ANGELES

CALIFORNIA 90025

ARTISAN INTERACTIV

JON D. FROMAN

PHONE. 310.312.2002

FAX: 310.312.0607

CHICAGO • LOS ANGELES

Micro Perfumery

GLEN METELMANN

THE MICRO-PERFUMERY, MINC
P.O. BOX 2121 • BONITA SPRINGS, FLORIDA 34133
tel: 800.682.8082 • web: www.microperfume.com
email: glenm@microperfume.com

Cynthia Pougiales, AIA

ARCHITECTURE :: DESIGN/BUILD

incorporated

350 Old Y Road - Golden, Colorado 80401 tel> 303.526.9128 fax> 303.526.9131cell > 720-581-9128 email > pougiales@msn.com

LISA ROMANOWSKI 23486 CURRANT DRIVE

lisa@studioRoman 303 | 526 FAX | 526

GOLDEN, COLOR www.studioRoman

rd means health, s beauty.

ARTMENT TOWER KE SHORE DRIVE

OIS 60611

DORINDA ALLHANDS ESTHETICIAN/REFLEXOLOGIST

Design Firm Roman Design

Client Fortress Technologies Lisa Romanowski Designer

Artisan Interactive Client Lisa Romanowski Designer

The Micro-Perfumery, Inc. Lisa Romanowski Client Designer

Client Thira, Incorporated Lisa Romanowski Designer

Client Designer Lisa Romanowski

6. Client Roman Design Lisa Romanowski Designer

FORM + FUNCTION

Donna M. Panko
Image Builders, Inc.

Professional Presence Training
& Image Enhancement

10651 Hollow Tree Road
Orland Park, Illinois 60462
phone: 708.226.0699
fax: 708.226.0698
email: imagebld@megsinet.net
web: www.iwwi.com

3.

www.gentner-drehteile.de

4

NOVAZET GmbH Zerspunungstechnik Max-Planck-Str. 5/1A D-78549 Spaichingen www.novazet.com

Tel. 07424 5275 Fax 07424 5306 info@novazet.com

INNOVATION **PRÄZISION SERVICE**

www.novazet.com

78647 Trossingen-Schura

Tel. 07425 1788 Fax 1739 mobil 0170 5617304

JAN SCHÖNDIENST

Design Firm Roman Design

(4-7)
Design Firm revoLUZion, advertising

Client Form + Function Designer Lisa Romanowski

Client Dream Interiors, Inc. Designer Lisa Romanowski

Client Image Builders, Inc. Designer Lisa Romanowski

Gentner, Tuttlingon Designer Bernd Luz

Client Designer Silke Alber, Fridingen

Client

Novazet GmbH, Spaichingen Designer

Client Designer

Geflügelhof Schöndienst

Micromed
Medizintechnik GmbH
Esslinger Straße 37
D-78532 Tuttlingen
Tel +49 7462 92 32 50
Fax +49 7462 92 32 46
esteidle@micromed.biz
www.mlcromed.biz

bwproperty.

Brad Wheatley Principal & L.R.E.A 96A Glenhaven Road Glenhaven NSW 2156

M 0408 414 070 T/F 02 9894 5787

E enquiries@bwproperty.com.au

W www.bwproperty.com.au

DWPROPERTY.

119 McEvoy Street Locked Bag 5010 Alexandria NSW 2015 Australia

Jason Garrett Product Development Manager Tel (61 2) 8399 4999 Mobile 0403 857 542 Fax (61 2) 8399 2277 jgarrett@jct-technologies.com.au

8.

www.jet-technologies.com.au

Patrick Gallagher
MANAGING DIRECTOR

Suite 1, 271 Pacific Highway North Sydney 2060 Ti 07 9922 21/7 F: 02 9922 5944

M: 0405 100 751 E: patrick@ghm.net.au

1-6)
Design Firm revoLUZion, advertising and design

(7-9)
Design Firm Aslan Design & Graphics

Design Firm Asian Design & Graphic

1

Client Harder Friseurfachschule Designer Bernd Luz

Client Softwork GmbH, Mühlheim Dosigner Bernd Luz

Client Allform Immobilien AG
Designer Bernd Luz

Client Rolf Luz GmbH, Neuhausen Designer Bernd Luz

5.
Client Micromed Medizintechnik GmbH
Designer Bernd Luz

Client Wieser, Mühlheim Designer Bernd Luz

Client bw property
Designer Charlene Walker

Designer Charlene Walker

Client Jet Technologies
Designer Charlene Walker

Client Gallagher Hotel Management Designer Charlene Walker

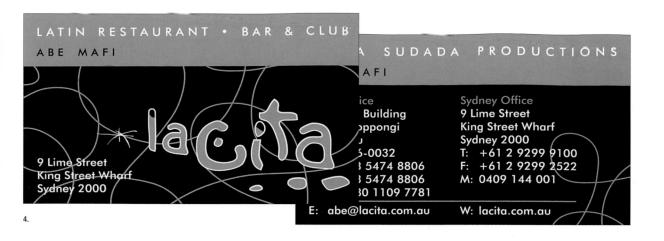

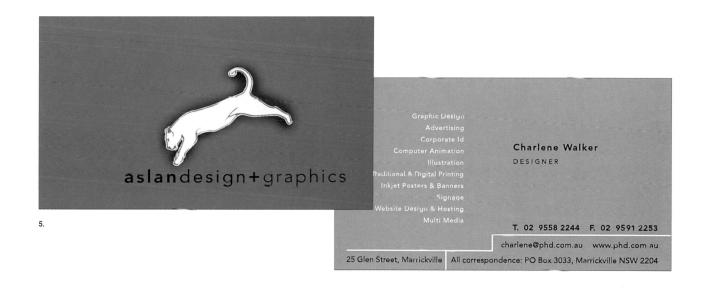

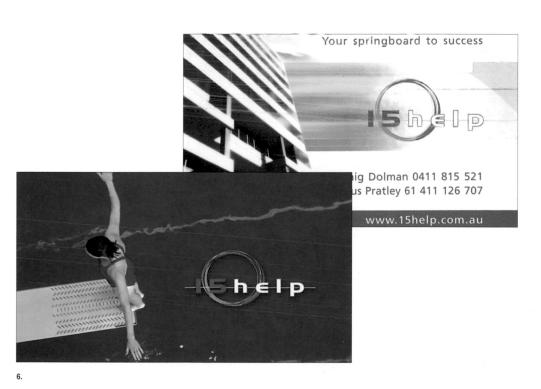

Design Firm Aslan Design & Graphics Client Margaret's Place Designer Charlene Walker 2. Client Incognito Events Designer Charlene Walker 3-4. Client La Cita Restaurant Designer Charlene Walker Client Aslan Design & Graphics Designer Charlene Walker Client 15 Help Designer Charlene Walker

Christina Farrugia

Director

Unit 1, 2 Endeavour Road Caringbah NSW 2229

T: 02 9526 2457

F: 02 9526 145 M: 0418 388 86

christina@nailmar nailmart.com.au

citrus group

Citrus Group Pty Ltd PO Box 380 Vaucluse NSW 2030

T: 1800 097 957

+ 61 2 9388 8894

sales@dibi.com.au

W: www.dibi.com.au

nroader, Sr.

T . 253.460.9261 F . 253.566.9901 C . 253.861.8845 4618 Alameda Avenue West . University Place, WA 98466

4.

Sukhui Rodgers, RDH, BS

1100 Station Drive, Suite 221 DuPont, Washington 98327 Tel 253.912.4443 Fax 253.912.4426 WebSite www.dupontdental.com

Take exit 119 off I-5, head west to Wilmington Dr., turn right.

Barksdale Station is on the right, we are on the second floor above Starbucks.

5.

www.jndprinting.com

Jim Vitzthum

jim@jndprinting.com

253.272.2600 ex.211 253.572.1464 fax 253.606.8088 cell

815 South 28th Street, Tacoma, Washington 98409

(1-3)
Design Firm Aslan Design & Graphics
(4-6)
Design Firm Colin Magnuson Creative

Client Nail Mart Australia Charlene Walker Designer Citrus Group Designer Charlene Walker Client Platinum Designer Charlene Walker Client Lorden Professional Services Colin Magnuson DuPont Dental Client Designer Colin Magnuson Client J&D Printing

Colin Magnuson

Designer

Always Remember.

CREATION **DENTAL** ARTS

Robb J. Stilnovich President robb.stilnovich@tacomamonument.com

2309 South Tacoma Way . Tacoma, WA 98409
Tel | **800.426.5973** . Fax | 253.472.4832
www.tacomamonument.com

GARRETT T. ZUMINI | Financial Officer gtz@creationdental.com

7727 40TH STREET WEST UNIVERSITY PLACE, WA 98466 CDA

p 253 565 1035 f 253 565 4801

tf 800 694 1035

www.creationdental.com

2.

Darin Rueppell President

2605 Jahn Ave. NW . Suite D-7
Gig Harbor, Washington 98335
1.877.RUEPPELL (783.7735)
Fax . 1.877.257.5127
info@rueppell.com

ROBERT E. WAGNER, D.C.

10415 Canyon Road E Puyallup, WA 98373

Tel 253 537 6000 Fax 253 536 5544

Design Firm Colin Magnuson Creative

Client Tacoma Monument Designer Colin Magnuson Creation Dental Arts Designer Colin Magnuson Rueppell Home Design Client Designer Colin Magnuson Crest Builders Client Colin Magnuson Designer 5.

Client LoanTek Colin Magnuson Designer

Client Casualty Loss Consultants Colin Magnuson Designer

Client Atlas Services Designer Colin Magnuson

> Client Chase Chiropractic Colin Magnuson Designer

301

WWW.QUALITYPAINTINGINC.COM

15111 105th Avenue Court East
Puyallup, Washington 98374

253 tel 848 8153
fax 845 6898

253 cell 405 5333

Specializing in commercial painting,
special coatings, wall coverings,
and water repellents for the
Northwest's environment

PAINTING

Marlene Anglemyer

INCORPORATED

2.

marlene@qualitypaintinginc.com

Told old

5

Scott E. Parker principal scott@fuellounge.com

fuellounge.com 348 south main st. akron, oh 44311 tel 330.434.FUEL /3835/ fax 330.761.9795

imported beers indulgent. foods

Leslie R. Letner EVENTS COORDINATOR

546 Grant Street Akron, OH 44311-1158 p: 330 535 6900 x237 f: 330 996 5337

leslie@akroncantonfoodbank.org www.akroncantonfoodbank.org

7.

Keeven White

keeven@whitespace-creative.com

WhiteSpace Creative 24 North High Street, Suite 200 Akron, OH 44308

330.762.9320 // Fx: 330.762.9323 www.whitespace-creative.com

Design Firm Colin Magnuson Creative

Design Firm In full view

Design Firm ...oid design

Design Firm WhiteSpace Creative

Client The Tax Store Designer Colin Magnuson

Client

Quality Painting Colin Magnuson, Rachel Costner Designers

3. Client Designers

Chatelain Property Management Colin Magnuson, Rachel Costner

Client Designer

In full view Nadia Mahfoud

Client Designers

.oid design Ben Grosz, Dong Uong

Client

Fuel Wine and

Martini Lounge Sharon Griffiths, Designers Keeven White

Client

8.

Akron-Canton Regional Foodbank Designers Jennifer Barnby,

Keeven White

Client Designers

WhiteSpace Creative Jennifer Barnby, Sean Mooney, Keeven White

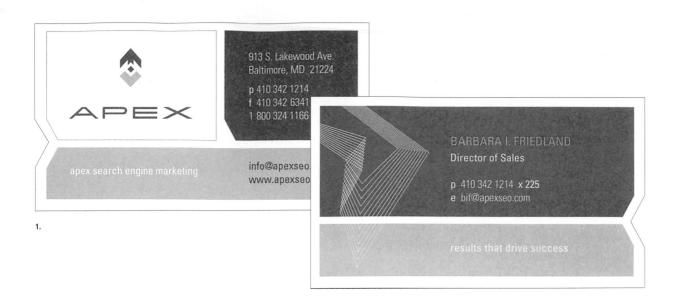

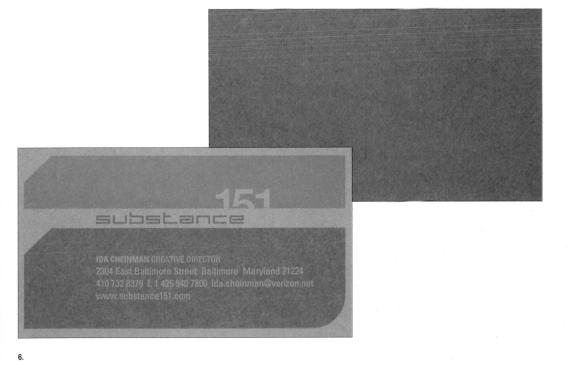

(1-6)Design Firm Substance151 1. Client Apex SEO Designers Ida Cheinman, Rick Salzman Client National Foundation for Debt Management Designers Ida Cheinman, Rick Salzman Client Plethora Technology Ida Cheinman, Designers Rick Salzman Client InSource Designers Ida Cheinman, Rick Salzman Client Litecast Designers Ida Cheinman, Rick Salzman Client Substance151 lda Cheinman, Rick Salzman Designers

Gregory J. Sarno President & CEO

gsarno@clubads.tv

542 Westport Avenue Norwalk CT 06851

203 840-0020 Office 203 840-1310 Fax 203 919-2005 Cell

Get Noticed™

www.clubads.tv

S♣ Margaret

Margaret Tobelman PO Box 921, Killingworth, CT 06419 www.cadc.org 860.663.1264 860.663.2018 m_tobelman@cadc.org

Alli Ugosoli **Photography**

123 rivington st #9 new york ny 10002

917 566 2536

alliuphotography

Alli Ugosoli

@yahoo.com

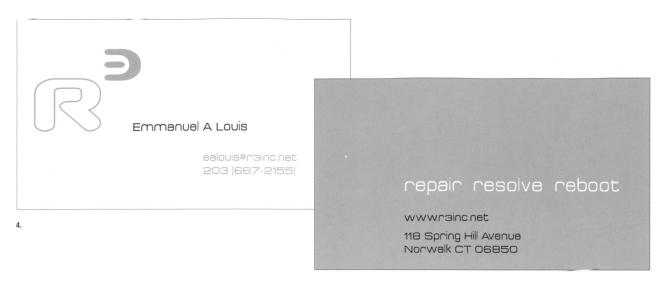

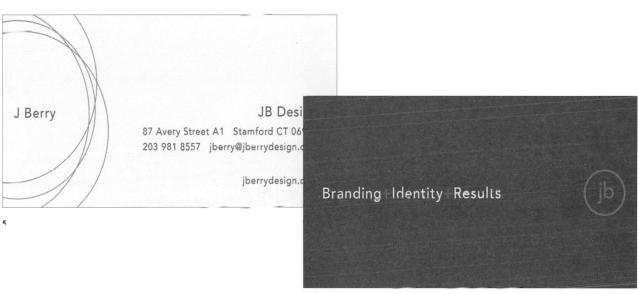

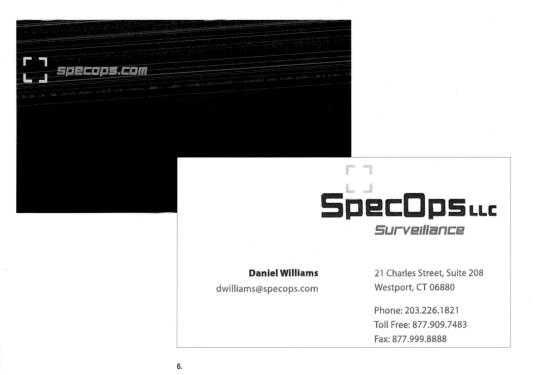

(1-6) Design Firm **JB Design** Client ClubAds Designer J. Berry 2. Client CADC 3. Client AU Photography Designer Client J. Berry Designer 5. Client JB Design J. Berry Designer Client Spec Ops J. Berry

Designer

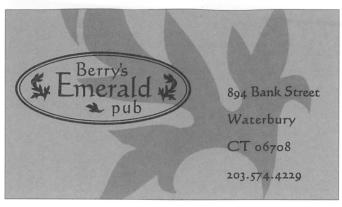

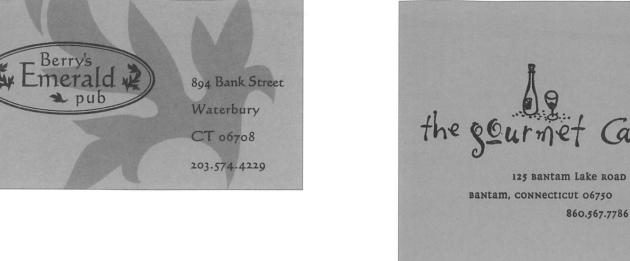

live jazz & blues

15 N Main Street South Norwalk, CT 203. 838. 3531

werbe

BEATE HEMMERLEIN

WERBE 3 / FLIEDERWEG 3 / A-2380 PERCHTOLDSDORF TELEFON +43 1 86 53 400 / FAX +43 1 596 82 24 MOBIL +43 676 311 56 00 / EMAIL beate@trias.at BUNDESRAT I.R.

Manfred Abautner Abarkhof

PROF. DR. H.C., GESCHÄFTSFÜHRENDER GESELLSCHAFTER

MAUTNER MARKHOF

INDUSTRIEBETEILIGUNGS G.M.B.H.

SIMMERINGER HAUPTSTRASSE 101 A - 1 1 1 0 W I E N

TELEFON (43) 1 740 44-121 TELEFAX (43) 1740 44-228

EMAIL profmmm@mmag.at

vision

maxim m. rivkin president

h)vision

128 wheeler road, burlington, ma 01803 781.505.8360 fax 781.998.5656 max@nvisionoptics.com www.nvisionoptics.com

Design Firm **JB Design** (4-10)Design Firm über, inc.

Client Designer

Berry's Emerald Pub

J. Berry

The Gourmet Cafe

Designer J. Berry

Designer

J. Berry

Designer

Mautner Markhof Herta Kriegner

Client

Werbe 3 Edita Lintl

Ton Ab!

Edita Lintl

Designer

Client Designer

Client N-Vision Optics Edita Lintl Designer 10. Client Coturn Gias Designer Jimmy Ng

Client

Client

Designer

Designer

Perfect Security

Sari Gallinson

Edita Lintl

e-solutions bring it alive

olzhuber geschäftsführer

holzhuber marketing und werbegesellschaft m.b.h.

campus 21 - businesspark wien süd | liebermannstraße f03 402

a-2345 brunn am gebirge fon +43-1-866 70 222 88

mobile +43-664-343 00 88 | fax +43-1-866 70 222 81

thomas.holzhuber@impaction.at | www.impaction.at

dr. thomas holzhuber | geschäftsführer holzhuber marketing und werbegesellschaft m.b.h.

campus 21 - businesspark wien süd | liebermannstraße f03 402

a-2345 brunn am gebirge | fon +43-1-866 70 222 88

mobile +43-664-343 00 88 | fax +43-1-866 70 222 81

thomas.holzhuber@impaction.at | www.impaction.at

dr. thomas holzhuber geschäftsführer

mobile +43-664-343 00 88 | fax +43-1-866 70 222 81

belly Bb basics°

Juliana Alvim Brand Director

Juliana@BellyBasics.com

55 W 39th St, 17th FI. NY, NY 10018 T 212.685.6825 F 212.768.3470

www.blueribbonprostateinitiative.org www.brprostate.org

250 West 57th St, Suite 716 New York, NY 10107 212.489.0 1616 Walnut St, Ste 1520 Philadelphia, PA 19103 215.732.2

Julie Lewit-Nirenberg PRESIDENT & CEO Blue Ribbon Prostate Initiative jlcwit@brprostate.org

Dr. Howard Ehrenkranz

201 S. Livingston Ave. Livingston · NJ 07039 tel 973 994 4200 fax 973 994 3933

lynn knoepfler

dental hygienist

(1-5)
Design Firm über, inc.

Client Designer

Holzhuber Impaction Jimmy Ng

Client

Belly Basics Designer Herta Knegner

Client Designer

Blue Ribbon Prostate Initiative Herta Kriegner

Client Designers

über, inc. Herta Kriegner, Suzanne Jennerich

5.

Client Dr. Ehrenkranz Designers David Wolf, Jimmy Ng

pearl PUBLIC RELATIONS

wendy s. schwimmer

anthea

sofia crokos 591 broadway, loft 3f new york city, 10012 tel 212.219.2800 fax 212.219.2841 sofia@antheaevents.com

www.antheaevents.com

2.

printie

hamidpourkay

7 West 18th Street New York, NY 10011 Fe 212-655-4489 Fex 212-627-4317

www.printicon.com

www.printicon.com

Alfred C Sanft InfoDesign Management Inc

480 946 0846

Richard J. Ozga Director of Operations 1205 South Park Lane Suite 5 Tempe, AZ 85281

v 602 894 9225 f 602 894 9231

JQC DEVELOPMENT COMPANY, LLC

Robert A. Campbell PO Box 1549 602 568 0850 Managing Member Scottsdale, AZ 85252 480 949 8150 fx

Client

Client

Designer

Designer

JQC Development Company

Prima Commercial Leasing

Alfred C. Sanft

Alfred C. Sanft

COMMERCIAL LEASING

Robb Horlacher **Executive VP**

8350 McDonald Dr. Ste C 480 951.8989 Scottsdale AZ 85250

480 951.8995 fx

Design Firm über, inc.

(4-7) Design Firm InfoDesign Management Inc.

Client Pearl Public Relations Designer Tanya Pramongkit

Client Anthea Events Designer Jimmy Ng 3.

Client Print Icon Designer Jimmy Ng 4.

InfoDesign Management Inc. Alfred C. Sanft, Mookesh Patel Designers

Client Multimedia Telesys, Inc. Alfred C. Sanft, Paul Howell Designers

Operations

Dr. Tony Miszlevitz

President

114 Carmel Valley Rd 831 951.2244 Carmel Valley, CA 93924 831 219.0128 F Taylor Homes

Jonathan Taylor President 55 East Harvard Road Phoenix AZ 85002 602 568 0900

2.

Property One Management

James W. Scott

CFO

8350 McDonald Dr. Ste C Scottsdale AZ 85250

480 951.8989 480 951.8995 fx FSTWIND CES

Ron Strong General Manager

732 West Deer Valley Rd. Phoenix, AZ 85027

480 991.5557 623 587.9198 fx

3.

USER ADAPTABLE LEARNING & TEACHING ENVIRONMENTS

DARREN PETRUCCI SCHOOL OF ARCHITECTURE, ASU 480 329 1888 DARREN.PETRUCCI@ASU.EDU

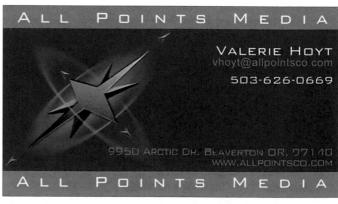

6

5

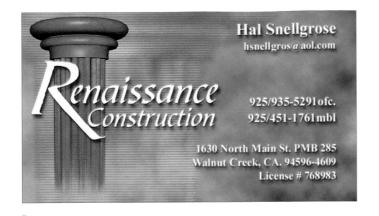

8.

10.

Design Firm InfoDesign Management Inc. (G-11) Design Firm Panghansen Creative Group Carmel Valley Center for Life Client Alfred C. Sanft Designer Client Taylor Homes Alfred C. Sanft Designer Client Property One Management Designer Alfred C. Sanft Westwind Air Services Client Designer Alfred C. Sanft Client uALTe, Arizona State University Designer Alfred C. Sanft All Points Media Client Lili Pang Designer Renaissance Construction Client Chris Hansen Designer 8. Client Unforgettable Honeymoons Lili Pang Designer 9. K2 Media Consulting Client Designer Lili Pang 10. Thalia Consulting Client Lili Pang Designer 11.

Maucy Cleaning Services

Lili Pang

Client

Designer

HEALTH BENEFITS THAT WORK FOR Y

•AFFORDABLE dental, vision, prescription pac •DISCOUNTS for ALTERNATIVE MEDICAL need •ESSENTIAL NUTRIENTS - the way foods used •Provide cost savings to meet HIGH DEDUCTIE •All PRE-EXISTING CONDITIONS accepted

Sondra Hampe

503.618.8133

1121 SE 214th Avenue Gresham, OR 97030-3444 www.yourfreedomchoices.com

Kobe Austin

Assistant Program Director On Air 3 - 7 PM Z100 - KKRZ - Portland Clear Channel Radio

> ph: 503.323.6495 fx: 503.323.6677

kobeaustin@z100portland.com 4949 SW Macadam, Portland, Oregon 97239

PANGHANSEN
creative group

p: 503.775.9097
f: 503.236.4542
www.panghansen.com
1562 SE Tacoma St. Portland, OR 97202

CREATECREDIBILITY

THE CIMARRON GROUP

THE MOUNTAIN WILL TRANSFORM YOU

605 County Road 23, Ridgway, Colorado 814 p. 970-626-3438 f. 970-325-0384 www.cimarronleadership.com

MICHAEL O'DONNELL, PRINCIPAL

970-325-4597 modonnell@cimarronleadership

Tom Caprel CEO tcaprel@itlighthouse.com

7560 Quincy Street
Willowbrook, IL 60527
630 789.3880 main
630 918.0757 cell
630 789.3556 facsimile
www.itlighthouse.com

The way small business manages information technology ™

5.

GEOFFREY C. FENNER, M.D.

Chief of Plastic Surgery

1000 Central Street, Suite 840 Evanston, IL 60201

www.fennerplasticsurgery.com

T · 847.570.1300

F · 847.570.1352

(1-3)
Design Firm Panghansen Creative Group
(4-6)

Design Firm Torque Ltd.

1. Clier

2.

3.

4.

5.

Client Freedom Choices Ltd.

Designer Lili Pang

Designer Lin r an

Client Clear Channel–Z100 KKRZ-Portland

Designers Chris Hansen, Lili Pang

Client Panghansen Creative Group

Designers Chris Hansen,

Lili Pang

Client The Cimarron Group

Designer Tim Hogan

Client IT Lighthouse Designers Dexter Cura,

Adam Lilly

Client Fenner Plastic Surgery

Designer Ian Law

2.

2

Sherwood Anderson

P.O.Box 367

Menlo Park, CA 94026-0367
c 650 804 1395
t 650 330 1892
f 650 330 1792
sherwood@menlobuilders.com
www.menlobuilders.com

CA License #732412

Patricia O'Brien, Development Director patricia.obrien@ pacificartleague.org

668 Ramona Street, Palo Alto, California 94301 t 650 321 3891 x 14 f 650 321 3617 www.pacificartleague.org

5.

4

Cliff F. Kilb
Senior Technical Education Specialist
ckilb@convera.com

CONVERA

1921 Gallows Road, Suite 200 Vienna VA 22182 T 703 761 3700 F 703 761 1984

www.convera.com

David M. Licurse, Sr., CFO & VP Operations

www.atpos.com

7.

WEALTHCYCLE"

900 ISLAND DRIVE, SUITE 102 | REDWOOD CITY, CA 94065

Joe Welsh Director, Strategic Accounts

T 650 413 5854 C 281 382 5391

F 650 413 5761

E jwelsh@wealthcycle.com

8.

www.wealthcycle.com

SANDHILL ADVISORS

Enrique Figueroa, CFA Senior Research Analyst 3000 Sand Hill Road Building 3, Suite 150 Menlo Park . CA 94025-7116 T 650 854 9150 F 650 854 2941

.

(1-3)
Design Firm Torque Ltd.
(4-9)
Design Firm Michael Patrick Partners, Inc.

Client Healthware Systems Designer Adam Lilly Client Torque Rich Smith Designer Client Ethos Studio Hellbox Design Designer Client Menlo Builders Designer Dan O'Brien Pacific Art League Designer Dan O'Brien Convera Designer Eko Tjoek @POS.com Designer Eko Tjoek WealthCycle Designer Dan O'Brien

Sand Hill Advisors

Eko Tjoek

9.

Client Designer

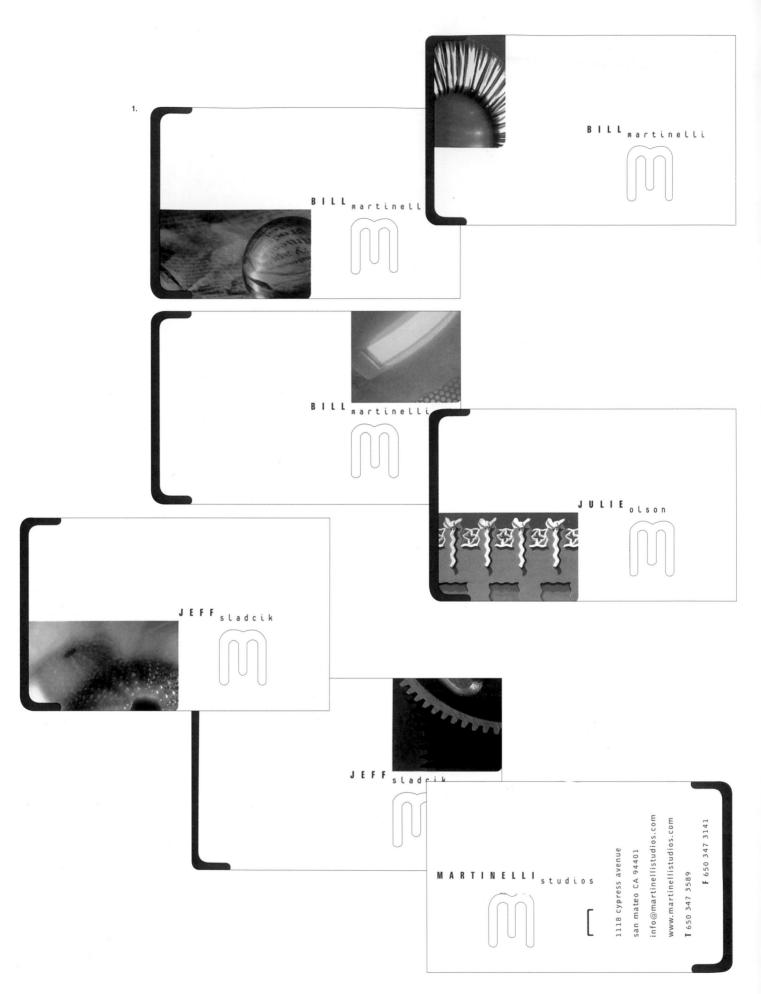

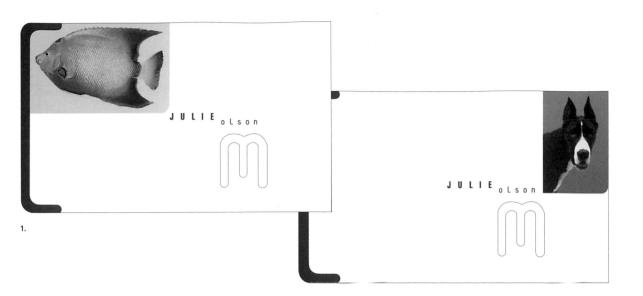

financialprinter com

Randy Churchill

| client development

rchurchill@financialprinter.com 10100 santa monica boulevard suite 600 los angeles ca 90067 main 310 407 1200 fax 310 407 1300 direct 310 407 1215 mobile 310 770 2068

2

a conscium business

Tim O'Bryan Principal Consultant eServices

555 North Mathilda Avenue Sunnyvale, CA 94086 tel/fax 408.743.5700 cell 415.999.8249 main fax 408.743.5701 tobryan@icarian.com

(1-3)
Design Firm Michael Patrick Partners, Inc.

Client Designer Martinelli Studios Dan O'Brien

Designer Dan V

Client financialprinter.com Designer Duane Maidens

3. Client

Client Icarian Designer Eko Tjoek

MICHELE MAIDENS DESIGN

H O M E D E S I G N

776 COTTON STREET * MENLO PARK * CA * 94025

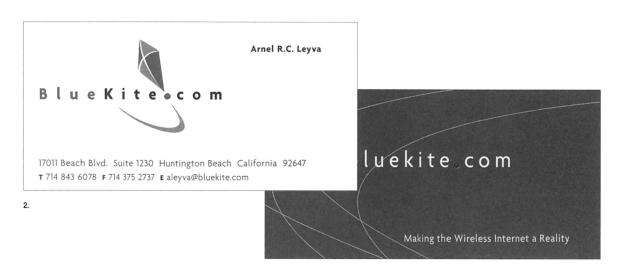

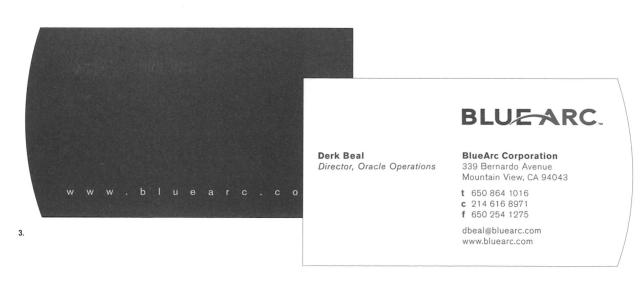

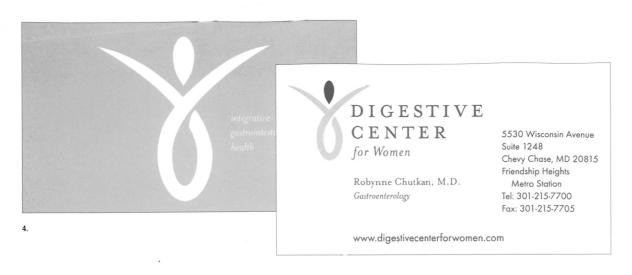

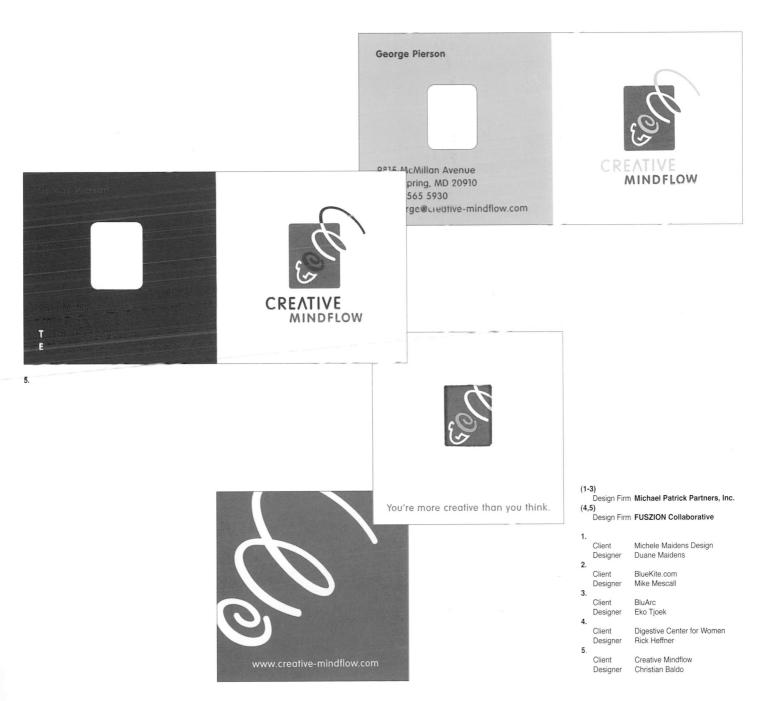

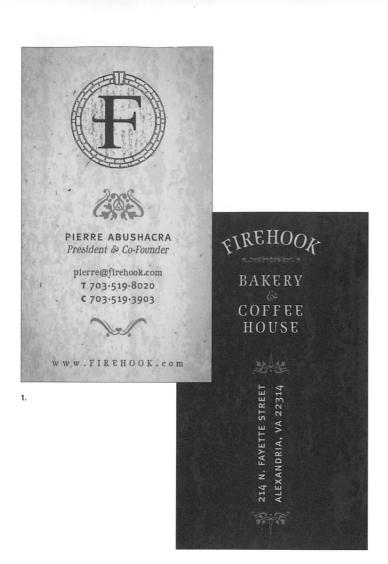

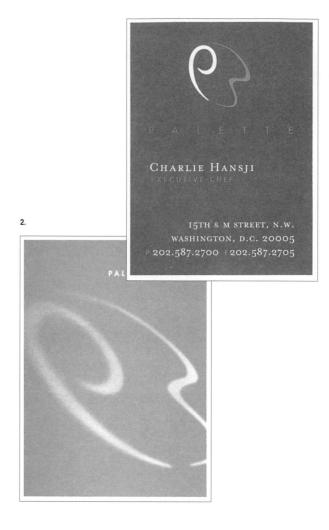

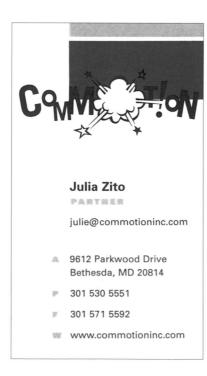

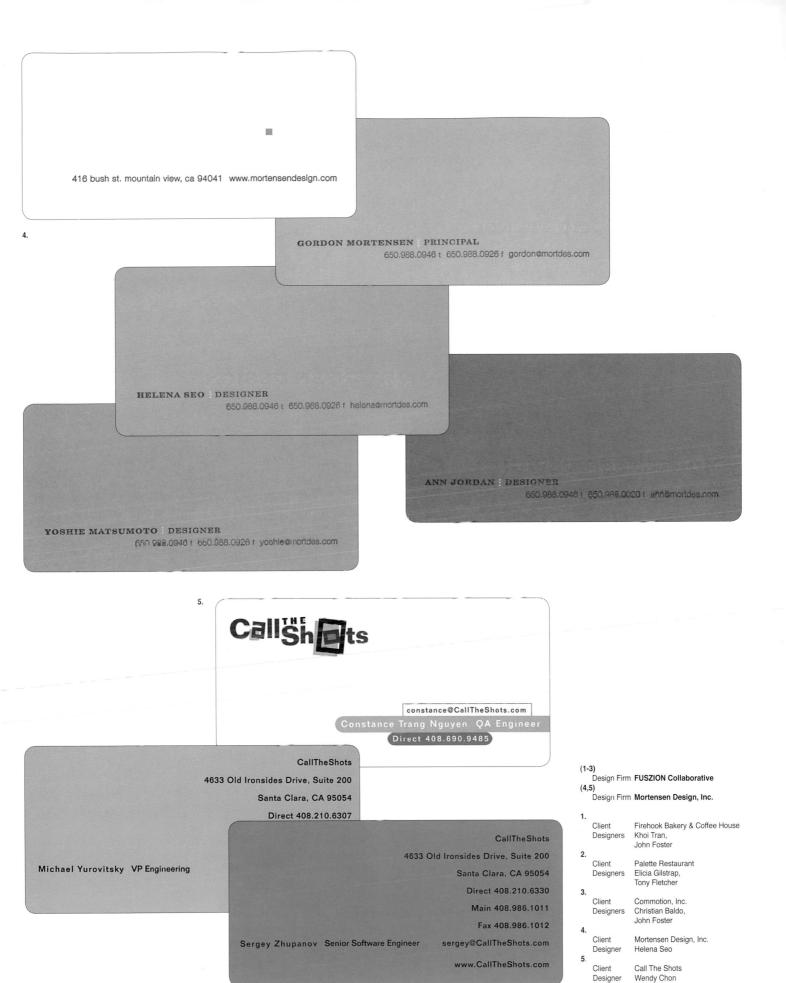

416 bush street mountain view, california 94041 T | 650 965 9531 F | 650 988 0926 cmort@cmdzine.com residential garden design

Circle 6. Edie Fain Customer Service Representative

CIRCLE BANK 1400A Grant Avenue, Novato, CA 94

t {415} 898.5400 f {415} 898.3742 www.circlebank t {415} 493.3107 direct

(1-7)Design Firm Mortensen Design, Inc. Client Junglee Corporation Designer Diana Kauzlarich 2. Cristine Mortensen Designs Client Gordon Mortensen Designer Client Rendition Gordon Mortensen Designer My Play PJ Nidecker Client Designer Client Cristine Mortensen Designs Designer Ann Jordan Circle Bank Client Designer Ann Jordan Client Handspring, Inc. Designer PJ Nidecker

Fax 650.566.2222

rhaitani@handspring.com

IAN GETREU | director of partnership development ian@ambric.com

direct 503 601 6505 cell 503 888 2372

radius

AMBRIC, INC. | 15655 sw greystone court, suite 150. beaverton, or 97006 503.601.6500 503.601.6596

Barbara Gibson | freelance writing | bga@earthlink.net = 251 Loucks Los Altos CA 94022

(P) 650-941-2300 (F) 650-949-3038

Edward T. Colligan

Director, Customer Marketing

Radius Inc.

1710 Fortune Drive

San Jose, CA 95131

(408) 434-1010

FAX: (408) 434-0127

Direct Line:

(408) 954-6831

Geoff Spring DIRECTOR

Spring Consulting Services PTY LTD

Ph 02 9999 0552 Int +61 2 9999 0552 Mob 0418 831 206 Email gspring@bigpond.com

155 McCarrs Creek Road Church Point PO Box 1251 Mona Vale 1660

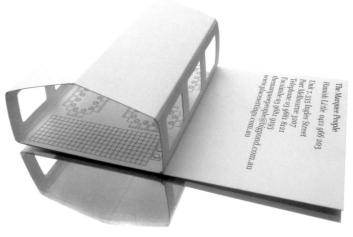

Professor Tony Guttmann

ARC Centre of Excellence for Mathematics and Statistics of Complex Systems

139 Barry Street The University of Melbourne Parkville Victoria 3010 Australia

T +61 3 8344 1618 F +61 3 9347 8165

director@complex.org.au www.ms.unimelb.edu.au/~tonyg

AUSTRALIAN RESEARCH COUNCIL Centre of Excellence for Mathematics and Statistics of Complex Systems

Reinout Quispel

Professor of Mathematics La Trobe University

Chief Investigator

www.complex.org.au

10.3777 CELL

DATA-FACTORY DESIGNS . OD (. DELINE) . 144. or/designer 1331 40th street | suite 315 | emeryville | california | 94608 510.547.7777 TEL | www.data-factory.com

Design Firm Mortensen Design, Inc. Design Firm Designoz Design Firm GollingsPidgeon (7,8)Design Firm Surindar Olingu Design Firm Data-Factory Designs Client Ambric, Inc. Patricia Margaret Designer 2. Barbara Gibson Designer Sabiha Basrai 3. Client Radius, Inc. Gordon Mortensen Designer 4. Client Geoff Spring Designers Greg Campbell, Medium Greg 5. Client Hamish Little, The Marquee People Designer David Pidgeon 6 Tony Guttman, ARC Centre of Client Excellence for Mathematics & Statistics of Complex Systems John Calabro Designer Client Anil Kumar Surinder Singh Designer Client Extreme Special Ceramics Designer Surinder Singh

Data Factory

Adam Gross

Client

Designer

design freshen up your look

PROMOTIONALS

IDENTITY/LOGO

COLL ATERAL

WEB/INTE RACTIVE

PACK AGING

ILLUST RATION

CONTIGLI

LUCIANO CONTIGLI DIRECTOR CREATIVO luciano@contigli.com

CONTIGLI ESTUDIO DE DISEÑO

Campichuelo 279 (c1405boa) Capital Federal Buenos Aires Argentina Tel: +(5411) 4903-6610 Fax: +(5411) 4901-4737 www.contigli.com

David E. Koetsch Technical Consultant

Tel: 604.240.5384 Fax: 604.857.0409 techshop@telus.ca

#104-5498 267 St. Langley, BC V4W 3S8 ,Canada

Automation Equiptment, Design Manufacturing & Service

7.

Design Firm La Creativa

Design Firm Sequent Mktg. & Comm.

(3) Design Firm La Chispa

Design Firm Say Finn

Design Firm Twointandem Design

Design Firm Greenhouse PhotoGraphix

Design Firm Contigli

Client

Brentano Patrick Brentano

Client Designer

Linkum Tours Andrew Metz

Client Designer

beguiled Emma Arnold

Client Say Finn Caroline Tse Designer

Two in Tandem Design Client Elena Ruano Kanidino

Designer Client Contigli

Luciano Contigli Designer

Precision Automation Byron A. Smith Client Designer

KEES MENSCH | MANAGING DIRECTOR

Mob: 06 54 20 81 38 kees.mensch@keyonline.nl

Geelvinckstraat 18 1901 AH Castricum Tel: 0251 67 20 88 Fax: 0251 67 20 85 www.keyonline.nl

Bradley J. Kabanuk President brad@kabanuk.com

content enablers

Content Enablers Inc. 9803 Thunderhill Court Great Falls, VA 22066

P 703-757-8088

F 703-757-9894

M 202-247-7101

2.

Jack E. Handy Director, Network jehandy@esymmetrix.com

■■■ eSymmetrix

13808 Holly Crest Lane, Dayton, Maryland 21036 443-535-9368x302 443-535-9369 410-627-2820

www.esymmetrix.com

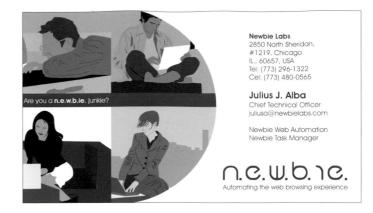

(1)
Design Firm Contigli (2,3)
Design Firm Apparatus Media Lab (4)
Design Firm Thinking Cap Design (5,6) Design Firm Kuy Digital Design Firm Eduard Cehovin Client Key Luciano Contigli Designer Content Enablers Client Designer Sharad Nayak Client esymmetrix Sharad Nayak Designer Thinking Cap Design Kelly D. Lawrence Client Designer

Client Newbie Designer Oliver Kuy Express A Few Words Oliver Kuy Client Designer Client Designer Ivana Wingham Eduard Cehovin

333

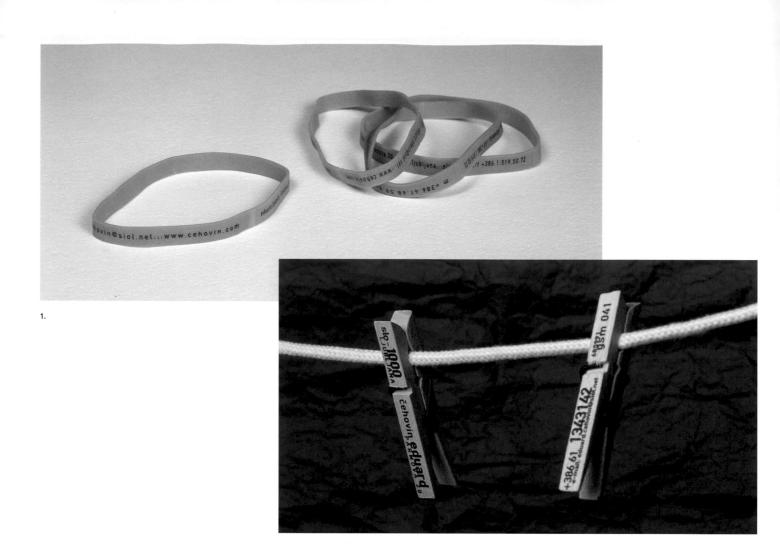

www.petrevolution.com

Pet Revolution Inc.

#2-6344 Kingsway Burnaby, BC. V5E 1C5

Jae-Won Sim

Co-Founder & Industrial Designer

tel: 604.451.0321 fax: 604.451.0322 cel: 604.780.9984

jaewon@petrevolution.com

٠,	Design Firm	Eduard Cehovin
2)	Design Firm	Pet Revolution
3)	Design Firm	Florin Suhoschi
4,5		Mónica Torrejón Kelly
1.	Client Designer	Cehovin Eduard Cehovin
3.	Client Designer	Pet Revolution Jae-Won Sim
	Client Designer	Scandanavian Pro Products Florin Suhoschi
1. 5.	Client Designer	Burning Media Mónica Torrejón Kelly
ο.	Client Designer	Darby Automation Mónica Torrejón Kelly

,

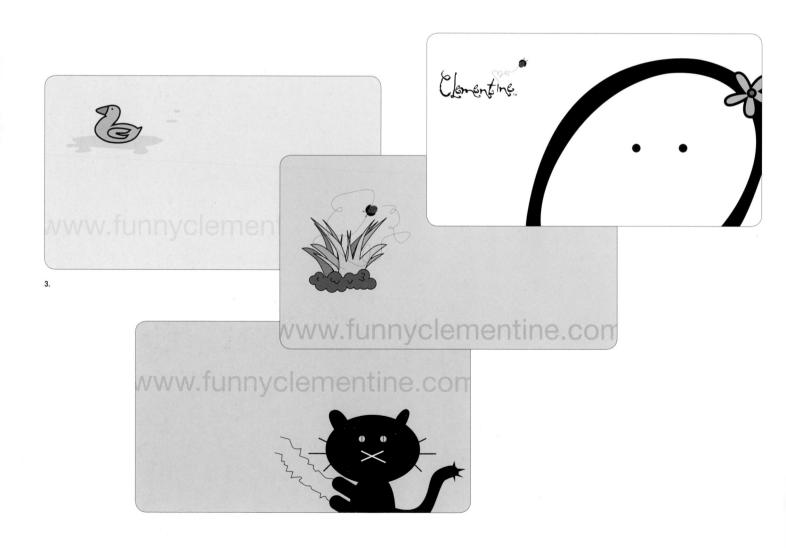

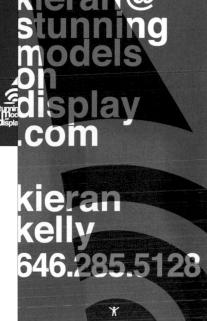

360 Fillmore St. #3 San Francisco, CA 94117 www.DWORKZ.com

STAS UDOTOV

Senior Art Director

stas@DWORKZ.com

email

415 378 7840

phone

DESTINATION ANALYSTS

Design Firm Mónica Torrejón Kelly (5,6)
Design Firm **D.Workz Interactive**

Client Spore

Designer Mónica Torrejón Kelly

Client Squarehand

Mónica Torrejón Kelly Designer 3.

Client

Funny Clementine Mónica Torrejón Kelly Designer

Client SMOD

Mónica Torrejón Kelly Designer

Client Designer

dWorkz Stas Udotov

Client DestinationAnalysts Designer Stas Udotov

XCUSEME

ELIE NAKAMURA

ashion designer

415.216.7386

elie.xcuseme@gmail.com

www.2shin.net/xcuseme

1.

2.

MARK KERSEY

mkersey@identitybusiness.com

identity

MANAGEMENT

signage · project management · solutions

telephone 817-849-8787 mobile 817-975-6429 fax 817-428-1027

> 1513 Pembrook Court Keller, Texas 76248

www.identitybusiness.com

4.

designcandy

ph 832.651.5384 fax 713.523.5582

www.designcandy.com

integration and extension architects

KFVIN KFNDAII

director
kevin.kendall@edgebound.com

edgebound corporation
6300 Goliad
Dallas, Texas 75214

tol: 1001 281 304 0426
fax: +001 281 304 4026
email: info@edgebound.com
website: www.edgebound.com

Docign Firm D.Workz Interactive (2-5)

Design Firm Cadence Studio (6-8)
Design Firm Design Candy Client Xcuseme Designer Stas Udotov Cadence Studio Client Jill Beck Designer Outrageous Red Jill Beck Client Designer Identity Client Jill Beck Designer Client Adventures in Copper Designer Jill Beck

6.
Client Design Candy
Designer Erin Dunn
7.
Client Edgebound
Designer Erin Dunn
8.
Client Fleur de fini
Designer Erin Dunn

Matthew Kirby, President 2020 Howell Mill Road Suite 170 Atlanta, GA 30318

P 404.355.3401
F 404.745.8012
E mkirby@restauranttalent.com
restauranttalent.com

1.

restauranttalent.com

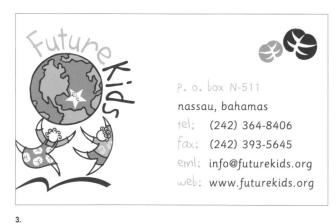

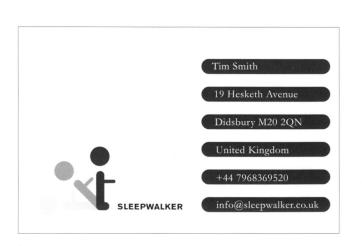

metorical [marcus tonndorf] *identity + visual communication* **1.** pappelallee 6, 10437 berlin, germany **2.** tel +49 30 48492039 fax +49 30 48492038 **3.** tonndorf@metorical.com, www.metorical.com

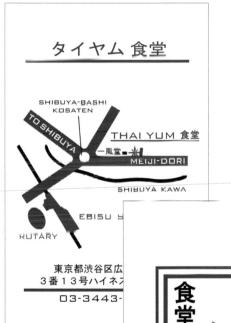

7.

食 堂 thai yum

THAI YUM 食堂

Suzanne Khattari BA PGD M Phil Director

Aura Castings
1 Floor, 126 Long Acre
Covent Garden
London WC2E 9PE
t 020 7379 1901
t 020 7379 5893
f 020 7240 5150
into@aura.co.uk

6.

(1,2)
Design Firm Design Candy
(3)
Design Firm Smith + Benjamin
Art + Design
(4-6)
Design Firm Metorical
(7)
Design Firm SIMC Co. Ltd.

I. Client RTD

Designer Erin Dunn

Client Blinds.com
Designer Erin Dunn

2.

Client Future Kids
Designer Dionne Benjamin-Smith

Client Sleepwalker Designer Marcus Tonndorf Client Metorical
 Designer Marcus Tonndorf
 Client Aura
 Designer Marcus Tonndorf
 Client Thai Yum Shop
 Designer Hidekazu Tsutsui

1.

小柴 大樹 DAIKI KOSHIBA

SIMPLE INNOVATIVE MODERN CONCEPT 代表取締役 MANAGING DIRECTOR

03-3475-5720

080-5077-6676

DKOSHIBA@SIMC-JP.COM

SIMC CO., LTD.

1-10-6 MINATO-KU NISHI-AZABU NISHI-AZABU 1106 BLDG, B1 T106-0031

東京都港区西麻布 1-10-6 NISHI-AZABU 1106 BLDG. B1 〒106-0031

2.

516-889-7958

6.

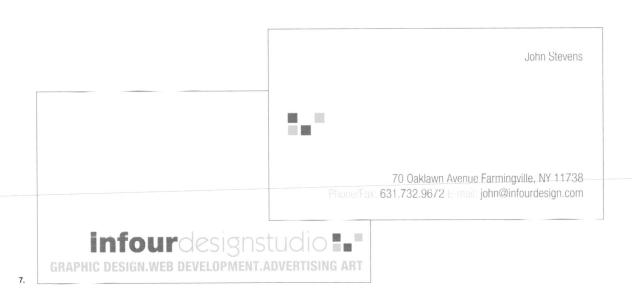

Design Firm SIMC Co. Ltd. Client Edward B. Dee Design Firm elf design Designer Randie Marlow Client Scott Rossi Design Firm Randie Marlow (6-8)Designe John Stevens Design Firm **infour design** Client infour design Client SIMC Client Morris Electric Hidekazu Tsutsui Designer Designer John Stevens Client Woowire Erin L. Ferree Designer Client MetaBrainz Foundation Designer Erin L. Ferree Client T.J. Moore Designer Randie Marlow

Generation Smart is dedicated to child

The new "Scholastic sing-a-longs" CD fun educational lyrics and memorable m Valuable lessons and facts are revealed as discovers the joy of each song.

Broaden your child's knowledge. Provide background for math, science, and readin www.generationsmart.com for more in

G E N E R A T I O N S M A R T

www.generationsmart.com

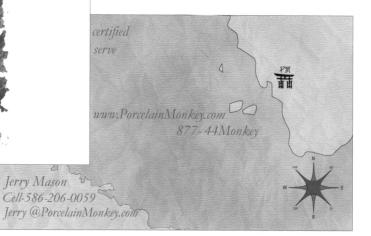

Design & Experimental Medium www.Rekonstrukt.com

Dorian J. Compo Designer

248.224.3477 dorian@rekonstrukt.com

Phone: 248-224-3306 Flishbeth Courtney Raley www.UnderXposed.com Elisabeth Underxposed.com

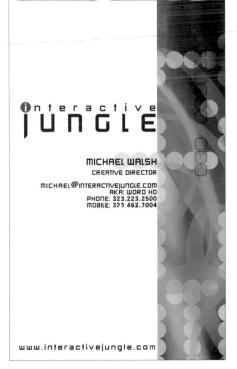

Design Firm infour design (2-5)
Design Firm Mayk

Design Firm Jungle 8

Client Designer 2.

Generation Smart John Stevens

Client

Mayk Dorian J. Compo Designer Client Porcelain Monkey

Designer Client

Rekonstrukt Designer Dorian J. Compo

Dorian J. Compo

UnderXposed Dorian J. Compo Client Designer

Client Designer

Interactive Jungle Lainie Siegel

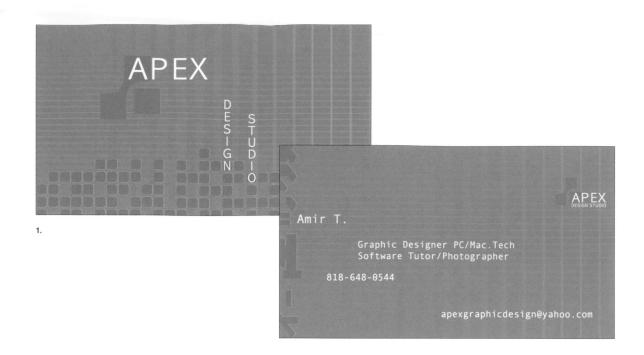

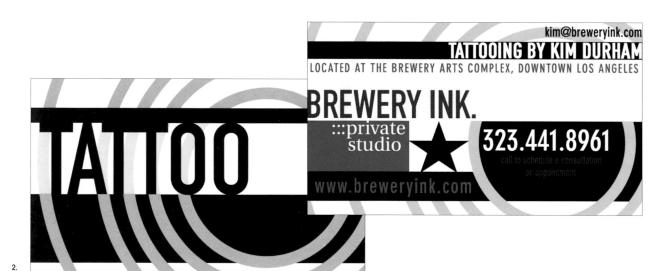

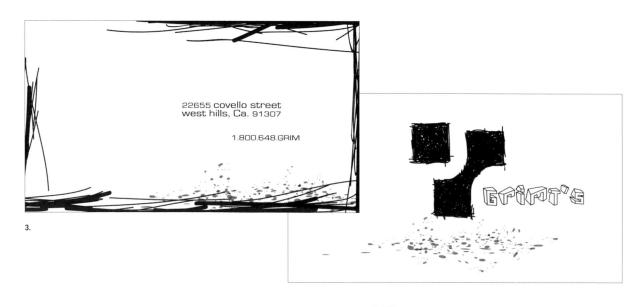

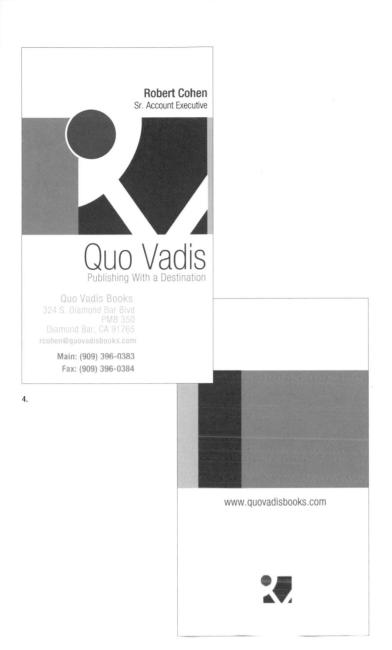

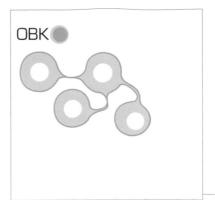

5.

www.obk.org

Robert James Vice President of sales rjames@obk.com

The Michelin Building 20 Shorbard Court NE Suite 8000 Cincinnati, Ohio 80662-0994 912.538.8851

MAHESH PABREKAR Business Development Manager

1, Hiren Ind. Estate, Mogul Lane, Mahim. Mumbai-400 016, India Tel:4466160,4459691,Fax:4460546,e-mail:uppindia@mail.com

7.

Design Firm Jungle 8 Design Firm Grandmother India

Client Apex Design Studio Designer Lainie Siegel

Brewery Ink Lainie Siegel Client Designer

3. Client Grimt Designer Lainie Siegel

Client Quo Vadis Lainie Siegel Designer

Client Designer

obk Lainie Siegel

Client Designer

Leigh Salgado Lainie Siegel

Client

UPP

SY GOW ATIONS + EVENTS MANAGEMENT

ROCK BOTTOM @ HOTEL RAMEE GUESTLINE A B NAIR ROAD JUHU, MUMBAI TEL 022 56935550 FAX 022 26202821 EMAIL ROCKBOTTOMINDIA@REDIFFMAIL.COM

2.

as the state of the VITAMIN TALENT MANAGEMENT Sucharita Nan

#6, 10th Main, 1st Cross, Indiranagar 2nd Stage, Bangalore-560038, Phone: 91-80-5202818, Email: suchi@vitamintalent.com, www.vitamintalent.com

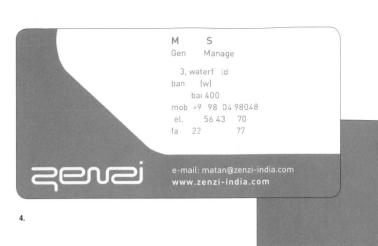

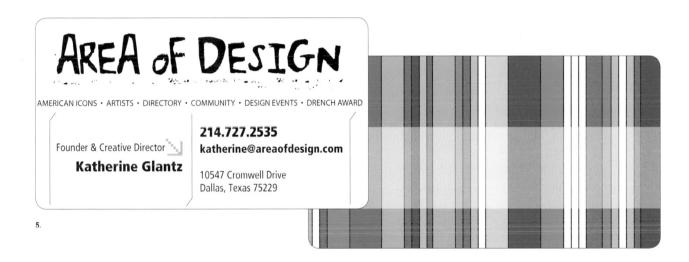

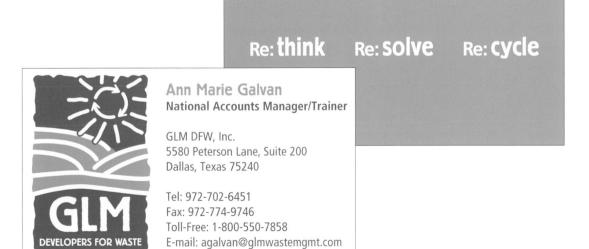

(1- (5,	Design Firm	Grandmother India	
1.	Client	Neon 69 Rock Bottom	
3. 4.	Client	Vitamin Zenzi	
5. 6.	Client	Area of Design GLM DFW	

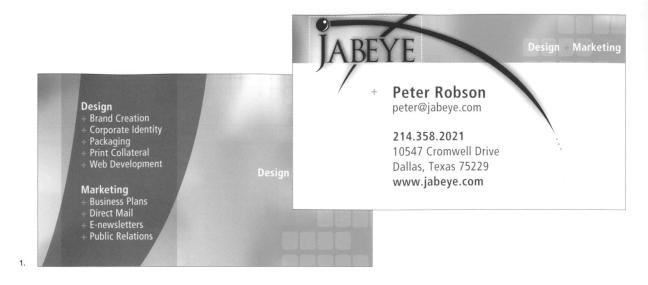

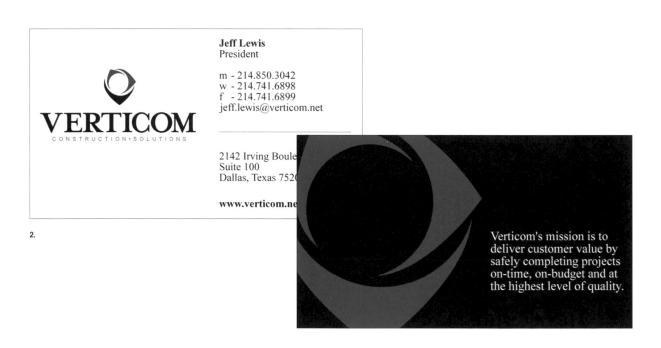

(1,2) Design Firm **Jabeye**

(3) Design Firm Inestudio

Design Firm **D. Brian Ward**

2.

3.

Client Jabeye

Client

Verticom

Client Indiewebsource.com Designer Heidi Segal

Client Designer ldea Factory D. Brian Ward

Patrick Deschênes deschenes.p@versalab.ca

MOBILIER DE LABORATOIRE LABORATORY FURNITURE

539, RUE ST-AMABLE STREET ST-BARNABÉ-SUD (QUÉBEC) JOH 1GO

TÉL./PHONE (450) 792.2442 MONTRÉAL (514) 861.4577 TÉLÉC./FAX (450) 792.3608

michelle paré
michelle@ardoise.com

24. AVENUE DU MONT-ROYAL QUEST
BUREAU 601 MONTRÉAL (QUÉBEC) H2T 252
TÉL.: 514.287.1002 FAX: 514.287.1040

ardoise design communications inc.
www.ardoise.com

EBC*L

European Business Competence* Licence

International Centre of EBC*L

Mag. Andrea Setznagel
Project Management

EBC Licencing GmbH

Aichholzgasse 4/8 A-1120 Wien

Tel. +43-1-813 997 745

a.setznagel@ebcl.info www.ebcl.info

3.

liesbet vandebroek & dieter dubkowitsch

NEUSTIFTGASSE 34/9, A-2500 BADEN

TEL: +43 2252 206 792 FAX: +43 2252 206 931

mobil: LIESBET: +43 664 392 75 75 mobil: DIETER: +43 664 308 22 02

email: l.vdb@flandern.co.at email: dubkowitsch@bahntours.at

Martin Widtmann

Niederösterreichische Audiovision Ges.m.b.H. Filmstadt Wien Speisinger Straße 121-127

A-1238 Wien

Produktionsleitung

Fon +43(0)1-889 33 62-31 Fax +43(0)1-889 28 31 Mobil +43(0)664-412 11 06 e-mail: office@nav.at http://www.nav.at/nav

5.

E mail aostranderconsulting@ms

ric J a e g e r

3975 1/2 Zuni Street roomfield Co 80020 e I 720.872.1891 a x 720.872.1897 jaeger@englehomes.com

Design Firm Ardoise Design

Design Firm motterdesign (6,7)

Design Firm Noble Erickson Inc.

Client Designer

Designer

Versalab Michelle Paré

DEFINING TRANSPORTATION SOLUTIONS

Client

Ardoise Design Communications Inc. Michelle Paré

Client Designer

International Centre of EBC*L Siegmund Motter

Client

Liesbet Vandebroek & Dieter Dubkowitsch Siegmund Motter

Designer Client

NAV Niederösterreichische

Audiovision GmbH

Designer Peter Motter Client

Designer

Ostrander Consulting Steven Erickson

Client Designer

McKay Landing Steven Erickson

PENTERRA PLAZA

8110 East Union Avenue Denver Colorado 80237 Telephone 303.783.6633 Facsimile 303.789.0672 dgregory@penterraplaza.com www.penterraplaza.com

DAWN GREGORY

York Management, Inc.

FORD CRIMINAL LAWYERS

Chris Ford BEC LLB

Ford Criminal Lawyers Suite 201, 370 Pitt St T 02 9261 2982 F 02 9261 2989 M 0418 40chris@criminallaw.net.au www.criminallaw

2.

FORD

Richard Jefferson Managing Director

GJ Electronics Ltd, Units 8-10, Wembdon Business Centre, Bower Road, Smeeth, Ashford, Kent TN25 6SZ U.K. tel. +44 (0)1303 814224 fax. +44 (0)1303 814073 richard@gjelectronics.co.uk mob. 07785 947962

Andrew Hasler

AJH Studios, Suite 206 20-22 Bayswater Road Potts Point, NSW 2011

T: +61 2 9331 0902 F: +61 2 9331 0807 M: 0412 818 858

Australia

E: andrew@ajhstudios.com.au

ABN: 47 440 826 525

www.ajhstudios.com.au

Martin J. McNeese CREATIVE DIRECTOR 2151 HAWKINS STREET 704 343 9280 704 343 9285 SUITE 100 MMCNEESE@TECHNIKONE.COM CHARLOTTE, NC 28203

Research **Brand Management** Strategic Planning Corporate Identity Media Service

BRANDSAVVY

Karl Peters

Senior Art Director

BrandSavvy, Inc.

66 West Springer Drive Suite 206 Highlands Ranch, CO 80129 303.471.9991 Tel 720.344.2394 Fax 720.205.2048 Cell peters@brandsavvyinc.com www.brandsavvyinc.com

Water Works Association

Jon R. Runge

Communications and Marketing Director

6666 West Quincy Avenue Denver, CO 80235-3098

M 303.794.7711 F 303.795.1989

D 303.347.6232

jrunge@awwa.org

www.awwa.org

Advocacy Communications Conferences Education and Training Science and Technology Sections

Design Firm Noble Erickson Inc. Design Firm Ident

Design Firm TechnikOne Design Firm Brand Savvy

Client Designer

Penterra Plaza Steven Erickson

GJ Electronics

Jeremy Tombs

Client

Ford Criminal Lawyers Designer Jeremy Tombs

Client Designer

Client AJH Studios Designer Jeremy Tombs Client Designer TechnikOne

Client Designer Brand Savvy

Client Designer

American Water Works Association Karl Peters

iic	SMTWTFS		SMTWTFS	SMTWTFS
.T'S 200	1 2 3 4 5 6 7 8 9 10 11 12 13 14 15 16 17 18 19 20 21 22 23 24 25 26 27 28 29	JAN	1 2 3 4 5 6 7 8 9 10 11 12 13 14 15 16 17 18 19 20 21 22 23 24 25 26 27 28	1 2 3 4 5 6 7 8 9 10 11 12 13 14 15 16 17 18 19 20 21 22 23 24 25 26 27 28 29 30 31
WHATI	1 2 3 4 5 6 7 8 9 10 11 12 13 14 15 16 17 18 19 20 21 22 23 24 25 26 27 28 29 30	APR	1 2 3 4 5 6 7 8 9 10 11 12 13 14 15 16 17 18 19 20 21 22 23 24 25 26 27 28 29 30 31	1 2 3 4 5 6 7 8 9 10 11 12 13 14 15 16 17 18 19 20 21 22 23 24 25 26 27 28 29 30
J, GUESS	1 2 3 4 5 6 7 8 9 10 11 12 13 14 15 16 17 18 19 20 21 22 23 24 25 26 27 28 29 30	JUL	1 2 3 4 5 6 7 8 9 10 11 12 13 14 15 16 17 18 19 20 21 22 23 24 25 26 27 28 29 30 31	4 5 6 11 12 13 18 19 20 25 26 27
HEY JOAN, GUESS WHATIT'S 2005!!	1 2 3 4 5 6 7 8 9 10 11 12 13 14 15 16 17 18 19 20 21 22 23 24 25 26 27 28 29	130 0CT	1 2 3 4 5 6 7 8 9 10 11 12 C 13 14 15 16 17 18 19 20 21 22 23 24 25 26 27 28 29 30	4 5 6 11 12 13 18 19 20 25 26 27
				10.07

WE NEED TO SEND THE INVITATIONS PESTY...HOW'S IT GOING

DESIGNING TO THE PRINTER! THE CARDS?

FORTUNE: YOU WILL FIND HUMOR IN THE DARNDEST PLACES.

#66 SIX INK FELT BASEBALL PENNANTS

For your room, club or den-—5" x 15" pennant. For EACH pennant send 100 BAZOOKA JILL comics or 20¢ & 5 BAZOOKA JILL comics to:

BAZOOKA JILL C/O SIX INK 518 N. CHARLES ST, BALTIMORE, MD 21201 410-385-9975

Comics not transferrable. Valid only where legal.

rising sun catering

2.

Heather Harris EVENT DESIGNER

aw road francisco, ca 94080

(650) 589-0157 (tel) (650) 589-6783 (fax)

gastronomia mexicana

prepared in the ancient tradition

east bay consortium of educational institutions, inc.

Nancy Chou, Associate Director

@eastbayconsortium.org

st 10th Street, Room 9 nd, CA 94606

879-8367

879-8301 www.eastbayconsortium.org

A California Student Opportunity and Access Project (Cal-SOAP)

improvingeducationalopportunities

415-781-1141 PHONE

415-345-0809 DIRECT

415-626-4493 FAX

One Daniel Burnham Court Suite #350c San Francisco, CA 94109

Danielle Slanina

Operations Coordinator

dslanin www.sh

_

[sharp ideas. sharp solutions.]

Formation

Judy Lichtman

Designer

Design Firm Six-Ink

1.
Client Six-Ink
Designer Judy Lichtman

2.
Client Rising Sun Catering
Designer Judy Lichtman

3.
Client Cancún Sabor Mexicano
Designer Judy Lichtman

4.
Client East Bay Consortium of
Educational Institutions, I

Educational Institutions, Inc.
Designer Judy Lichtman

Client Sharp Events
Designer Judy Lichtman

Debra Chasnoff

Director/Producer

2180 Bryant St., Suite 203 San Francisco, CA 94110

415-641-4616 phone 415-641-4632 fax

chasnoff@respectforall.org www.respectforall.org

a program of Women's Educational Media

5

Heather A. Hiles, MBA President & CEO

415|848|4488 [P] 415|309|7704 [C]

52 Coleridge Street San Francisco, CA 94110 415 | 268 | 4234 [F]

heather@hilesgroup.com www.hilesgroup.com

 G R O U P

J.B. Enterprise & Associates, LLC

Roger Busch

Commercial Sales Manager

Kihei Self Storage, 300 Ohukai Rd, # I-3, Kihei-Maui, HI 96753 phn: (808) 891-2319 / (800) 504-2011 cell: (808) 870-5997 / fax: (808) 891-0382 emall: Info@jbpool.com / web: www.jbpool.com

7.

Barbara Fuller

2510 Main Street Suite D Santa Monica California 90405

310.392.3331 *tel* 310.392.4811 *fax*

(1-6)
Design Firm Six·Ink
(7,8)
Design Firm Treehouse Design

I. Client La Bella Designer Judy Lichtman

Client Haloc
Designer Judy Lichtman

Client Six•Ink
Designer Judy Lichtman

Client Tonya Ingersol
Designer Judy Lichtman

Client Women's Educational Media
Designer Judy Lichtman

Client The Hiles Group Designer Judy Lichtman

Client J.B. Enterprise & Associates, LLC Designer Tricia Rauen

Client Salon Blu
Designer Tricia Rauen

Don Morgan

President, Board of Directors

11100 South Central Ave. Los Angeles, CA 90059 323-383-7588 phn 323-564-9009 fax www.urbancompass.org info@urbancompass.org

Guiding Youth Toward a Hopeful Future

DETH V. DRAGOO ASI 67520

BETH V. DRAGOO ASI 67520

ACCOUNT EXECUTIVE

10720 SAND KEY CIRCLE
INDIANAPOLIS, IN 46256

TEL: 317.577.3610 FAX: 317.577.3615

E-MAIL: bdragoo@lillianvernon.com
WWW.LILLIANVERNON.COM

John Coates

President

Codel Enterprises Burns USA

P.O. Box 269

Bethel, CT 06801

ph: 203 205 0056

fx: 203 205 9062

john@Burnsusa.com

3.

2.

Jim Ree jim@8speed.co: 415.348.080

SPEAK!

You need to communicate.
We'll make it resonate.

Visual Intelligence Agency, inc.

Kevin Gardner Slacker

155 Main Street, Danbury, CT 06810 203.730.6300 ext. 202

fax 203.730.6303

kevin@viaworldwide.com

www.viaworldwide.com

5.

Visual Intelligence Agency, inc.

Darryl Ohrt

Instigator

155 Main Street, Danbury, CT 06810

203.730.6300 ext. 201

fax 203.730.6303

darryl@viaworldwide.com

www.viaworldwide.com

Visual Intelligence Agency, inc.

David Plain

Jedi Knight

155 Main Street, Danbury, CT 06810

203.730.6300 ext. 206

fax 203.730.6303

dave@viaworldwide.com

www.viaworldwide.com

Visual Intelligence Agency, inc.

Justus Johnson High Roller

155 Main Street, Danbury, CT 06810

203.730.6300 ext. 207

fax 203.730.6303

justus@viaworldwide.com

www.viaworldwide.com

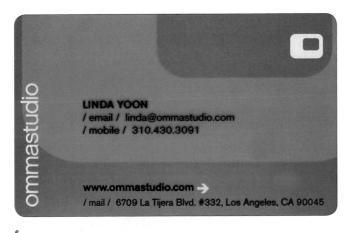

Design Firm Treehouse Design

(2-4)
Design Firm Visual Intelligence Agency, Inc.

Design Firm 8 Speed Multimedia

Design Firm Ommastudio

Client

Urban Compass Tricia Rauen Designer

Client

Lillian Vernon Designer Kevin Gardner Client Designer

Burns USA Kevin Gardner

Client

8 Speed Multimedia Jim Reed

Designer

Visual Intelligence

Client

Agency, Inc. Judy Lichtman Designer

Client Ommastudio

Designer Linda Yoon

FITSCHEN + ASSOCIATES INC.

JON GREGORY, designer 560 SUTTER ST. NO: 210 SAN FRANCISCO, CA 94102-1104

telephone NO:

415.788.0220

FAX 415.788.0112 EMAIL jon@fitschendesign.com

www.fitschendesign.com

1217 SAN BRUNO AVENUE SAN FRANCISCO, CALIF 94110 415.821.0144 TELEPHONE 415.821.1140 FACSIMILE MARIANNE@MITTENDESIGN.COM

2.

THREE GOLDEN APPLES

FINE JEWELRY

3.

91 Point Judith Road Narragansett, RI 02882 (401) 792-TOYS (8697)

Monday-Saturday 10am to 8pm Sunday 12pm to 5pm

Visitors Expected. For a map visit www.HeripDes

Herip Associates

5995 Center Street P.O. Box 113 Peninsula, Ohio 44264-0113

> 330 657:2231 Akron 330 467:8583 Cleveland 330 467 8507 Fax www.HeripDesign.com

Walter M. Herip President & Creative Director

Brand Management & Marketing Communications

The James/Gregory Group Inc. P.O. Box 434

James G. Dalessandro

Cleveland

216.461.1709

The James/Gregory Group Inc.

James G. Dalessandro

President

P.O. Box 434

Cleveland

Ohio

44040-0434

216.461.1109

REEDER SIG N

Rachelle E. Reeder President Design Consultant

Surface Design, Colorations and Styling Services

244 Kelso Road E. Columbus, Ohio 4 3 2 0 2 6 1 4 / 2 6 7 . 4 3 3 7 Design Firm Mitten Design

(3-6)
Design Firm Creative Vision Design Co.

Design Firm Herip Associates Design Firm Rickabaugh Graphics

Client Fitschen + Associates, Inc. Marianne Mitten Designer

Client Mitten Design Marianne Mitten Designer

Three Golden Apples Designer Greg Gonsalves

Client Brainwaves Toyshop Designer Greg Gonsalves

Client

Designer

Image By Design Greg Gonsalves

Client Designer

"Hey, Larry!" Greg Gonsalves

Client Herip Associates Walter M. Herip

Designer Client

The James/Gregory Group Inc. Designer Walter M. Herip

9. Client Rachelle E. Reeder Designer Eric Rickabaugh

3.

Dr. Melissa Viker
Optometrist
952.829.9024

The Eye Doctors Inc
See The Difference

12195 Singletree Lane Eden Prairie, MN 55344 @ Wal-Mart

Design Firm Rickabaugh Graphics Design Firm Conway Design Design Firm Maremar Graphic Design (6-8)Design Firm Armstrong Graphics Client Phil Hellmuth Poker Challenge Eric Rickabaugh Designer Client Rickabaugh Graphics Eric Rickabaugh Designer Client Conway Design Christina Conway Designer Open MRI Center Designer Marina Rivón

5.
Client Cocina Creativa
Designer Marina Rivón
6.
Client Stirsby
Designer R. Bruce Armstrong
7.
Client Armstrong Graphics
Designer R. Bruce Armstrong
8.
Client The Eye Doctors Inc.
Designer R. Bruce Armstrong

8.

a b c d e f g h i j k l m n o p q r s t u v w x y z

young zeck image communications

greg zeck

1.

7038 lake shore drive minneapolis, mn 55423 phone: 612-245-9090 fax: 612-243-9091 www.youngzeck.com gregzeck@youngzeck.com Sue Scheirer
Air & Water Purification Consultant
303-979-2498

2.

DAVID G. ARTHUR, DC, CCCN Certified Chiropractic Clinical Neurologist

3646 South Galapago Street, Englewood, CO 80110 • 303 781 5617 Fax 303 781 1045 • www.mountain-health.com • doctor@mountain-health.com

3.

5

DUNNA TRIBBY 477 S. ROSEMARY AVE **SUITE 193** WEST PALM BEACH, FL 33401

T: 561_833 4001 F: 561_833 4006 E: dtfadonna@aol.com W: donnatribbyfineart.com

DONNA TRIBBY FINE ART AT CITY PLACE

Andrew Kelly akelly@urbanusfurniture.com

305/576-9510 ext 102 305/576-4735 fax

89 northeast 27 street miami, fl 33137

www.urbanusfurniture.com

Design Firm Armstrong Graphics (2-4)
Design Firm Catalyst Creative (5) Design Firm LunaFX (6-8)

Design Firm Inkbyte Design Client Young Zeck Image Communications
R. Bruce Armstrong Designer 2.

Client AirSource Designer Jeanna Pool

Client Mountain Health Designer Jeanna Pool Client

Pool Design Group Designer

Client LunaFX YuLiya Chepuznaya Designer Client Targum Shlishi Designer Peter Roman Client DTFA/Donna Tribby Fine Art Peter Roman Designer Client Urbanus Peter Roman Designer

Celia Domenech

305.665.0892 celia@celiadomenech.com

www. fitness.com

Sports Art FITNESS

19510 144th Avenue NE, Suite A1 Woodinville, WA 98072

800.709.1400 425.488.8155 866.709.1750

Gloria W Chen

Senior Graphic Designer

Sports Art FITNESS

t: 425.481.9479~130 f: 425.488.8155 gloria@sportsartamerica.com

上海耀迪化工有限公司

羅培貽 博士

上海市浦东向城路15号锦城大厦22楼口座 电话: 86-21-58300131 • 86-21-58300132

传真: 86-21-58300770

RADCOS

Shanghai Radcos Chemical Co., LTD

p, Ph.D

Building 22F/D

No. 15 Xiangheng Road • Pudong, Shanghai, PRC t: 86-21-58300131 • 86-21-58300132 • f: 86-21-58300770

Rob Butterworth

Director, Operations & Administration

Boston ★ 2004 Nothing conventional about it.

Three Copley Place, Suite 50I | Boston, MA 02II6 | rbutterworth@boston04.com Phone 617.247.2004 | fax 617.247.1430 | cell 617.594.1586

Rosetta Mazzei

Marketing Coordinator 203-845-1373 (direct) 203-845-4257 (fax)

rosetta.mazzei@tycohealthcare.com

autosuture E

www.autosuture.com

United States Surgical 150 Glover Avenue Norwalk, CT 06856 203-845-1000 (main) 800-722-8772 (toll free)

tyco

Sherry Paul

Tel: 415.388.7575 Fax: 415.388.7979

Email: sherry@brandtherapy.com

6.

DANA G. KEILES, D.M.D. SPECIAL NEEDS DENTISTRY

> 390 LAUREL STREET, SUITE 310 SAN FRANCISCO, CA 94118 TEL 415.563.4261 FAX 415.563.1476 EMAIL MAIL@DRBLENDE.COM

WEB WWW.DRBLENDE.COM

Client Designer

Peter Roman

Design Firm Plumbline Studios, Inc.

Design Firm Inkbyte Design

Design Firm Hill Holiday

Design Firm Gloria Chen Design

Designer

(6,7)

SportsArt Gloria Chen

Client Designer

3.

Radcos Gloria Chen

Client

Designers

Democratic National Convention Vic Cevoli, Sean Westgate

Client

United States Surgical Designers Vic Cevoli, Carrie Brown

Client

Brand Therapy Designer Dom Moreci

Client Blende Dental Group Designer Dom Moreci

PH: 925.275.1626 FX: 925.215.2531 3058 Fostoria Circle, Danville, CA 94526 www.opux.com

Elizabeth Chyr Marketing Coordinator

70 Galli Drive Novato, CA 94949 USA

T 415.883.8842 D 415.883.8999 x109 F 415.883.1031

3.

echyr@academystudios.com www.academystudios.com

2.

Tel: 415.456.7404 Fax: 415.459.4613

E-mail: marols@leapgroup.com

38 Knoll Road, San Anselmo, California 94960

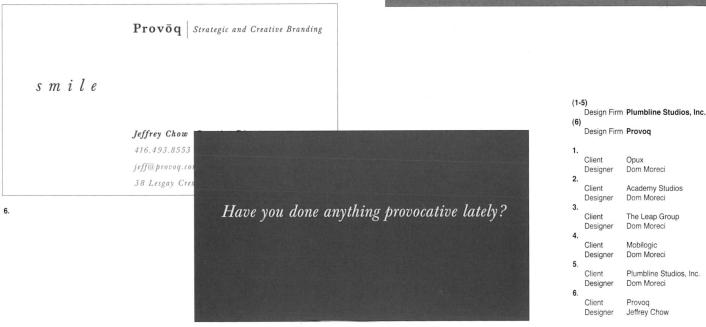

Jeff Messmer V.P. Sales & Marketing

25 37th Street NE Auburn,WA 98002

253.839.0222 phone 206.940.0571 cell 253.839.5544 fax

jeffmessmer@c-dory.com www.c-dory.com

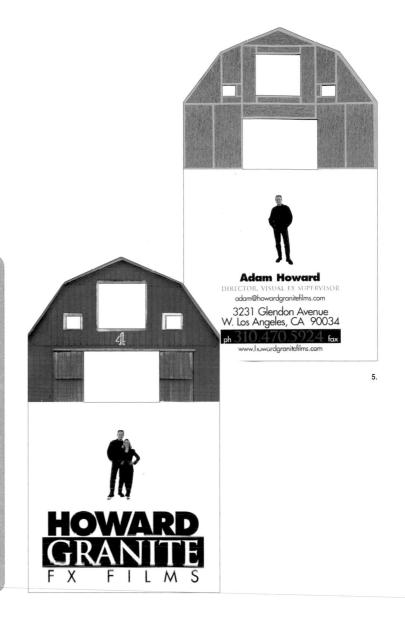

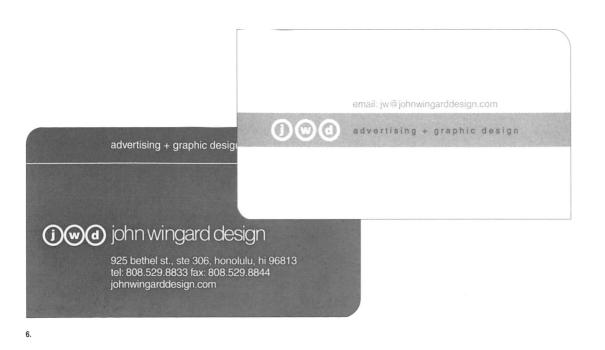

Design Firm Daigle Design Design Firm Carlow Design Design Firm John Wingard Design C-Dory Designer Candace Daigle Cibo Naturals Designer Candace Daigle Client Las Olas Designer Candace Daigle Client travel2events.com Designer Richard Carlow Client Howard Granite Designer Richard Carlow Client John Wingard Design John Wingard Designer

2.

3.

Custom Web Applications Software Development eMarketing Systems

eCommerce Solutions Business Intelligence Strategic IT Consulting

1088 Bishop Street, Suite 309 Honolulu, Hawaii 96813 Cell: 808.387-1415 • Fax: 808.599-2985 ttan@luminetsystems.com

Scott Doiron

374 Con Boston, Tel 617

Fax 617

scott@a

www.artisent.com

HEATING, COOLING, AIR AND WATER SYSTEMS

> Darrell L. Leach Service Technician

1235 S. SANTA FE WICHITA, KS 67211 TEL 316 264 2299 TEL 888 4 MANNYS FAX 316 264 0903 mannys@feist.com

Tame Your Environment.

JAMES STRANGE

7 316 263 1004 EXT 106 F 316 263 1060

1425 EAST DOUGLAS • WICHITA, KS 67211

WWW.GRETEMANGROUP.COM

EMAIL JSTRANGE@GRETEMANGROUP.COM

6.

Design Firm Greteman Group Design Firm AIARA Art & **Design Studio** Client Luminet Systems Group John Wingard Designer Artisent, Inc. Designer Viktoria Rogers Designer James Strange Greteman Group Designer James Strange Mercado Latino Client Designer Adriana Ayala Client Arco-Iris Adriana Ayala Client Clay Cat Studio Adriana Ayala Designer

Design Firm **John Wingard Design**Design Firm **Artisent, Inc.**

Anthony Nex Photography 8749 West Washington Boulevard Culver City California 90232 tel 310.836.4357 fax 310.837.2646

Jeff Blake Proprietor

jblake@brandgrowers.com brandgrowers.com

Burbank, CA 91505 t 818-333-5005

500 W. Olive Ave, 5th Floor 9457 S. University Blvd, #350 Highlands Ranch, CO 80126 t 720-320-7656 f 866-209-4190 f 866-209-4190

branding marketing naming • concepts copy design • broadcast print web

STREAMLINE GRAPHICS 2639 TWENTY-NINTH STREET SANTA MONICA CA 90405 TELEPHONE 213.452.7828 FAX NUMBER 213.452.4997

2.

Eric O. Kallen Managing Director Eric@HayekKallen.com

121 Fairhope Avenue Fairhope, Alabama 36532 251.928.8999 251.928.8991 Fax

www.HayekKallen.com

Michael G. Myles, President

mgmyles@InsTrustInsurance.com | www.InsTrustInsurance.com

251.665.2400 251.660.7051 Fax

P.O. Box 190339 | Mobile, Alabama 36619

5.

Jeane P. Stein

Jake's Owner jeane@jakesdoghouse.com

P.O. BOX 3748, Cherry Hill, NJ 08034 Phone: 856-751-5905 fax: 856-751-8511 www.jakesdoghouse.com

David Girgenti

Chief Commanding Officer

www.designcommandcenter.com

7.

Design Firm Evenson Design Group (4,5)
Design Firm Pixallure Design Design Firm The Star Group Client Nex Photography

Stan Evenson Designer Client Brand Growers Designer Stan Evenson

Client Streamline Graphics Designer Stan Evenson

Hayek Kallen Designer Terry Edeker

Client InsTrust Insurance Group Designer Terry Edeker

Jake's Dog House Client Designe Dave Girgenti

Design Command Center Client Designer Dave Girgenti

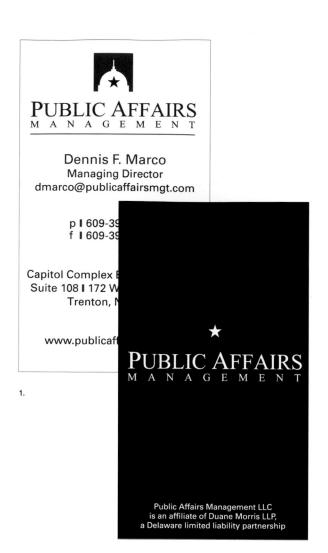

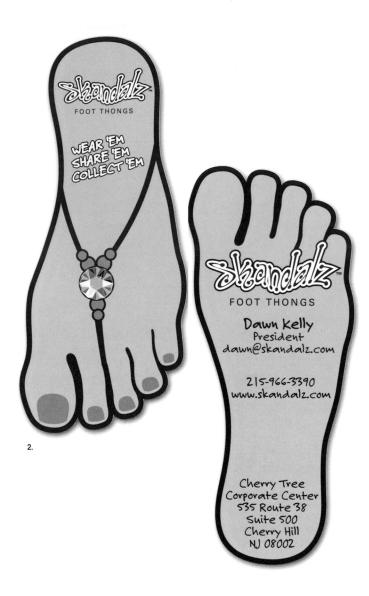

3.

Box care restaurant 189 Collins Street Melbourne Victoria 3000, T 03 9663 0411, F 03 9663 0422

Frank Sheron

President/CEO

260.432.5636 franklin@bluefroginhome.com

www.bluefroginhome.com

Print Design

The Visual Sense Los Angeles, California

gunnar swanson

Design Firm The Star Group

Design Firm Mia & Jem

Design Firm The Visual Sense

Design Firm Gunnar Swanson Design Office

Client Public Affairs Dave Girgenti Designer

Client Skandalz

Dave Girgenti Designer

Client Box Restaurant

Designer Mia & Jem

Client Blue Frog

Designer Diane Foley

Client The Visual Sense

Designer Diane Foley Client Gunnar Swanson

Design Office Designer Gunnar Swanson

Symbols

...oid design 303 ...Ping! 155 @POS.com 319 11:59 Nightclub 27 15 Help 297 30sixty advertising+design 37 4 x 4 153 5280 Realty 29 7 On Third 11 8 Speed Multimedia 361

Abhaya 95 Abric Berhad 111 Academy Studios 371 Acme Communications, Inc. 223 Ad-Lib Theatrical 131 Adam Raphael Photography 117 Adatto 65 Adra 9 Advanced Audi Volkswagen 245 Advanced Heating & Air-Conditioning 89 Advantage Point Telecom 201 Adventure Life Church 71 Adventures in Copper 339 Adverb 187 AD WORKS 251 Aerzone 23 Agile Oak Orthopedics 143 AlaRa Art & Design Studio AIGA Tweet Street 167 Aire Design Company 87 AirSource 367 AJH Studios 355 AJM 41 Akron-Canton Regional Foodbank 303 Alexander Isley Inc. 159 alkemi creative 99 Allan J. Rickmeier 153 Allergy & Asthma Associates 207 Allform Immobilien AG 295 Alliance Aviation 215 Alliance Building Services 95 Alliance Venture Mortgage 263 Allison Carroll Motorsports 45 All Phase Landscape 29 All Points Media 315 Aloi Na! 39 Alpha Video 207 Alpine Glass 283 Alpine Lutheran Church 89 Altesa 227 Ambassade Hotel 279 Ambric, Inc. 329 American Water Works Association 355 Amore 15 Amy Jo Kim, NAIMA 273 Andresen 187 Andy Kitchen Photography 137 angryporcupine_design 249, 251

Anil Dave 133

Anil Kumar 329 Ann's Contemporary Clothing 207 Ann E. Cutting 35 Ann Reese Photographer Antares 167 Anthea Events 313 Apartment in Paris 91 Apex Design Studio 347 Apex SEO 305 Apparatus Media Lab 333 Appareo 179 Apple Farm 207 Apple Valley Villa 35 Apropos Retail 177 Aquafuture 43 aQuantive Corporation 15 Aquatic Therapy International 155 Aquea Design 239 Aquius 133 Archives for Historical Documentation 269 Archway 119 Archworks 141 Arco-Iris 375

Ardoise Design Communications Inc. 353 Area of Design 349 Argyle Associates, Inc. 53 Armstrong Graphics 365, 367 ARMT 115

Arthouse 107 Artisan Interactive 291 Artisent, Inc. 375 Artsopolis 189 Arts Council Silicon Valley Art Council of the Valley 121

Ascent Learning + Development Inc. 63 Ash Kousa Visual Solutions Aslan Design & Graphics

295, 297, 299 Associated Credit Services

Atlantic Fire Stopping 103 Atlas Services 301 Attenex 15

Attitude Online 239 Atwater Foods LLC 267 At First Sight 37, 39, 41 AudioBase 189

Audra 227 Aura 59, 341 Aurovision 135 AU Photography 307 Avanti Salon Spa 289

Azar 127

В

B. Anthony & Company 207 B'nai B'rith Youth Organization 123 Babbling Brook 155 BAE International Inc. Sdn Bhd 107 BAIGlobal, Inc. 53 Baker | Brand Communications 91 Baldwin Graphics 127 Barbagelata 69 Barbara Gibson 329

Index

Bare Feet Studios 233 Bayside Insurance Associates, Inc. 129 BBKstudio 227 Be.Design 189 Bear Creek Web 175 Beaver Country Day School 53 Bedinger Group 157 beguiled 331 Bellingham Bell Foundry 141 Belly Basics 311 Belyea 127, 129 Berry's Emerald Pub 309 bestlodging.com 69 Bethel Construction 45 Beth Singer Design, LLC 123 Beyond Brittle 35 Beyond Spa 117 Be Design 187,191,193 Bigreen Leaf Restaurant Sdn Bhd 111 Big Island Candies 15 Big Sky Artifacts 165 Big Sur River Inn 47 Big Weenie Records 7 Bill Walsh Agency 235 Biro za komunalo 83 Birtna Jerlang, Klinisk Psykolog 251 Bizzarri Ristorante 39 Black Diamond Productions, LLC 27 Blake Printery 207 Blende Dental Group 369 Blinds.com 341 Block 7 107 BluArc 323 BlueBolt Networks 159 Bluefish Concierge 33 BlueKite.com 323 BlueStem Restaurant 235 Blue Dove Design 161 Blue Frog 379 Blue Heron Rowing Center 101 Blue Noise 47 Blue Ribbon Prostate Initiative 311 Blue Sun 189 **BMC** Landscape Construction 37 Bochner Chocolates 233 Body Aesthetic 229 Bold Enterprises 213 Bonato Design 219 Bondepus Graphic Design 67,69 Bone-A-Patreat 69 Boost Your Sales Club 283 Boot Loot 229 Bow Tie Billiards 43 Box Restaurant 379 Bradshaws 207 Brainwaves Toyshop 363 Brain Traffic 35 Brandscend 281 Brand Equity Project 141 Brand Growers 377 Brand Savvy 355

Brew Worx 97 Brightwater Ranch 11 Brillhart Media 163 Broadway on Tour 139 Brock Partnerships 203 Brohard Design Inc. 185, 187 Brooke Jury Graphic Design 169 Brothers International Food Corporation 143 Brotherton Strategies 175 Brown Commercial Group, Inc. 243 Brummel, Myrick & Associates 207 Bryce Bennett Communications 251 BST 79 BUILD 195 Building Industry Association **BUILD Youth Business** Incubator 99 Bungalow Baking Co. 145 Burning Media 335 Burns USA 361 Buttgereit und Heidenreich GmbH 277, 279, 281 bw property 295 Byrd, Proctor and Mills 215

С

C-Dory 373 C2 Investment Group 35 C2 Team 277 Cad-Ware, Inc. 115 CADC 307 Cadence Studio 339 Cafe 222 169 CAI Communications 35 Caledon Closets 241 Calhoun Place 249 Calif. Beach Co. 13 California Horse Park 73 Callibre 77 Call The Shots 325 Cambria Nursery & Florist 211 Cambria Pines Lodge 211 Camerad, Inc. 239 Camp/Arts Council Silicon Valley 197 Canai & Such International Holding Sdn Bhd 111 Cancún Sabor Mexicano 357 Capello Winery 143 Capic 59 Capital Associated Industries 35 Capitol Risk Concepts, Ltd. 53 CardioQuickSys, LLC 235 Carl's Donuts 239 Carleton Corporation 57 Carlow Design 373 Carmel Hills Care Center 41 Carmel Valley Center for Life 315 Carmens Nightclub 131 Caroline Cory 227 Carrie Flynn, Beach House 271 Casey's Kettle Corn 129 Castile Ventures 283

Casualty Loss Consultants Catalyst Creative 367 Catholic Social Services 237 Cavalier Oceanfront Resort 207 Cave Design Agency 31, 33 Cave Images 33 CDE Management 51 CDI Studios 173, 175 Cea Cohen-Elliott 249 Cehovin 335 Cena Restaurant 115 Charnock Design 71 Chase Chiropractic 301 Chatelain Property Management 303 Chesapeake PERL, Inc. 221 Chicago Sinfonietta 25 Children's Miracle Network of Greater Philadelphia 155 Children's Trust Foundation 127 Chris Jobin Voice Over 121 CHR Communications 127 Ciao Bambino! 179 Cibo Naturals 373 Cindy Eksuzian 273 Circle Bank 327 Citrus Group 299 Citura 95 City Finds, Inc. 255 City of Chamblee 125 Clair de Lune 181 Clark Creative Print & Graphic Design 91 Clayton's 145 Clay Cat Studio 375 Clearwire 17 Clear Channel - Z100 KKRZ-Portland 317 Clear Solutions International 105 ClubAds 307 CMP 227 CNI Advertising 239 Coach Club 41 Coastline Captive Solutions Coast Gallery Maui 47 Coast National Bank 213 Cocina Creativa 365 Cognito 281,283 Colin Magnuson Creative 299, 301, 303 College of Visual Arts 247 Collett Collett 259 Collins Construction Group

ColumnWorks West 73

Commotion, Inc. 325 Communications Strategies Community Foundation for

Monterey County 43 Community Partnership of Santa Clara County 283 Compass Rose Media 195 Computer Repair Express 41

Comventures 283 Concept Information 217 Condominium Lofts at Station Plaza 63 Conover 15 Consolite Boat Decals 9

Brand Therapy 369

Breathe 249

Brentano 331

Brewery Ink 347

Brave Heart Fund 269

Content Enablers 333 Conte & Green 229 Contigli 331, 333 Convera 319 Conway Design 365 Cool Fire Mechanical 241 CoreData 175 Core Painting 203 Corporate ID Asset Management Limited 253 Corporate Occasions 103 Corrigo 189 Coturn Gigs 309 Country Critter 7 County Materials Corporation Courtney Architects 213 Cowboy Pizza Company 45 CPI Business Groups 267 Cradles and All 243 Cranberry Hill Kitchens 241 Cranium 67 Crawford Museum of Transportation and Industry 85 Creation Dental Arts 301 Creative Design Group 79 Creative Mindflow 323 Creative that Clicks 101 Creative Vision Design Co. 363 Crescent Finstock 133 Crest Builders 301 Crew Construction Corp. Criatino Mortensen Designs 327 Crossroads 255 Crossroads Bar & Grill 175 Crossroads Espresso 145 Crossroads Records, Inc. 163 Culinary Center of Monterey 43 cuppa' jo 221 CWAPC 179 Cynthia Davis, CPA 47 Cypress Cafe Street 213

D.Workz Interactive 337, 339 D. Brian Ward 351 Daigle Design 373 Dainius Balciúnas 225 Dai Dai 231 Dana Denman, Shamrock Ranch 271 Daniel Green Eye-D Design Daniel Murphy Scholarship Foundation 25 Darby Automation 335 Data-Factory Designs 329 Data Factory 329 Datin Jacqueline Ong 111 David Deeble 29 David Harrell 259 Davis Design Group-Porch Home & Garden 207 Dayton General Hospital 259 Deb's Freelance 241 DeForest Architects 175 Delicat 149 Deli Up 179 Del Monte Aviation 45

Democratic National Convention 369 Dennis Crews Photography 163 Dennis Treviño 153 Dental Genius 247 Denver Oral & Maxillofacial 31 Deployment Solutions, Inc. 155 Dermedics 157 Designing Women 235 DesignKarma Inc. 171 Designoz 329 Design Candy 339, 341 Design Command Center 377 Design Gemini 225 Design Group West 13 Design Karma Inc. 171 Design North, Inc. 225 Design Nut 199, 201 Design Scope 133 DestinationAnalysts 337 Dever Designs 163 Devon Self-Storage 191 Diamond Tool Company 103 Digestive Center for Women digigami 167 Digital Production Group 237 Dirtworks, P.C. 223 Display Boys 37 DIY Theater.com 237 Document Security Systems, Inc. 267 Doc Popcorn 123 Donna Debs Yoga 217 Donna Parker Media Group 49 Don Eglinski 289 Dove Valley 11 Dr. Chocolate 207 Dr. Ehrenkranz 311 Dr. Michelle Johnson 245 Dream Interiors, Inc. 293 DTFA/Donna Tribby Fine Art 367 DuPont Dental 299

Ε

dVVorkz 337

E&G Group 123 E-lift Media TM 173 Eagle Investment Resources East Bay Consortium of Educational Institutions, Inc. 357 East Hampton Picture Framing 229 Ecoripe Tropicals 33 Edgebound 339 Edith's Gourmet Baking Co. 141 Eduard Cehovin 333, 335 Edward B. Dee 343 Ed Cassilly 149 Ekko Restaurant 165 Eldersupport Services, Inc. 285 Elder + Company 69 elf design 343 eliptica 191 Ellen Bruss Design 105, 107 emeryfrost 85

Emgeen Holdings 135 emspace design group 121, Emtek Products, Inc. 91 Enforme Interactive 49 Environmental Management Services, Inc. 215 Envision 25 Enyouth Singapore Pte Ltd EPOS, Inc. 91 Equality Virginia 201 Erin Scott Gardner, M.D. 287 Escuela De Diseño 149 Esteban Ismael Durãn 141 esymmetrix 333 Ethos Studio 319 etrieve 17 Événements Cobalt Events 163 Evenson Design Group 377 Everest Marketing 249 Evoke Idea Group, Inc. 171 Evolutis 163 Evolve Developments 221 EVS Realty Advisors, Inc. 285 Exalto Solutions 163 Expand Beyond 65 Exponent Capital, LLC 283 expowal 279 Express A Few Words 333 Extreme Special Ceramics 329 Eyebeam Creative LLC 127 Egroup 18/

F

Fagerholm & Jefferson Law Corporation 91 Fairtrasa 149 Farrell 247 Fat City Graphics 49 FBK Systems San Bhd 113 Fenner Plastic Surgery 317 Fevzi Gandur Denizcilik A.S. 271 Fidelity FCAT 55 financialprinter.com 321 Fine Catering by Russell Morin 255 Fine Feline Photography 177 Finger Lakes Tourism 265 Firefly 243 Firehook Bakery & Coffee House 325 First & Main Properties 285 First American Title Company of Jefferson County 129 Fitschen + Associates, Inc. Five Visual Communication & Design 235, 237 Flavorbank 217 Fleury Design 229,231 Fleur de fini 339 Flex-p 181 Flightcraft 51 Flight Wine Bar 171 Florin Suhoschi 335 Flying Horse Ranch 11 Focus 123 Footage Bank 95 Ford Criminal Lawyers 355 Formation 357

Form + Function 293 Fortress Technologies 291 Fossil Creek 209 Foth & Van Dyke 129 Foundation for Women's Wellness 107 Four Seasons Farm 143 Franke + Fiorella 225 Franny Cheung Design 79 Freedom Choices Ltd. 317 FreeMotion 17 Free At Last 197 Fresh & Spice 151 Frontpath 263 Fuel Wine and Martini Lounge 303 Full House Gaming 53 Funké Hair Body Soul 87 Funny Clementine 337 Fun Zone 81 FUSZION Collaborative 323, 325 Future Kids 341 Futurological 219

G

G. Ellis & Co. 145

Gabriela Gasparini Design Gallagher Hotel Management 295 Gallery Hotel 75 Garden Court Physical Therapy 155 Gary Osborne & Associates 263 Gato Mia 141 Gee + Chung Design 283, 285 Geflügelhof Schöndienst 293 Generation Smart 345 Genesis Family Enterprises Inc. 143 Genghis Design, LLC 27, 29, 31 Gentle Touch Family Dentistry 121 Gentner, Tuttlingen 293 Gentry Smiles 121 Geoff Spring 329 Gerald Emanuel 275 Ghemm 169 Gillian Ellenby 195 Ginger & Barry Ackerley Foundation 129 Giorgio Davanzo Design 65, 67 Gironda's Restaurant 75 Give Something Back International 285 GJ Electronics 355 Glassboro Center for the Arts 155 GLM DFW 349 Global Frut 151 Gloria Chen Design 369 Glorious Events 257 Golden Retriever Rescue of Michigan 263 GollingsPidgeon 329 Grace Tavern 119 Grafika Paradoks 83 Grandmother India 347, 349 Grapeco 141 Graphica 177, 179 Graphicat Limited 253, 255

Graphiculture, Inc. 35 Graphic Communication Concepts 133, 135, 137 Great Lakes Cylinders 127 Great Rivers Greenway 229 Greener Grass 105 Greenhaus 13, 15 Greenhouse PhotoGraphix 331 Green Jespersen CPA 43 Green Options Marketing 41 Gregory Hartranft 117 Gregory Richard Media Group 121 Greg Wilhelm 209 Greteman Group 375 Grimt 347 Grip Training Workshop 113 Grizzell & Co. 63 GT Hiring Solutions 185 Gunnar Šwanson Design Office 379 Guru Dutt 135

н

"Hey, Larry!" 363 H2O Plumbing Services 71 Haight Street Garage 245 Hair Loft 179 Haloc 359 Halsa 291 Hamish Little, The Marquee People 329 Handspring, Inc. 327 Harbor Physical Therapy 231 Harder Friseurfachschule 295 Hard Hats 183 Harwood Services 123 Hausman Design 77, 79 Haus der Beratung 281 Hawall Hi-Lo 53 Hawks Point 11 Hayek Kallen 377 Hazen Keay 65 HeadsUp Entertainment 203 Healing Connections 51 Healthware Systems 319 Healthy Earth Homes 37 Hoalthy Transitions 79 Heather K. Whittington, PRYT 49 Heath Campbell Photographer 55, 57 Heavenly Stone 17 Helen Woodward Animal Center 7 HERA 287 Herip Associates 363 Heritage Apron Company 13 Hernandez 151 Hershey Imports 161 Hewlett-Packard Women's Challenge 191 Hilltop Ranch Inc. 147 Hill Holiday 369 Hired Gun Design 233 Holberg Design 115 Holle 279 Holly Tashian 215 Holzhuber Impaction 311 HomeWarehouse.com 77 Horizon College 225 Horizon Financial Consultants 105 Horizon Mechanical, Inc. 31

Hornall Anderson Design Works 15, 17, 19, 21, 23 Horton Farmer's Market 13 Hotel Mons 83 Hotel Rössli 281 Hothouse 191 Howard Granite 373 **Hubbard Street Dance** Chicago 65 Hubbell Design Works 137, Hubbub Advertising 139 Hulingshof 281 Hullaballoo 45 Hunter Roberts 97

1

i 221

Icarian 321

Ice Life Canada Inc. 241 ICS 143 IDBI Intech 135 Idea Factory 351 Ident 355 Identity 339 IE Design + Communications 79,81 IFM Infomaster 231 Im-aj Communications & Design, Inc. 255, 257 Image Builders, Inc. 293 Image By Design 363 Immanuel Lutheran Church Impact Print Solutions 265 impli 17 inc3 123 incitrio design {brand} media 153 Incognito Events 297 Indianapolis Museum of Art 25 Indicia Design, Inc. 233, 235 Indiewebsource.com 351 Indigo 261 Inestudio 351 InfoDesign Management Inc. 313. 315 infour design 343, 345 Inkbyte Design 367, 369 InMarket Partners, LLC 119 Insite Associates 209 InSource 305 Institut za primerjalno pravo 81 InsTrust Insurance Group 377 Interactive Jungle 345 International Centre of EBC*L International Color Posters 139 International Health Emissaries 45 International Spy Museum 87 Inua Gallery 247 Investment Agriculture Foundation of British Columbia 181 In full view 303 In the Hunt Canine & Equestrian Farm 137 iQ inc 241 Ireland Global 131 IshopDesMoines.com 71 Island Queen Cruise 205 IT Lighthouse 31/

Ivana Wingham 333 Ivara Corporation 205

J

J&B Properties 67 J&D Printing 299 J.B. Enterprise & Associates, LLC 359 J.B. Scott 225 j. creative 259 J. Robert Faulkner Advertising 101 Jabeve 349, 351 Jacob Rosenberg 275 Jake's Dog House 377 James Phillip Wright Architects 191 Jamiesons Audio/Video 261 Japanese Village Plaza 13 Jasras Digital 135 JB Design 307, 309 Jeff Fisher LogoMotives 223 Jeff Lee 153 Jeff Shewey 127 Jeff Silva 147 Jeff Silva: make sense(s) 147 Jennifer Nicholson 79 Jennifer Shanley 219 Jenny Kolcun Design 239 Jensen Design Associates, Inc. 157, 159 Jerree Nicolee 51 Jerry Brenner Promotions Jet Technologies 295 Jewelex New York 135 Jill Wijangco Photography 79 Jim Craig 243 JK Associates LLC 79 Joe Miller's Company 195, 197, 199 JOFA 93 John Bigham Racing 45 John Kneapler Design 115, John Trippiedi 101 John Wingard Design 373, 375 Jonothan Woodward 165 Joseph Levine 277 Jowaisas Design 171 JQC Development Company 313 JRH Biosciences 239 Juanita Media 73 JumpStart Inc. 87 Junglee Corporation 327 Jungle 8 345, 347 JZ Racing 43 J Zeisloft Custom Builders 263

K K2 Media Consulting 315 K5 Trading 41 Kabel 127 Kamikaze Skatewear 13 Karacters Design Group 251, 253 Karl Imfeld 279 Karma Creations 191 Kathe Pults 209 Kazys Svidenis 227 Kelleen Griffin 199

Kelly Bryant Design 153

Kenneth Diseño 149, 151. 153 Ken Viale, Photography 271 Kevin Main Jewelry 209 Kev 333 Keystone Eye Associates 155 KFR Communications, LLC Kick Off 2006 TM 279 Kiku Obata & Company 229 Kingdom Housing, LLC/The Člubhouse, Inc. 29 Kingsley Giraffe 219 Kinzan 167 KIP 111 Koan Float Technologies 281 KOCH BUSINESS SOLUTIONS 173 kor group 53, 55, 57, 59 Kristina Zalnierukynaite 225. 227 Kristi Kay Petitpren 63 KROG, Ljubljana 81, 83, 85 KSJS Radio 197 Kusar Court Reporters 157 Kuy Digital 333

L

Landau Public Relations 87

Lance Ellis Real Estate &

Development 145

Landings 181

Landscape 111

Larsen 247 Larson Logos 89 LaserPacific Media Corporation 169 Las Olas 373 Laurel Black Design, Inc. 129, 131 Lauren Suszkowski 119 La Bella 359 La Bodega 151 La Casa Del Bebe 151 La Chispa 331 La Cita Restaurant 297 La Costa Oaks 11 La Creativa 331 La Place sur la Mer 129 La Strada 15 La Technique 217 Lease Crutcher Lewis 19 Ledden Design 125 Lee Communications, Inc. 53 Legacy Construction Corporation 267 Leigh Maida Graphic Design 117, 119, 121 Leigh Salgado 347 LeRoy Village Green 267 Lesniewicz Associates 261, 263, 265 Les Femmes Chic 93 Lido Peninsula Resort 169 Liesbet Vandebroek & Dieter Dubkowitsch 353 Life Settlement Insights 85 Lift 57 Light Rain 191 Lillian Vernon 361 Lily Kanter Sarosi 275 Linda Ramin, Art Representative 161 Linden Arms Apartmenta 69 Linkum Tours 331

Lisa Rhodes, Shamrock Ranch Dog Training 277 LISC Rhode Island 257 Liska + Associates Inc. 63, 65 Litecast 305 Littlefield Unlimited 161 Liz Shapiro Legal Search LJM Design Group 143 LoanTek 301 Lockes Diamantaires 173 LOGO 97 Lone Star Nuclear 185 Longwater & Company 105 Look 179, 181 Loop Island Wetlands 221 Loop Worx 67 Lorden Professional Services 299 Los Abanicos CourtHome Collection 169 Love it 229 Lowenstein Durante Architects 87 Lucas Vineyards 269 Lucence Photographic, Ltd. 53 Lucky Charm Designs 93 Lula's Pantry 57 Luminet Systems Group 375 LunaFX 367 Lupine Annie's 259 Luxor Executive Car Service 245

М

M. Stahl, Inc. 197 Madame Monarch 39 Madonna Inn 213 Mad Mary & Company 259 Mahalaxmi Jewellers 135 Majestic Wood Floors 49 Maju Curry House Sdn Bhd 113 Malaysian Institute of Baking Malmstrom Associates Orient Co. Ltd. 253 Mambo 143 Mandalay Advisors 231 Manny's 375 Mann Realty Associates 117 Manzoni Family Estate Vineyard 47 Maple Leaf Gift Stores 183 Marcia Herrmann Design 141, 143, 145, 147 Marcie Adary 181 Marcoz Antiques • Decorations 269 Marea Fowler 219 Maremar Graphic Design 365 Margaret's Place 297 Margaret Fisher-QiGong 267 Maria Manna Life Spa 183 Market Street Marketing 73, 75 Mark Fertig Design and Illustration 245 Marlin Central Monitoring 201 Marlin eSourcing 203 Marlin Logistics 203 Marlin Nutrillonal 205

Math Can Take You Places 27 Maucy Cleaning Services 315 Mautner Markhof 309 Maveron 19 Max Graphics 225 Max Power Advantage Sdn Bhd 113 Maycreate 201, 203, 205 Mayer Bros. 265 Mayhem Studios 91 Mayk 345 MC3, A.R. McIntyre & Company 29 MCD 147 McElveney & Palozzi Design Group, Inc. 265, 267, 269 McFarland State Bank 147 McKay Landing 353 McLean Software 125 McMillian Design 219 McNulty Creative 11 MDA Communications 15 MDS Architect 143 me&b Maternity 63 MeetingMakers.com 283 Megaluck Consulting 131 Melstar Information 137 Menlo Builders 319 Mercado Latino 375 MetaBrainz Foundation 343 Metorical 341 MetricsDirect 19 Metro Homes 97 Mey Jen Stage Productions 253 MFDI 245, 247 Mia & Jem 379 Michael Hat Farming 141 Michael K. De Neve & Co. 69 Michael Niblett Design 101 Michael Patrick Partners, Inc. 319, 321, 323 Michael Rubin Architects 223 Michele Maidens Design 323 MICI 105 Micromed Medizintechnik GmbH 295 Mid-State Bank & Trust 209 Mike Whitney 161 Millennium Graphics 55 Mind's Eye Creative 221 Mind & Motion 49 Mires 231, 233 Miro 13 Mitten Design 363 MJB 131 Mlinaric 81 ML Tea 191 Mobile World Telecom 133 Mobilogic 371 MOCA Museum of Contemporary Art Cleveland 85 Mockingbird Society 179 Moening Presentation Group 237 Mónica Torrojón Kelly 005,

337

Marlin Payment Solutions

Marquee Music, Inc. 165

Martin-Schaffer, Inc. 221

Martinelli Studios 321

201

Monkey Studios 9 Mono Design 55,57 Monster Design 175 Monterey.com 45 MontereyBay.com 41, 43 Monterey Pacific 43 Monterey Peninsula Country Club 47 Montgomery Productions, LLC 137 Moonlight Design 179 Moonstone Hotel Properties Moore Wealth Incorporated 49 Mopping Mama's 117 Morningstar Design, Inc. 61 Morris Electric 343 Mortensen Design, Inc. 325, 327, 329 Mosaic 25 Motoretta 61 motterdesign 353 Mountain Health 367 Mr. Big Film 63 MrSwap.com 191 Multimedia Telesys, Inc. 313 Mulvanny/G2 23 My Play 327 My Thai Cuisine 43

Ν

N-Vision Optics 309 N2 Consulting 271 Nail Mart Australia 299 Nanocosm Technologies, Inc. 283 Nassar Design 269, 271 National Foundation for Debt Management 305 NAV Niederösterreichische Audiovision GmbH 353 NBA Communications 163 Needles & Hooks 259 Nelson + Updike 65 Neon 69 349 Nesnadny + Schwartz 85, 87 NetBusiness Solutions 137 Newbie 333 Newmediary 57 Newton Pride Committee New Buyer 245 New England Reunions 217 Nex Photography 377 Nickel Properties, Inc. 141 Nicole Chabat 55 Noble Erickson Inc. 353, 355 Nodding Head Brewery & Restaurant 119 NOK Foundation Inc. 269 NorGlobe 199 Northern California Golf Association 41 Northwestern Nasal + Sinus Novazet GmbH, Spaichingen 293 NRC Inc. 143 NSC 217

0

Ó! 89 Oak Closet 205 obk 347

Oceanplace 9 Ocean Park Hotels 213 Octavo Designs 47,49,51 Odvetnik Peter Tos 83 Odyssey Classics 9 Ojo Photography 239 Old Market Street 153 Old Town Tea Co. 49 Old World Plastering 141 Ommastudio 361 One Bolt, Inc. 105 Ophthalmic Plastic and Cosmetic Surgery 157 Optimet 101 Optim Audio 39 Opux 371 Orapondiro 151 Orphan Sunday 187 Ortman Family Vineyards 209 Osmotech 161 Ostrander Consulting 353 Otay Ranch 15 Otis Design Group 171 Otoño 17 Our Saviors Lutheran Church Outrageous Red 339 oxygen design + communications 59, 61, Oxygen Space 59

P

P.L. Doyle 103 Pace International 23 Pacific Art League 319 Pacific Marine Credit Union Palette Restaurant 325 Panghansen Creative Group 315, 317 Paradowski Creative 285, 287 Paragon Realty & Financial, Inc. 9 Parkloft 13 Parksons Press 135 Park Capital Management Group 29 Paso Robles Inn 209 Patrick Barta Photography 179 Pat Dillon Photography 229 Pat Osbon, Circus Center SF 275 Pat Taylor Graphic Designer 103 Paul Kingsbury 215 Pawsitive Dog Training 139 PayXact 263 PC Assistance, Inc. 267 pd3 65 Pearl Public Relations 313 Pearl Real Estate 223 Pekoe Siphouse 193 PELHAMPRINT.com 121 Pellini 67 Pensaré Design Group 221 Penterra Plaza 355 Percept Creative Group 131, 133 Perfect Security 309 Perger 1757 83 Perkins School for the Blind Pernsteiner Creative Group.

Inc. 175, 177

Petals 35 Pete's Ladies & Mens Alterations 257 Peter Douglas 277 Peter Jerlang, Tandlaege Peter Seagle Construction 143 Petit Soleil 209 Pet Revolution 335 Philadanco (The Philadelphia Dance Company) 155 Philadelphia Chamber Music Society 155 Phil Hellmuth Poker Challenge 365 Phoenix Office Building Maintenance 247 Pierre Rademaker Design 207, 209, 211, 213, 215 Pinewoods 125 Pixallure Design 377 Pixie Maté 193 Platinum 299 Platinum Performance 209 Platinum Travel Group 47 Plethora Technology 305 Plink 369 Plumbline Studios, Inc. 369, 371 Pool Design Group 367 Popboomerang Records 37 Porcelain Monkey 345 Pound Interactive 31 Precision Automation 331 Preservation Studio South Pressley Jacobs: a design partnership 25, 27 Pressure Tek 211 Press Coffee Company 107 Preview Home Inspection Prima Commercial Leasing 313 Prime Time Sports TV 209 Prince, Lobel, Glovsky & Tye 57 PrintMedia 117 Print Icon 313 Print Resource 281 Progressive Viticulture 141 Prolumina 129 Propello 193 Property One Management Provincial Capital

Commission 183 Provoa 371 Psymark Communications 247

PS the Letter 101 Public Affairs 379 PuriLens, Inc. 53

PX Find 87

Quality Painting 303 Quality Vision Services, Inc. 265 Queensway Bay 9 QuestingHound 33 Quilts of Gee's Bend in context 153 Quo Vadis 347 QV Hotel & Suites 181

R R.J. Muna 271 R3 307 Rachelle E. Reeder 363 Rachel Andras 73 Racing for Recovery 261 Radcos 369 Radius, Inc. 329 RAM Digital 49 Randie Marlow 343 Randi Wolf Design 153, 155, 157 Rapidac Machine Corporation 265 Raquel Barrios, Dog Days 273 Rasa Tornau 227 Redpoint design 165 Red Barn Veterinary 259 Referral Works 255 Rekonstrukt 345 **REMI Companies** 93 Renaissance Construction 315 Rendition 327 Renew for 2 75 Resource 1 237 Resource Graphic 27 Restavracija Glazuta 85 Restoran Ali Berkat Jaya 111 Retina Consultants of Southwest Florida 31 Retreat 41 revoLUZion, advertising and design 293, 295 Reward-Link.com Sdn Bhd 111 Rhode Island Children's Crusade 257 Rickabaugh Graphics 363, Riordon Design 205 Rising Sun Catering 357 Rita Rivest 99 Riverbend 13 Riveredge Resort 267 Riverport Lakes 287 Riverview I lealth & Rehabilitation Center 105 RiverWest 249 Robert E. Hughes 89 Rocky Mountain 81 Rock and Roll Hall of Fame and Museum 85 Rock Bottom 349 Rolf Luz GmbH, Neuhausen 295 Roman Design 291, 293 Ronald B. Low 115 Roni Hicks & Assoc. 11 Ron Bartels Design 231 Rose M DeNeve 135 Rothschild Realty Inc. 63 Rottman Creative Group, LLC 103 Roxy Rapp & Company 77 Royal Roads University 181 RSP & Associates 235 RTD 341 Rueppell Home Design 301 Rule 29 243

RU Vodka 203

Sabingrafik, Inc. 7, 9, 11, 13

Sacramento River 75 Sadiesbiscuits.com 117 Safety Light 217 Sage Metering, Inc. 41 Salon Blu 359 Sam Smidt 91 Sandy Gin Design 87 Sand Hill Advisors 319 Santa Barbara Farms 211 Santa Rosa Open MRI Center 365 Santa Ynez Inn 211 San Diego City College Graphic Design 167 San Diego Gas & Electric 11 San Diego Museum Council San Francisco Marriott 23 San Luis Bay Inn 211 San Luis Creek Lodge 211 San Pacifico 9 San Pedro 149 Sapphire Grill 105 Sari Gallinson 309 Savannah Onstage Music & Arts Festival 105 Save-ory 145 Sayles Graphic Design 69, 71,73 Say Finn 331 Scandanavian Pro Products 335 Schafer Design 233 Schmakel Dentistry 261 Scholars Resource 33 Scholl & Company 43 Scott Rossi 343 Scraptivity 61 Seattle Convention & Visitors Bureau 23 SEBC Workforce Academy Security Plan 223 Seed IP 23 Seliquey Plantation 257 Senok 67 Sequent Mktg. & Comm. 331 Settlers Ridge 11 SFI-Anco Fine Cheese 217 SF Productions 145 shanghaiBASICS 139 Sharp Designs 99 Sharp Events 357 Sheila's Husband 119 Shelter Cove Lodge 211 Shields Design 237, 239 Shift 233 Shropshire Educational Consulting 161 Sightline Marketing 175 Silke Alber, Fridingen 293 Silk Abstract Company 119 Silk Road Collections, Inc. 259 Silueta 149 Silva Printing Associates 119 Silverlink Communications SilverSun, Incorporated 157 Silver Creative Group 217, 219 SIMC Co. Ltd. 341, 343 Simplify your life 279 Simply Dinners 87 Single Gourmet Hawaii 233

Six•Ink 357,359

Size 179 Skandalz 379 Skov Construction 69 SkylarHaley 193 sky design 125 Sleepwalker 341 Sloan Brothers Painting. Inc. 73 Small Biz Networks 261 Smith + Benjamin Art + Design 341 SMOD 337 Softwork GmbH, Mühlheim 295 SOMA Motors 245 South Central Iowa Solid Waste Agency 129 South Shore Marine 15 SOVArchitecture 21 Space Needle 21 Spangler Design Team 249 Spec Ops 307 Spike 251 Spore 337 SportsArt 369 Sports Chiropractic 67 Sports Placement Service, Inc. 227 Squarehand 337 St. Luke's Family Practice St. Paul's Lutheran Church St. Stanislaus 147 st3 201 Stacey 59 Stahl/Davis 197 Standing Partnership 287 Stargate Resources 111 STAR Products 185 Statewide Management, Inc. 115 Station Plaza of Kirkwood Stefany Lee Photography 51 Stephanie Astic Productions Stephen Longo 165 Stephen Longo Design Associates 165 sterling group 173 Steve Woods Printing Company 231 StillWaters Vineyards 215 Stirsby 365 Stoltz/The Outlets at Vero Beach 229 Stone Barns Center for Food & Agriculture 159 Stop. International for Spa 183 Stranded in Paradise 157 Strand Book Stall 133 Streamline Graphics, Inc. 187, 377 StreamWorks Consulting 251 Studio Moon 271, 273, 275, Stunt Clothing 131 Subaahana Malaysia Sdn Bhd 113 Substance151 305 Summit Construction 221 Superstar Exp 97 Super Bean International Pte Ltd 77 SureMerchant, LLC 233

Surinder Singh 329 SV Floral Consulting 261 Sweet Pea Gourmet 125

Т

T.J. Moore 343 Tacoma Monument 301 Tajima Creative 99,101 Talcott Holdings 277 Talking Business 173 Tamarindo Pacifico 9 Tango Cat 287 Tangram Strategic Design Tanning by the Sea 43
Tan In 10 173 Targum Shlishi 367 Tascha Faruqui 197 Tate Capital 247 Taylor Homes 315 Team.F 279 TechnikOne 355 TechSource 237 Telares Uruapan 149 Tender Touches Spa 131 Tequila Del Los Altos 149 Terra Firma 79 Terri Masters, Massage Therapy 157 Testa Renovations, Inc. 161 Thai Yum Shop 341 Thalia Consulting 315 Therapeutic & Relaxation Massage 259 The Anderson 121 The Buckley Group, LLC 233 The Centrella Inn 45 The Cimarron Group 317 The Eckholm Group 101 The Eden Communications Group 89 The Eye Doctors Inc. 365 The Fearey Group 129 The First Page 101 The Flowers Group 15 The Fluid Group 53 The Good Shepherd Fund 199 The Gordie Foundation 171 The Gourmet Cafe 309 The Hearing Group 165 The Hiles Group 359 The Idea Bungalow 171 The James/Gregory Group Inc. 363 The Lab 107 The Leap Group 371 The Lodge at Woodcliff 267 The Mavic Group 205 The Micro-Perfumery, Inc. 291 the Mixx no kidding! 91, 93, the organization 251 The Orientalist Singapore 75 The Paramount 13 The Park Manor 11 The Ridge 15 The Sandhurst Foundation 15 The Science Factory 259 The Sea Barn 215 The Spa at Salon Milano The Star Group 377, 379 The Stubbins Associates,

Inc. 271

The Tapestry Group 257 The Tax Store 303 The Township of West Orange 165 The Visual Sense 379 The Wecker Group 41, 43, 45.47 The Zone 239 Thinking Cap Design 333 Thira, Incorporated 291 Thirty-Five East Wacker Drive 25 Thomson French Matsumoto 269 Three Golden Apples 363 Timothy Paul Carpets + Textiles 199 Titan Industries 135 TLC Design 121 TOAST 93 Todd Nickel 141 Toledo Public Schools 261 Tompkins Square 217 Tom Fowler, Inc. 247 Tom Moon, FAB Logistics 275 Tonic 309 Tonya Ingersol 359 Tony Fortuna, Lenox NY 273 Tony Guttman, ARC Centre of Excellence for Mathematics & Statistics of Complex Systems 329 Ton Ab! 309 Torque 319 Torque Ltd. 317,319 total vein care 75 Tracy Moon 275 Tracy Nichols 273 Trang Dam 171 Trapeze Communications Inc. 181, 183, 185 travel2events.com 373 Travelport 19 Travel Signposts 253 Treats Frozen Desserts 27 Treehouse Design 359, 361 Tri-State Wallcoverings 157 Tribhovandas Bhimji Zaveri Triple 'B' Ranch Design 153 Truefaces Creation Sdn Bhd 107, 109, 111, 113, 115 TTL Distributors Sdn Bhd Turner Entertainment Company 9 Turnstone Group 249 Twenty Two C Partners Inc. 185 Two in Tandem Design 331 Tyler Blik Design 15

U

uALTe, Arizona State
University 315
über, inc. 309, 311, 313
UCI Inc/Urano
Communication
International 101
UCSD Tritons 13
Ukulele Brand Consultants
Pte Ltd 75, 77
Ultrabac 177
Umbrella Graphics 147
UnderXposed 345
Unforgettable Honeymoons
315

Unidesign Jewellery 133
United States Surgical 369
Univerzitetna knjiznica
Maribor 83
UPP 347
Urbanus 367
Urban Compass 361
Urban Mobility Group 19
Usaha Selatan Logistics Sdn
Bhd 115

٧

VAL Floors 95 Vancity 253 Varsity Entertainment 93 Vasaio 243 Vatsalya 135 Ventress Design Group 215 Veritas 173 Versalab 353 Verticom 351 Vibrant Enterprise Associates 147 VICAM 233 Victoria Cave 31 Victoria Conference Centre 185 Victoria Foundation 185 Village Green 211 Vineyard Creek Hotel & Spa 273 Vinski konvent sv. Urbana 83 Violet Online Gifts 275 Virtutech 21 Visual Asylum 165, 167, 169 Visual Intelligence Agency, Inc. 361 Vitamin 349 VMA, Inc. 219 Von Velohaus 149

W

Walker Foods 215

WAMSO Minnesota

Orchestra Volunteer

Association 249

Warm Lake Estate 265 Washington Mutual 99 Washington Park Christian Church 89 Water's Edge Gardening 237 Waterfront Design Group 97 Waterfront Mgmt. Systems WaterRidge 11 Watershed Designs 125 Watt Farms 265 WealthCycle 319 WEBDESIGNS-STUDIO. com 227 Wedding Creations 41 Weekendtrips.com 59 Welch Design Group, Inc. 147 Werbe 3 309 Westgate Biological Ltd. Westminster Presbyterian Church 89 Westwind Air Services 315 West Chester Chamber Alliance 235 Wheeler Design 225 Whitehall Properties 201

WhiteSpace Creative 303 Whitney Design Works, LLC Whitney Design Works & Explore Marketing 161 Whitney Edwards Design 129 Whitney Stinger 161 Wieser, Mühlheim 295 Wieuca Road Baptist Church 257 Wilcoxen Design 81 Wildwood Hills Ranch 71 Wild Rose Entertainment. LLC 69 Wilk Brand & Silver 119 William F. Maida & Son 121 William Shearburn Gallery 63 William Wilson Associated Architects 53 Willow Technology 195 WiMAX Forum 193 Wines from Slovenia 83 Wink 183 Winners Batting Cages 47 Wizmo, Inc. 273 Women's Educational Media 359 Woowire 343 Woodbury 13 Words & Ideas 153 Words by Design 77 Works/San José 195, 197, 199 Worldwise 193 World of Work 115

X

World Property Investments

World Sake Imports 101

www.brookejury.com 169

Wort und Tat 279

WVFiber 203

Xcuseme 339 Xinet, Inc. 285 Xsense 211

Y

Yale Appliance + Lighting 55 Yohay Baking Co. 217 Yorozu Law Group 101 Young & Martin Design 257, 259 Young Zeck Image Communications 367 You Grow, Girl 73 You Lucky Dog 169 Yung Luu 171

z

Zenergy 219
Zenzi 349
Zetta Lou's Heavenly
Catering 139
ZGraphics, Ltd. 171
Ziegeler Home & Garden
277
Zoetek Medical 267
Zoë Restaurant 115
Zonk! 7
Zoom 279
Zullo Communications 217
Zygo & Michael 253